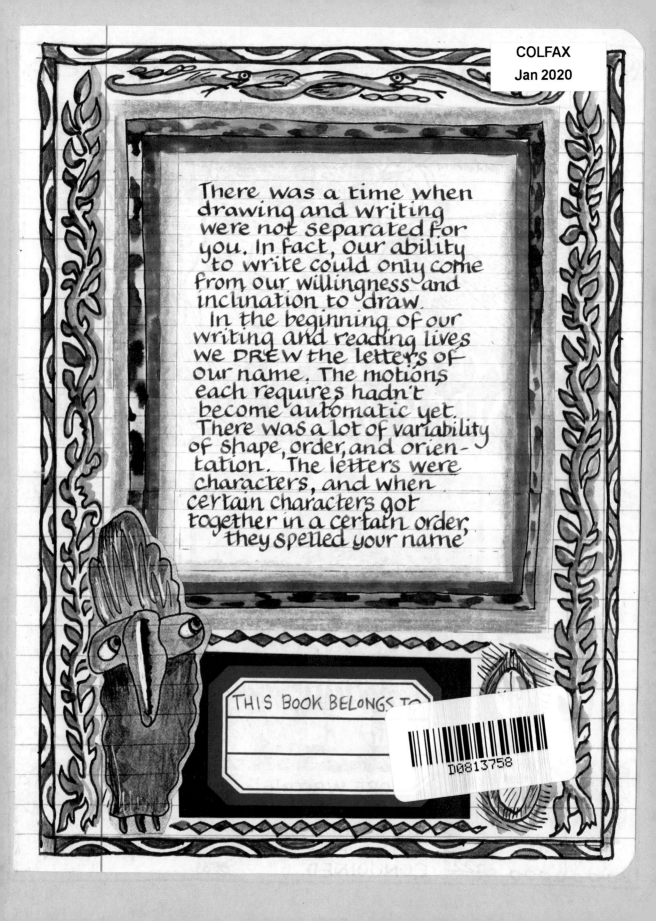

There was a time when drawing and writing were not separated for you. In fact, our ability to write could only come from our willingness and inclination to draw.

In the beginning of our writing and reading lives we DREW the letters of our name. The motions each requires hadn't become automatic yet. There was a lot of variability of shape, order, and orientation. The letters were characters, and when certain characters got together in a certain order, they spelled your name'

THIS BOOK BELONGS TO

WHO HAS THE TINDER BOX?

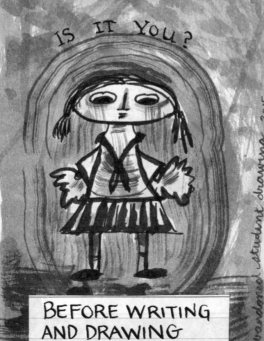

IS IT YOU?

WORDS

PICTURES

BEFORE WRITING
AND DRAWING
WERE SEPARATED
THEY WERE
CONJOINED.

What is

the difference?

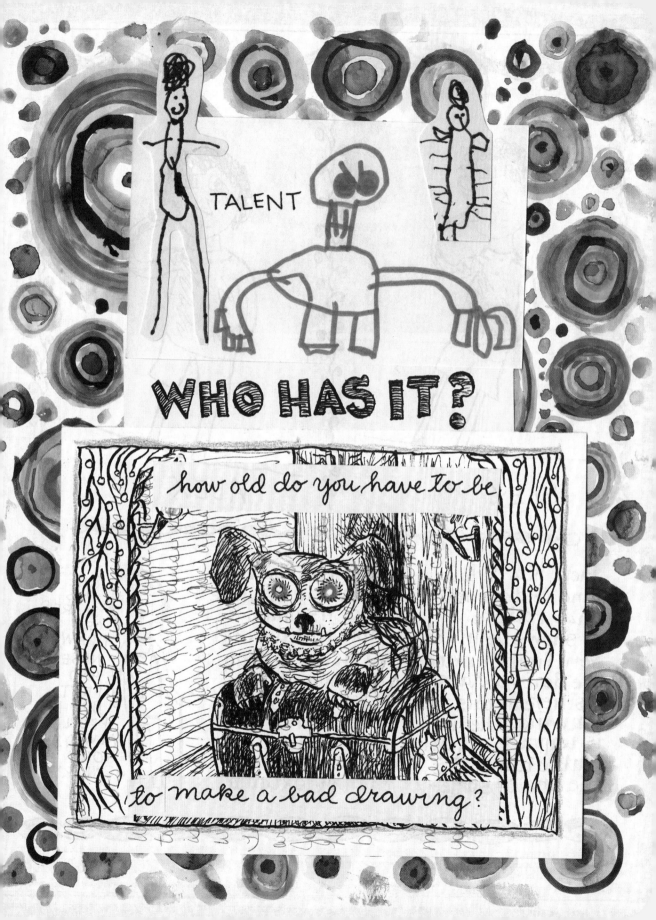

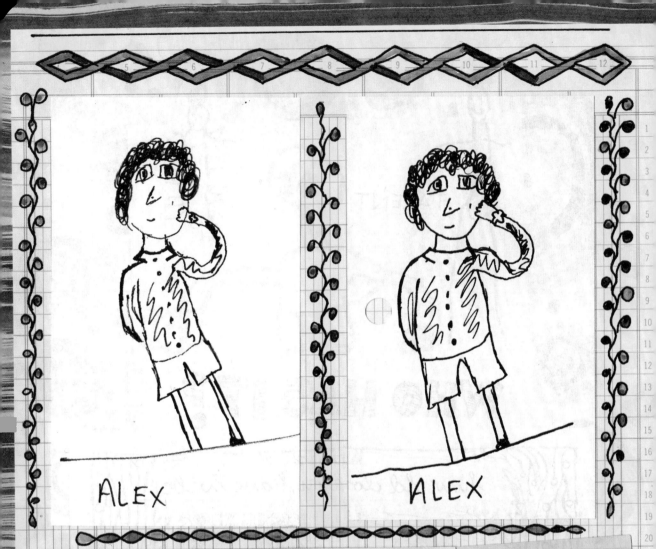

ALEX

ALEX

There is a certain kind of drawing that I adore. It shows up in the very first drawings we do as a class. It's here in this drawing. The line is unpracticed, even a little timid. It's the line of some-

one who quit drawing a while ago. It's impossible to fake and difficult to copy. My copy on the right is missing something. To me it's just a little less alive than the original.

SHE WAS SCARED OF DRAWING NOSES AND FEET BUT HER PEOPLE ALWAYS WORE JEWELRY

LILLY
MAX
ELLA
AL REX

It's the same sort of aliveness in this handwriting by a four-year-old who asked me to help her "draw" her friends' names. She could draw each letter as I spelled out the names, and I noticed spacing happening in unexpected ways. The letters are in real relation to both each other and to the page.

TELL A LIE ABOUT
drawing

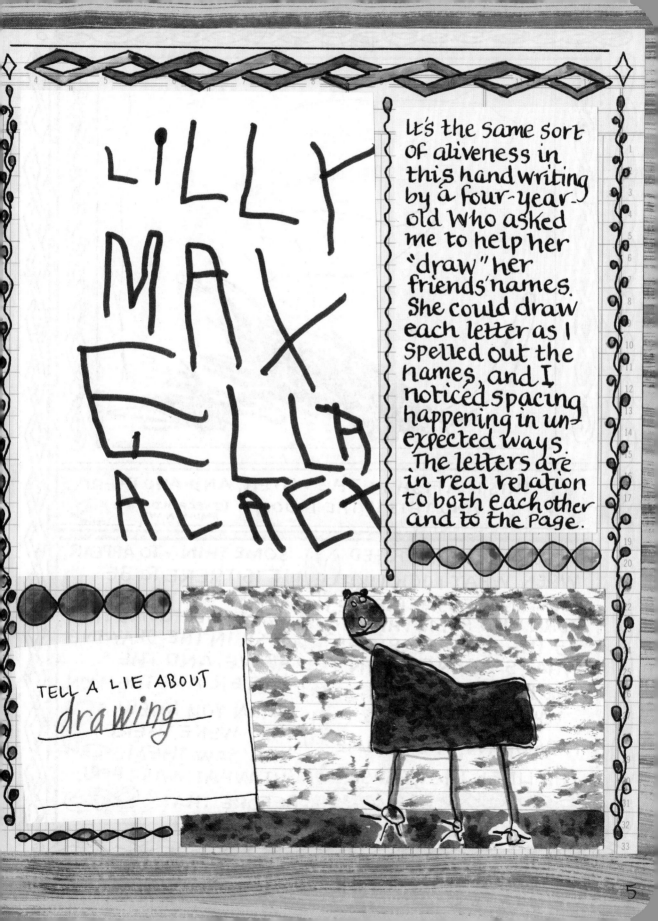

"THIS IS A FISH IN THE WATER, AND ANOTHER FISH. AND THIS IS THE MOON" [2 YEAR OLD MADISON, WI 2014]

ADULTS ARE SURPRISED WHEN WHAT LOOK LIKE MEANINGLESS SCRIBBLES TURN INTO SOMETHING AS THE KID DESCRIBES WHAT'S GOING ON IN THE PICTURE.

WHEN VERY YOUNG KIDS DRAW, THEY CAUSE THE LINES THAT CAUSE SOMETHING TO APPEAR, IT IS THERE TO BE FOUND IN THE SAME WAY YOU FOUND THE FISH IN THE DRAWING ABOVE. AND THE WATER AND THE MOON.

WHEN YOU KNEW THEY WERE THERE, YOU SAW THEM. BUT WHAT WAS THERE BEFORE THAT?

"One hundred years ago there were nice wolves and little Red Riding Hood lived in a tree. The sun was black and the moon was black but there's no more black so I used the purple."

4 YEAR OLD - 2013

WHEN I WORK WITH LITTLE KIDS, I DRAW ALONGSIDE THEM, SOMETIMES COPYING THEM AND SOMETIMES JUST DRAWING TO SEE WHAT SHOWS UP. I DON'T SAY MUCH ABOUT DRAWING - AND I'M NOT THERE AS A TEACHER. TO ME IT'S A LANGUAGE IMMERSION CLASS. KIDS SPEAK IMAGE.

THEY ARE FLUENT IN A WAY THAT ALLOWS ME NEW UNDERSTANDING ABOUT A CERTAIN STATE OF MIND THAT TWINS ITSELF WITH CERTAIN ACTIVITIES. IT'S SOMETHING I CAN'T LEARN BY TALKING ABOUT THEORY OR BY TALKING IN GENERAL. THIS IS A DIFFERENT SORT OF LANGUAGE.

THIS LANGUAGE IS WHAT I'M TRYING TO TEACH IN MY COMICS CLASSES. THIS LANGUAGE MOVES UP THROUGH YOUR HAND AND INTO YOUR HEAD. YOUNG CHILDREN ARE NATIVE SPEAKERS.

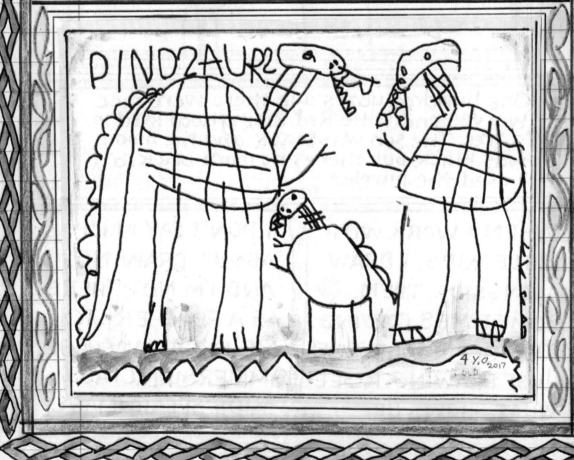

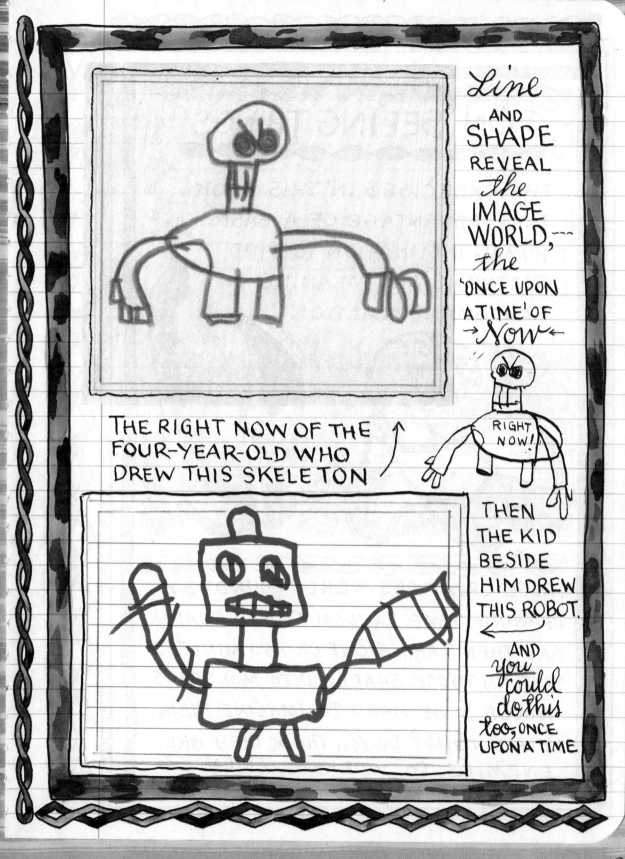

Line AND SHAPE REVEAL the IMAGE WORLD,— the 'ONCE UPON A TIME' OF →Now←

RIGHT NOW!

THE RIGHT NOW OF THE FOUR-YEAR-OLD WHO DREW THIS SKELETON

THEN THE KID BESIDE HIM DREW THIS ROBOT.

AND you could do this too, ONCE UPON A TIME

ON 'SEEING THINGS'

MANY OF
THE EXERCISES IN THIS BOOK
TAKE ADVANTAGE OF A BASIC
HUMAN INCLINATION TO FIND
PATTERNS AND MEANING IN
RANDOM INFORMATION.

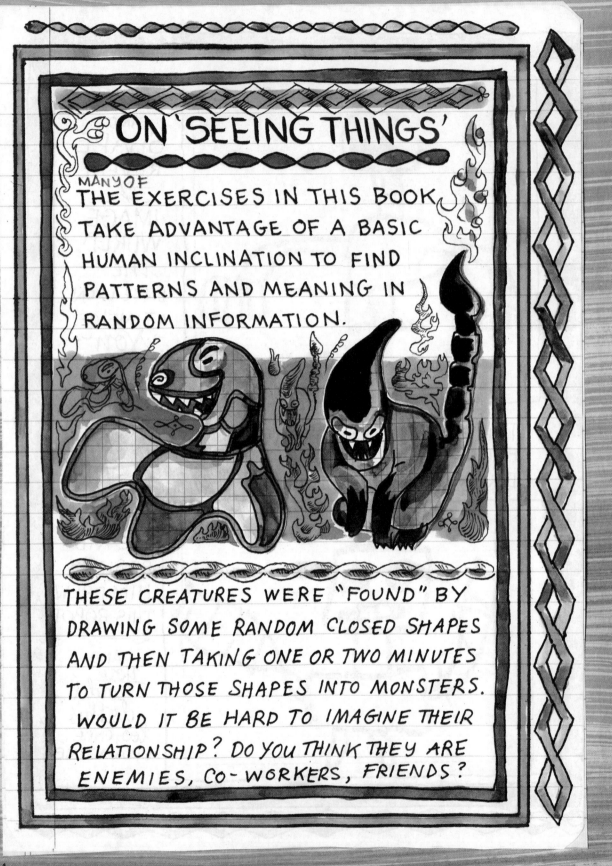

THESE CREATURES WERE "FOUND" BY
DRAWING SOME RANDOM CLOSED SHAPES
AND THEN TAKING ONE OR TWO MINUTES
TO TURN THOSE SHAPES INTO MONSTERS.
WOULD IT BE HARD TO IMAGINE THEIR
RELATIONSHIP? DO YOU THINK THEY ARE
ENEMIES, CO-WORKERS, FRIENDS?

WE MIGHT CALL WHAT WE ARE DOING WHEN WE USE IMAGES IN THIS WAY, A ~~FOR~~ A form of dreaming *This picture and that* — SOMETHING NOT QUITE WITHIN OUR CONTROL IS SUGGESTING ITSELF AND MOVING OUR PEN FORWARD. OUR TASK IS TO STAY CURIOUS AND

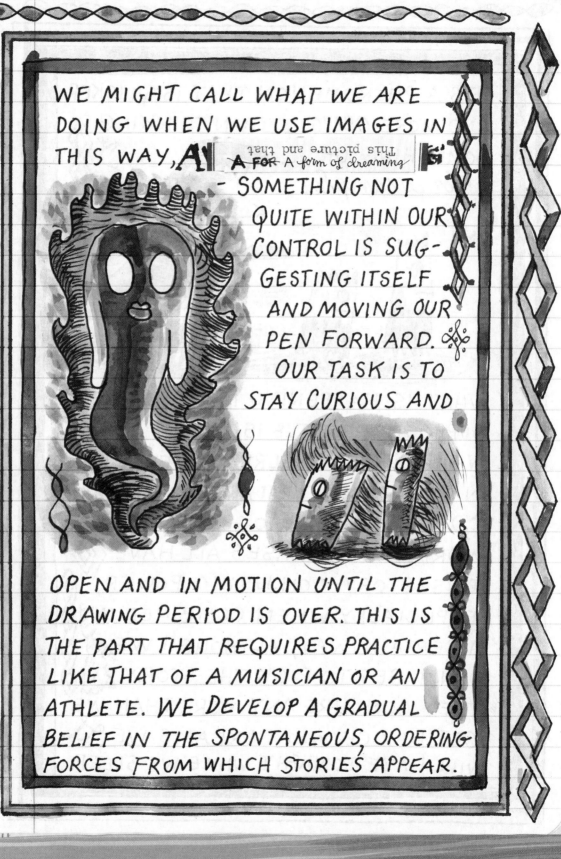

OPEN AND IN MOTION UNTIL THE DRAWING PERIOD IS OVER. THIS IS THE PART THAT REQUIRES PRACTICE LIKE THAT OF A MUSICIAN OR AN ATHLETE. WE DEVELOP A GRADUAL BELIEF IN THE SPONTANEOUS, ORDERING FORCES FROM WHICH STORIES APPEAR.

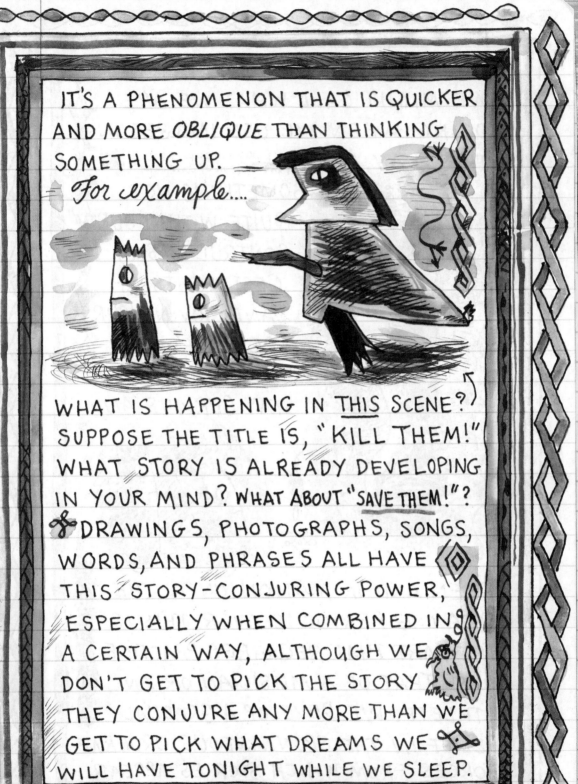

IT'S A PHENOMENON THAT IS QUICKER AND MORE *OBLIQUE* THAN THINKING SOMETHING UP. *For example...*

WHAT IS HAPPENING IN <u>THIS</u> SCENE? SUPPOSE THE TITLE IS, "KILL THEM!" WHAT STORY IS ALREADY DEVELOPING IN YOUR MIND? WHAT ABOUT "SAVE THEM!"? DRAWINGS, PHOTOGRAPHS, SONGS, WORDS, AND PHRASES ALL HAVE THIS STORY-CONJURING POWER, ESPECIALLY WHEN COMBINED IN A CERTAIN WAY, ALTHOUGH WE DON'T GET TO PICK THE STORY THEY CONJURE ANY MORE THAN WE GET TO PICK WHAT DREAMS WE WILL HAVE TONIGHT WHILE WE SLEEP.

my way of teaching comics is not about developing characters 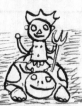 it's about waiting to see who shows up in certain circumstances

yes

THERE IS A FEELING I GET WHEN I DRAW OVER THE LINES OF A KID'S DRAWING. I'm on the path their hand took — it's a walking pace that gives me a different view of the image. NOW MY HAND IS *involved*.

YOUR HAND NEEDS TIME TO WANDER enough TO BE ABLE TO FIND SOMETHING YOU WEREN'T *aware* OF, LIKE AN EXPEDITION PARTNER who CAN SEE THINGS YOU CAN'T. The hand IS EXPERIENCING THE same world IN A DIFFERENT WAY. IT'S YOU BUT NOT YOU.

Two selves ready to go

NO

13

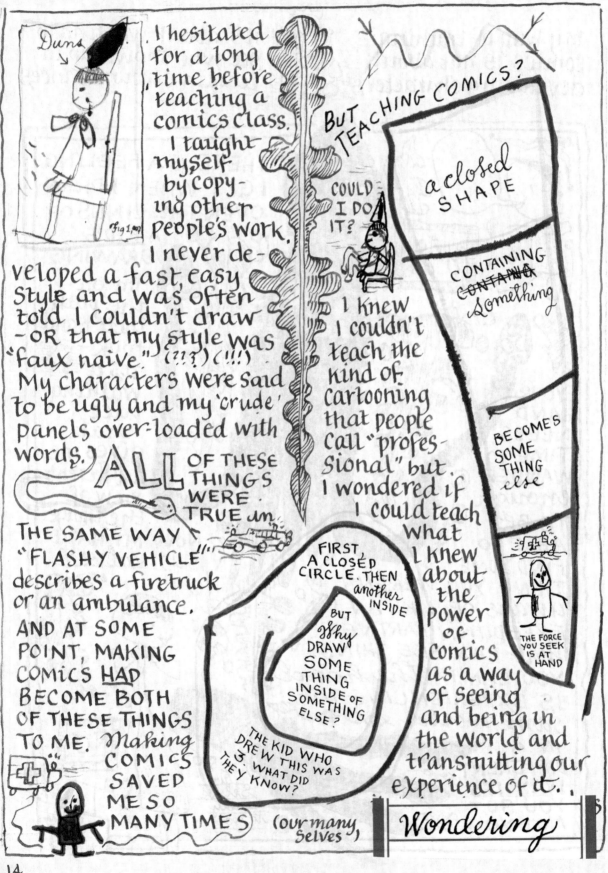

Duna

Fig 1.

I hesitated for a long time before teaching a comics class. I taught myself by copying other people's work. I never developed a fast, easy style and was often told I couldn't draw — or that my style was "faux naive." (?!?) (!!!) My characters were said to be ugly and my 'crude' panels over-loaded with words.

ALL OF THESE THINGS WERE TRUE in THE SAME WAY "FLASHY VEHICLE" describes a firetruck or an ambulance. AND AT SOME POINT, MAKING COMICS HAD BECOME BOTH OF THESE THINGS TO ME. Making COMICS SAVED ME SO MANY TIMES (our many selves)

BUT TEACHING COMICS?

COULD I DO IT?

I knew I couldn't teach the kind of cartooning that people call "professional" but I wondered if I could teach what I knew about the power of comics as a way of seeing and being in the world and transmitting our experience of it.

a closed SHAPE

CONTAINING something

BECOMES SOME THING else

THE FORCE YOU SEEK IS AT HAND

FIRST, A CLOSED CIRCLE. THEN another INSIDE BUT Why DRAW SOME THING INSIDE OF SOMETHING ELSE? THE KID WHO DREW THIS WAS 3. WHAT DID THEY KNOW?

Wondering

14

WE DRAW BEFORE WE ARE TAUGHT. WE ALSO SING, DANCE, BUILD THINGS, ACT, AND MAKE UP STORIES LONG BEFORE WE ARE GIVEN ANY DELIBERATE INSTRUCTION BEYOND EXPOSURE TO THE PEOPLE AROUND US DOING THINGS.

Everything we have come to call the arts seems to be in almost every 3-year-old

WHEN these CAPACITIES ARE ABSENT in A YOUNG child WE WORRY ABOUT THEM. THERE SEEMS TO BE AN understanding that THE THING WE CALL THE ARTS HAS a critical function for kids, THOUGH WE MAY HAVE A HARD TIME SAYING JUST WHAT IT IS, ESPECIALLY IF WE CALL IT "ART"—BUT "IT" EXISTED BEFORE THE WORD FOR IT EXISTED,

NOT JUST GENERALLY BUT FOR EACH OF US. WE WERE DOING ALL OF THESE THINGS BEFORE WE KNEW WHAT IT WAS WE WERE DOING, IT SEEMED TO BE SOMETHING COMING FROM THE INSIDE. WHEN 3-AND 4-YEAR-OLDS DRAW, THE THING THEY ARE DRAWING CAN CHANGE FROM ONE THING INTO ANOTHER, SURPRISING THEM.

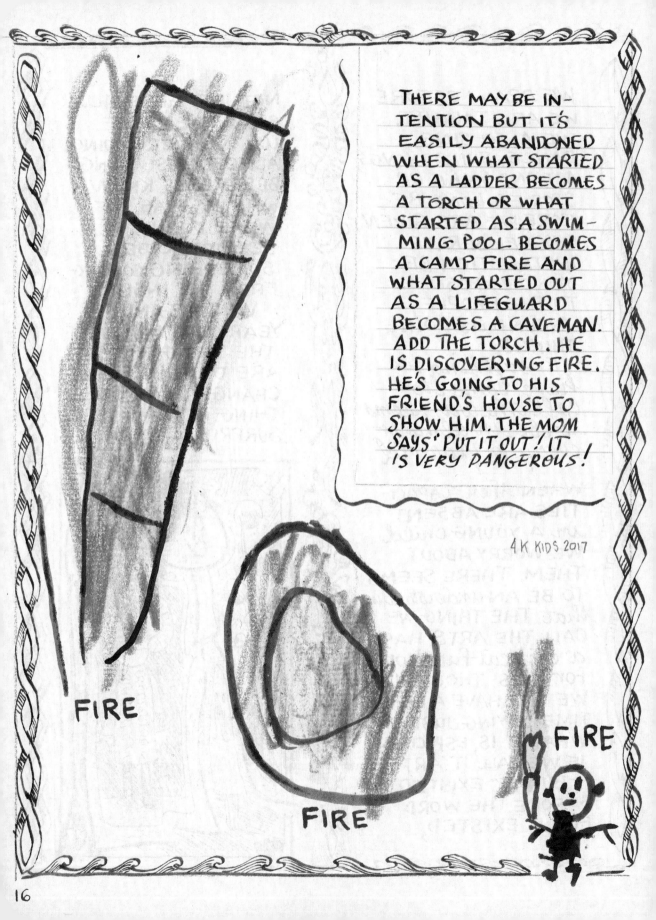

THERE MAY BE IN-
TENTION BUT IT'S
EASILY ABANDONED
WHEN WHAT STARTED
AS A LADDER BECOMES
A TORCH OR WHAT
STARTED AS A SWIM-
MING POOL BECOMES
A CAMP FIRE AND
WHAT STARTED OUT
AS A LIFEGUARD
BECOMES A CAVEMAN.
ADD THE TORCH. HE
IS DISCOVERING FIRE.
HE'S GOING TO HIS
FRIEND'S HOUSE TO
SHOW HIM. THE MOM
SAYS "PUT IT OUT! IT
IS VERY DANGEROUS!

4 K KIDS 2017

FIRE

FIRE

FIRE

16

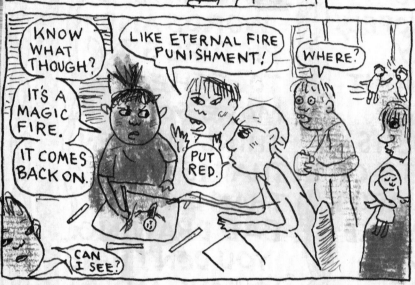

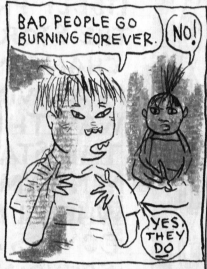

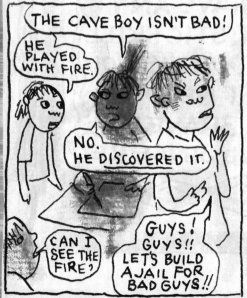

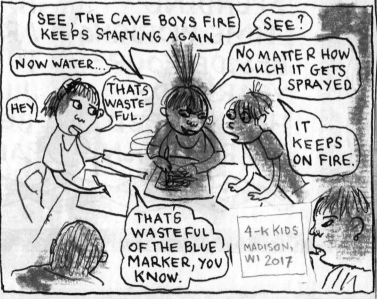

4-K KIDS
MADISON,
WI 2017

17

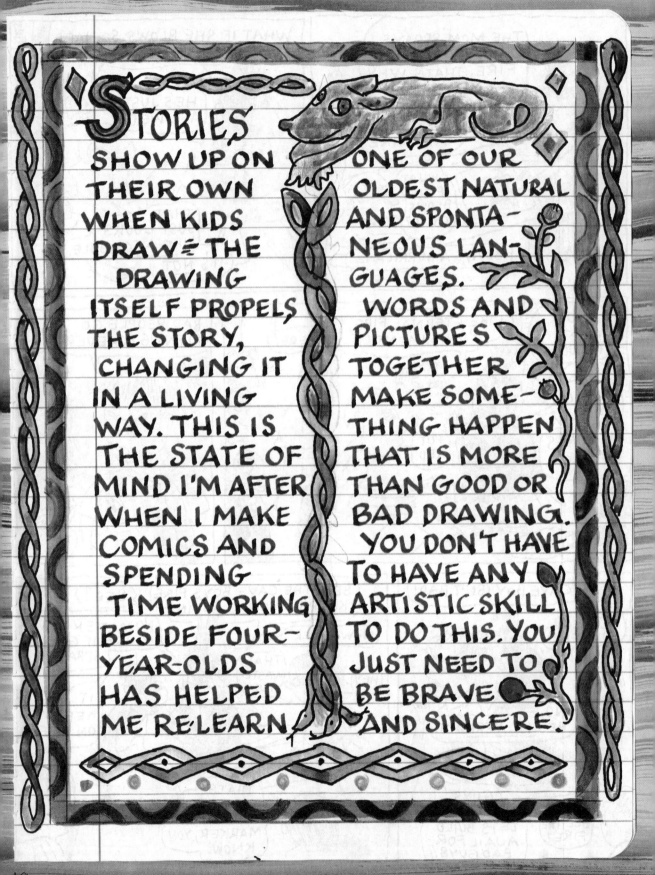

STORIES SHOW UP ON THEIR OWN WHEN KIDS DRAW ≈ THE DRAWING ITSELF PROPELS THE STORY, CHANGING IT IN A LIVING WAY. THIS IS THE STATE OF MIND I'M AFTER WHEN I MAKE COMICS AND SPENDING TIME WORKING BESIDE FOUR-YEAR-OLDS HAS HELPED ME RE-LEARN ONE OF OUR OLDEST NATURAL AND SPONTA-NEOUS LAN-GUAGES. WORDS AND PICTURES TOGETHER MAKE SOME-THING HAPPEN THAT IS MORE THAN GOOD OR BAD DRAWING. YOU DON'T HAVE TO HAVE ANY ARTISTIC SKILL TO DO THIS. YOU JUST NEED TO BE BRAVE AND SINCERE.

Making Comics 1

Materials
METHODS
Classroom Culture

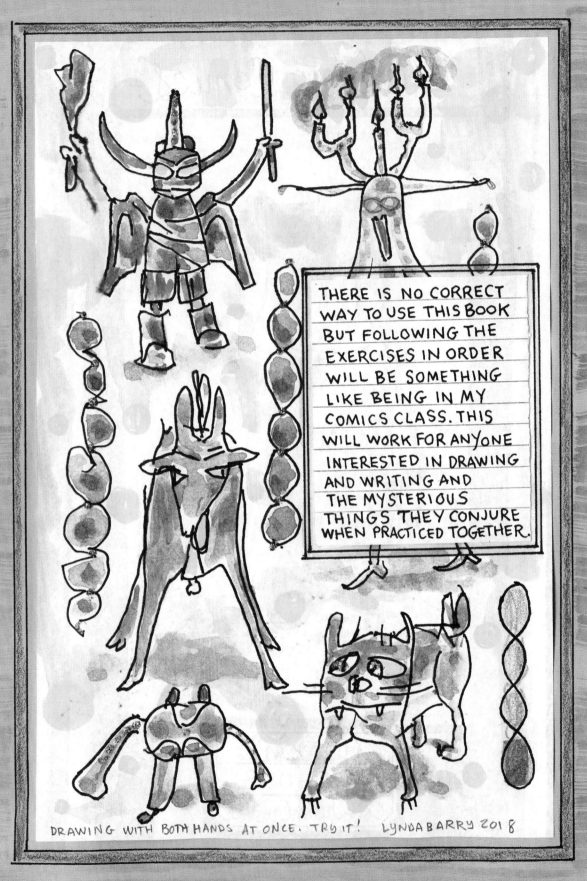

THERE IS NO CORRECT
WAY TO USE THIS BOOK
BUT FOLLOWING THE
EXERCISES IN ORDER
WILL BE SOMETHING
LIKE BEING IN MY
COMICS CLASS. THIS
WILL WORK FOR ANYONE
INTERESTED IN DRAWING
AND WRITING AND
THE MYSTERIOUS
THINGS THEY CONJURE
WHEN PRACTICED TOGETHER.

DRAWING WITH BOTH HANDS AT ONCE. TRY IT! LYNDA BARRY 2018

SEEING WHAT IS THERE GAZING

TALKING MAKES THIS *impossible.* BUT THE TALKING PART OF US DOESN'T KNOW THIS. IN FACT, THE TALKING PART OF YOU KNOWS VERY LITTLE ABOUT THE GAZING PART OF YOU THAT HAS SOMETHING OF A LIFE OF ITS OWN. THIS CLASS IS FOR THAT PART OF YOU.

Part of our WORK TOGETHER IS TO BE ABLE TO WATCH AN IMAGE IN A SUSTAINED WAY, AS IF IT WERE ALIVE AND CAPABLE OF CHANGE. PART OF OUR WORK IS TO TAKE TIME, TO WAIT LIKE ANY BIRD-WATCHER, TO HOLD STILL *and be* TAKEN IN.

MOST PEOPLE
QUIT DRAWING
AROUND THE
AGE OF NINE
OR TEN WHEN THEY
REALIZE THEY CAN'T
DRAW A NOSE. OR
SOMETIMES IT'S HANDS.
WHAT I LOVE ABOUT
COMICS IS THE ABILITY
TO LEAP OVER THIS
PROBLEM OF DRAWING
IN A 'REALISTIC' STYLE.
WE DON'T WANT A
PERFECTLY RENDERED
NOSE OR HYPER-REALIS-
TIC HANDS ON OUR
CHARACTERS. COMICS
ARE SOMETHING
OTHER THAN REPRE-
SENTATION. IT RELIES
ON A BASIC HUMAN
ABILITY TO SEE FACES
IN SIMPLE LINE DRAWINGS.

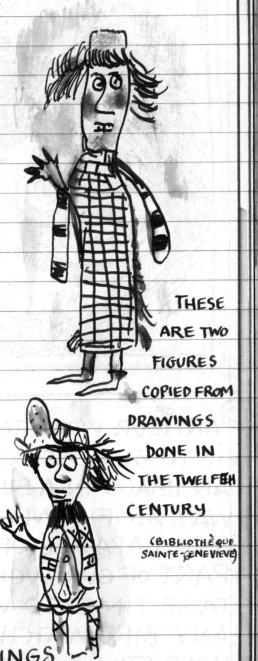

THESE
ARE TWO
FIGURES
COPIED FROM
DRAWINGS
DONE IN
THE TWELFTH
CENTURY

(BIBLIOTHÈQUE
SAINTE-GENEVIEVE)

WE CAN SEE FACES IN STAINS, AND WHOLE BEINGS TOO. THIS WAS ESPECIALLY SO WHEN WE WERE KIDS -- NOT BECAUSE WE WERE BETTER AT IT, BUT BE-CAUSE WE BELIEVED IN AND UNEXPECTED ~~SOME SORT OF~~ ALIVENESS IN THINGS. IT WAS THERE BECAUSE WE SAW IT AND WE SAW IT BE-CAUSE OF THE WAY WE LOOKED AT THINGS. WE LOOKED AT THEM LIKE THEY COULD LOOK BACK.

COPIED STUDENT DRAWINGS 2017 UW-MADISON

WHEN WE DREW WE WATCHED THE DRAWING HAPPENING, WE SAW IT TURN FROM ONE THING INTO ANOTHER, BASED ON WHATEVER MARKS OUR HAND WAS MAKING. IN THE BEGINNING WE MOSTLY JUST WATCHED OUR HAND CAUSING LINES TO APPEAR, MOVING FAST AND SLOW.

23

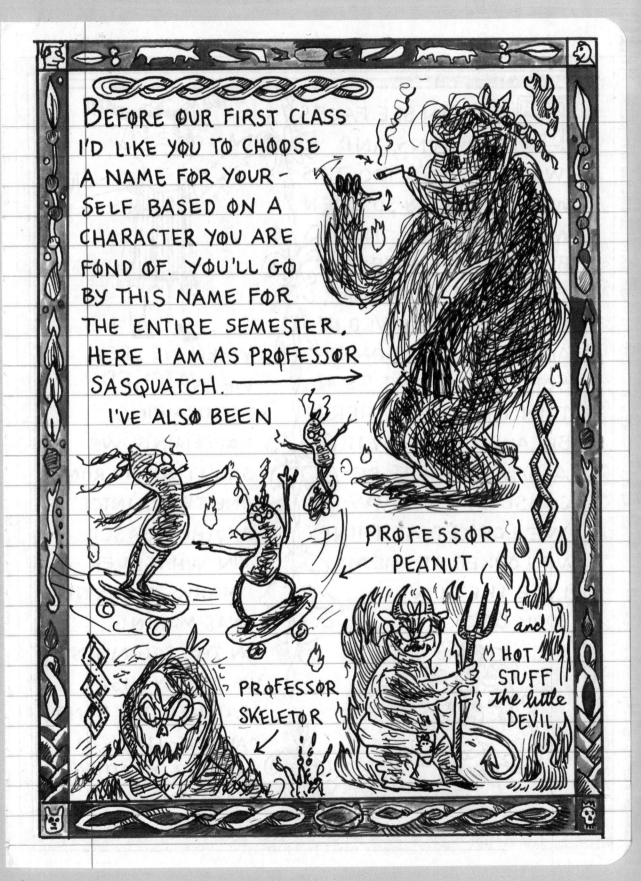

BEFORE OUR FIRST CLASS I'D LIKE YOU TO CHOOSE A NAME FOR YOURSELF BASED ON A CHARACTER YOU ARE FOND OF. YOU'LL GO BY THIS NAME FOR THE ENTIRE SEMESTER. HERE I AM AS PROFESSOR SASQUATCH. ——————→

I'VE ALSO BEEN

PROFESSOR PEANUT

PROFESSOR SKELETOR

and HOT STUFF the little DEVIL

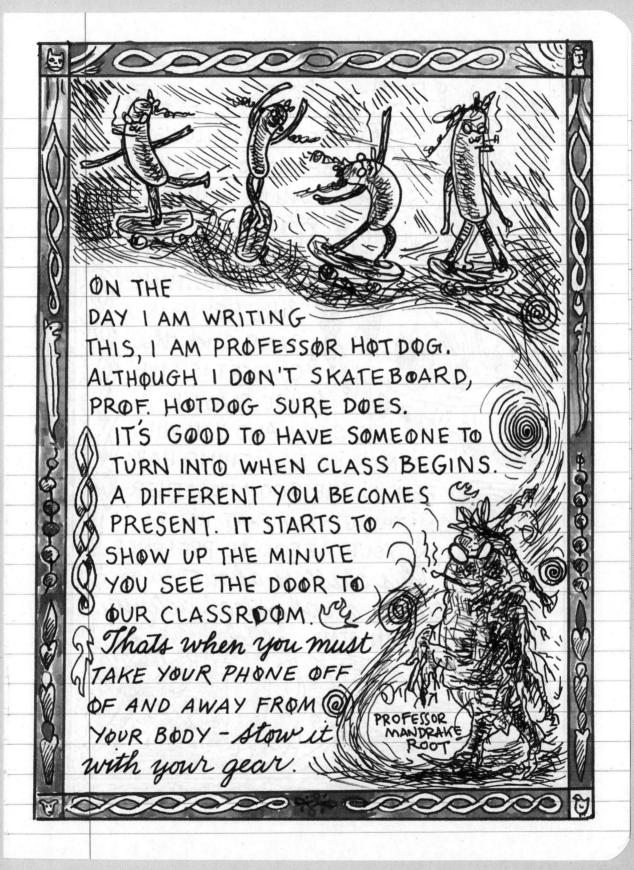

ON THE DAY I AM WRITING THIS, I AM PROFESSOR HOTDOG. ALTHOUGH I DON'T SKATEBOARD, PROF. HOTDOG SURE DOES.

IT'S GOOD TO HAVE SOMEONE TO TURN INTO WHEN CLASS BEGINS. A DIFFERENT YOU BECOMES PRESENT. IT STARTS TO SHOW UP THE MINUTE YOU SEE THE DOOR TO OUR CLASSROOM. *Thats when you must* TAKE YOUR PHONE OFF OF AND AWAY FROM YOUR BODY — *stow it with your gear.*

PROFESSOR MANDRAKE ROOT

CELL PHONES ARE *never* ALLOWED TO BE OUT OR ON *your person* DURING CLASS. THINK OF *our time* TOGETHER AS SOMETHING *like* BEING IN A BAND *and the* CONCERT IS LIVE. YOU'RE PLAYING A LIVE SHOW AND YOU WILL BE MAKING SOMETHING HAPPEN IN THE ROOM TOGETHER; SOMETHING NEW THAT RELIES ON YOUR ABSOLUTE PRESENCE. *This class is about practicing a physical activity* WITH A CERTAIN STATE OF MIND.

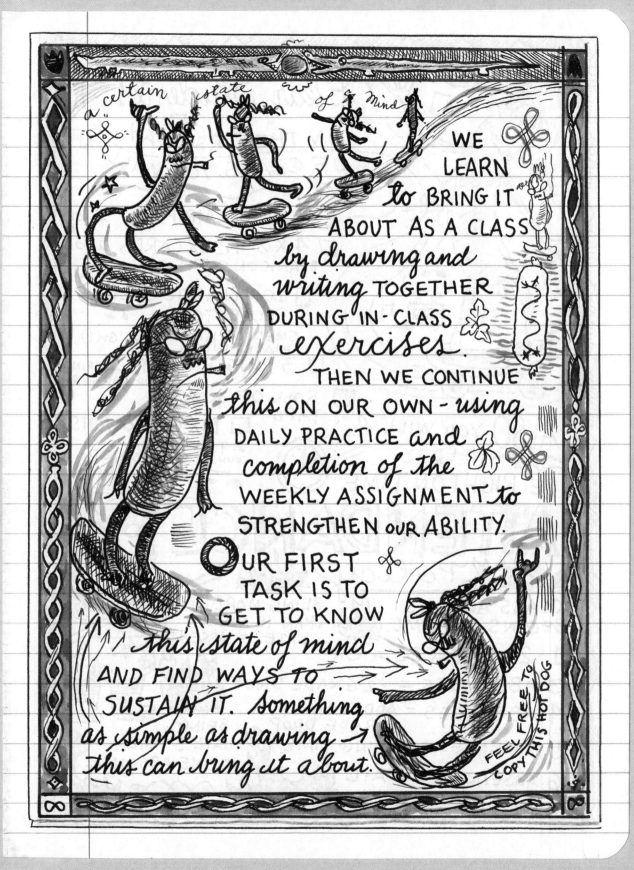

a certain state of mind

WE LEARN to BRING IT ABOUT AS A CLASS by drawing and writing TOGETHER DURING IN-CLASS *exercises*.

THEN WE CONTINUE this ON OUR OWN - using DAILY PRACTICE and completion of the WEEKLY ASSIGNMENT to STRENGTHEN our ABILITY.

OUR FIRST TASK IS TO GET TO KNOW this state of mind AND FIND WAYS TO SUSTAIN IT. Something as simple as drawing this can bring it about.

FEEL FREE TO COPY THIS HOT DOG

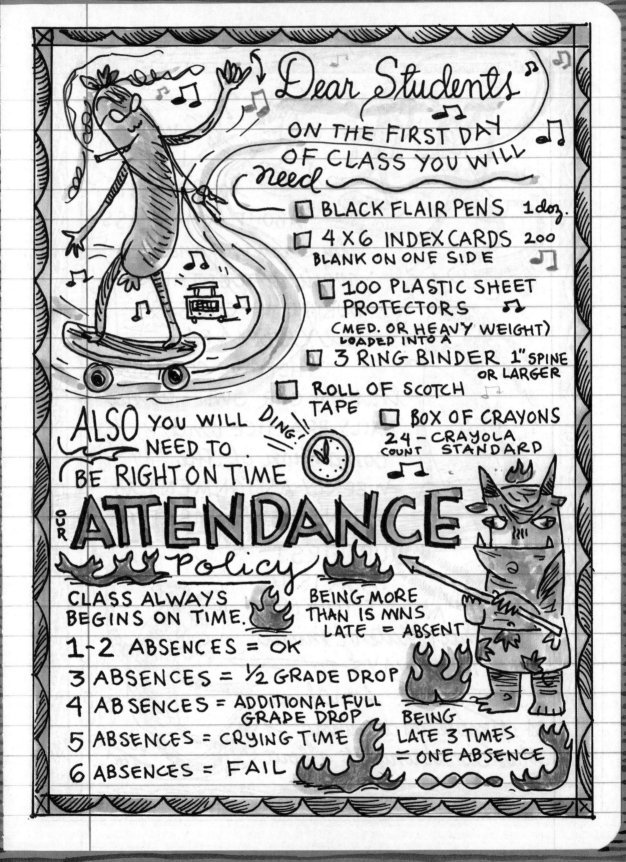

Dear Students

ON THE FIRST DAY OF CLASS YOU WILL need

- ☐ BLACK FLAIR PENS 1 doz.
- ☐ 4 X 6 INDEX CARDS 200 BLANK ON ONE SIDE
- ☐ 100 PLASTIC SHEET PROTECTORS (MED. OR HEAVY WEIGHT) LOADED INTO A
- ☐ 3 RING BINDER 1" SPINE OR LARGER
- ☐ ROLL OF SCOTCH TAPE
- ☐ BOX OF CRAYONS 24-COUNT CRAYOLA STANDARD

ALSO YOU WILL NEED TO DING!! BE RIGHT ON TIME

OUR ATTENDANCE Policy

CLASS ALWAYS BEGINS ON TIME.

BEING MORE THAN 15 MINS LATE = ABSENT

1-2 ABSENCES = OK

3 ABSENCES = ½ GRADE DROP

4 ABSENCES = ADDITIONAL FULL GRADE DROP

5 ABSENCES = CRYING TIME

6 ABSENCES = FAIL

BEING LATE 3 TIMES = ONE ABSENCE

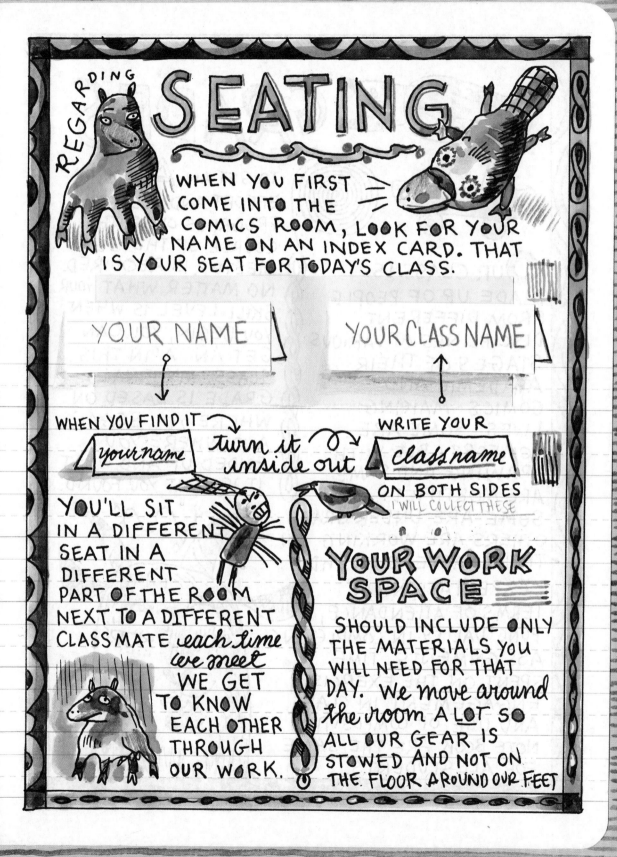

REGARDING SEATING

WHEN YOU FIRST COME INTO THE COMICS ROOM, LOOK FOR YOUR NAME ON AN INDEX CARD. THAT IS YOUR SEAT FOR TODAY'S CLASS.

YOUR NAME

YOUR CLASS NAME

WHEN YOU FIND IT → *your name* — turn it inside out → WRITE YOUR *class name*

ON BOTH SIDES
I WILL COLLECT THESE

YOU'LL SIT IN A DIFFERENT SEAT IN A DIFFERENT PART OF THE ROOM NEXT TO A DIFFERENT CLASSMATE *each time we meet* WE GET TO KNOW EACH OTHER THROUGH OUR WORK.

YOUR WORK SPACE

SHOULD INCLUDE ONLY THE MATERIALS YOU WILL NEED FOR THAT DAY. *We move around the room* A L**O**T SO ALL OUR GEAR IS STOWED AND NOT ON THE FLOOR AROUND OUR FEET

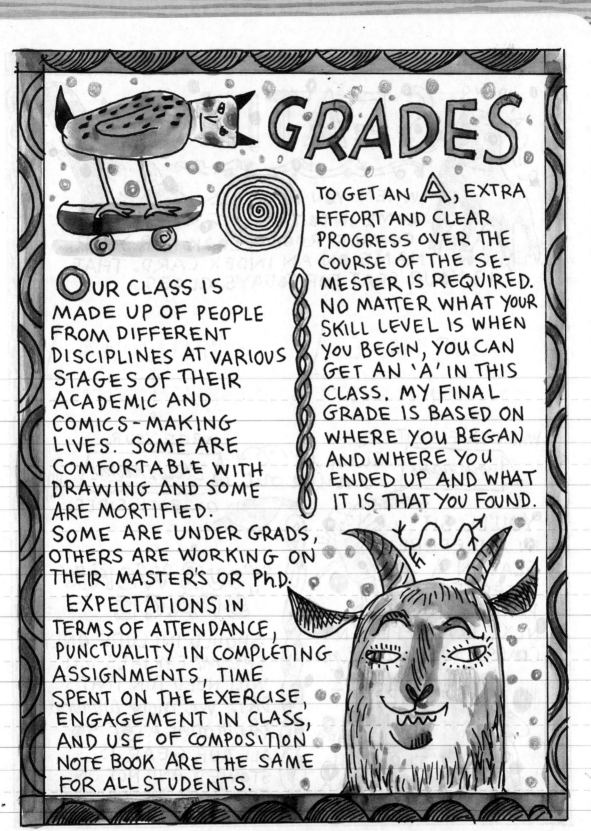

GRADES

OUR CLASS IS MADE UP OF PEOPLE FROM DIFFERENT DISCIPLINES AT VARIOUS STAGES OF THEIR ACADEMIC AND COMICS-MAKING LIVES. SOME ARE COMFORTABLE WITH DRAWING AND SOME ARE MORTIFIED. SOME ARE UNDER GRADS, OTHERS ARE WORKING ON THEIR MASTER'S OR Ph.D.

EXPECTATIONS IN TERMS OF ATTENDANCE, PUNCTUALITY IN COMPLETING ASSIGNMENTS, TIME SPENT ON THE EXERCISE, ENGAGEMENT IN CLASS, AND USE OF COMPOSITION NOTE BOOK ARE THE SAME FOR ALL STUDENTS.

TO GET AN **A**, EXTRA EFFORT AND CLEAR PROGRESS OVER THE COURSE OF THE SEMESTER IS REQUIRED. NO MATTER WHAT YOUR SKILL LEVEL IS WHEN YOU BEGIN, YOU CAN GET AN 'A' IN THIS CLASS. MY FINAL GRADE IS BASED ON WHERE YOU BEGAN AND WHERE YOU ENDED UP AND WHAT IT IS THAT YOU FOUND.

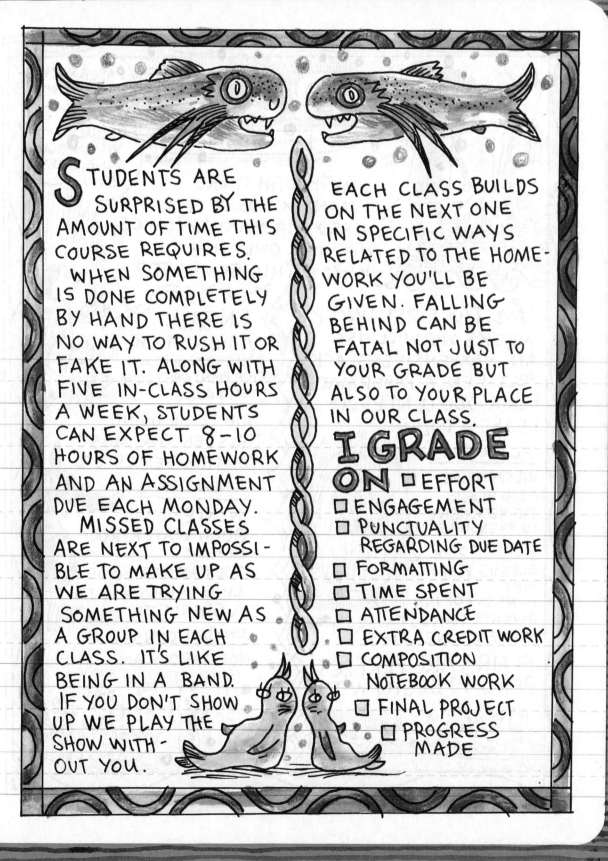

STUDENTS ARE SURPRISED BY THE AMOUNT OF TIME THIS COURSE REQUIRES. WHEN SOMETHING IS DONE COMPLETELY BY HAND THERE IS NO WAY TO RUSH IT OR FAKE IT. ALONG WITH FIVE IN-CLASS HOURS A WEEK, STUDENTS CAN EXPECT 8-10 HOURS OF HOMEWORK AND AN ASSIGNMENT DUE EACH MONDAY. MISSED CLASSES ARE NEXT TO IMPOSSIBLE TO MAKE UP AS WE ARE TRYING SOMETHING NEW AS A GROUP IN EACH CLASS. IT'S LIKE BEING IN A BAND. IF YOU DON'T SHOW UP WE PLAY THE SHOW WITHOUT YOU.

EACH CLASS BUILDS ON THE NEXT ONE IN SPECIFIC WAYS RELATED TO THE HOMEWORK YOU'LL BE GIVEN. FALLING BEHIND CAN BE FATAL NOT JUST TO YOUR GRADE BUT ALSO TO YOUR PLACE IN OUR CLASS.

I GRADE ON

- ☐ EFFORT
- ☐ ENGAGEMENT
- ☐ PUNCTUALITY REGARDING DUE DATE
- ☐ FORMATTING
- ☐ TIME SPENT
- ☐ ATTENDANCE
- ☐ EXTRA CREDIT WORK
- ☐ COMPOSITION NOTEBOOK WORK
- ☐ FINAL PROJECT
- ☐ PROGRESS MADE

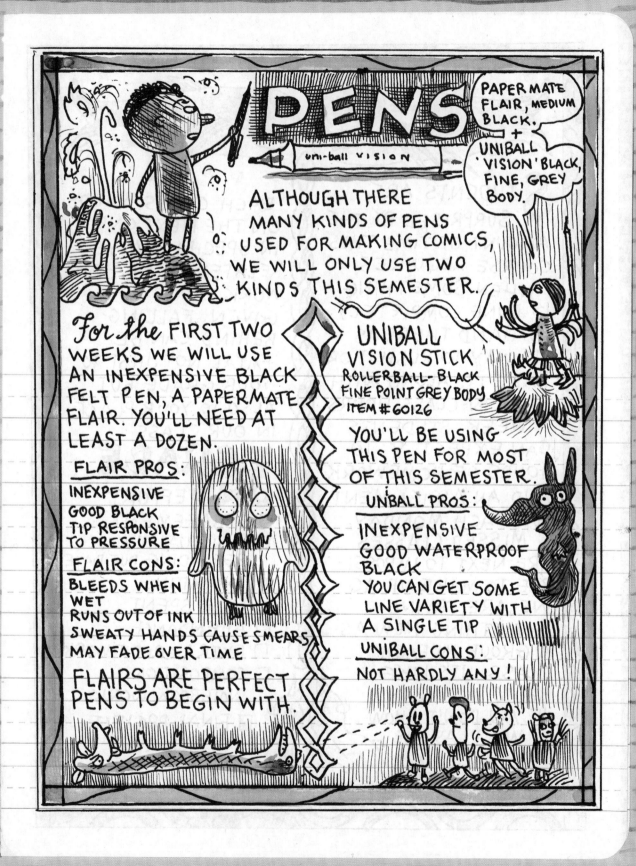

PENS

uni-ball VISION

PAPER MATE FLAIR, MEDIUM BLACK.
+
UNIBALL 'VISION' BLACK, FINE, GREY BODY.

ALTHOUGH THERE MANY KINDS OF PENS USED FOR MAKING COMICS, WE WILL ONLY USE TWO KINDS THIS SEMESTER.

For the FIRST TWO WEEKS WE WILL USE AN INEXPENSIVE BLACK FELT PEN, A PAPERMATE FLAIR. YOU'LL NEED AT LEAST A DOZEN.

FLAIR PROS:
INEXPENSIVE
GOOD BLACK
TIP RESPONSIVE TO PRESSURE

FLAIR CONS:
BLEEDS WHEN WET
RUNS OUT OF INK
SWEATY HANDS CAUSE SMEARS
MAY FADE OVER TIME

FLAIRS ARE PERFECT PENS TO BEGIN WITH.

UNIBALL VISION STICK
ROLLERBALL- BLACK
FINE POINT GREY BODY
ITEM # 60126

YOU'LL BE USING THIS PEN FOR MOST OF THIS SEMESTER.

UNBALL PROS:
INEXPENSIVE
GOOD WATERPROOF BLACK
YOU CAN GET SOME LINE VARIETY WITH A SINGLE TIP

UNIBALL CONS:
NOT HARDLY ANY!

PAPER

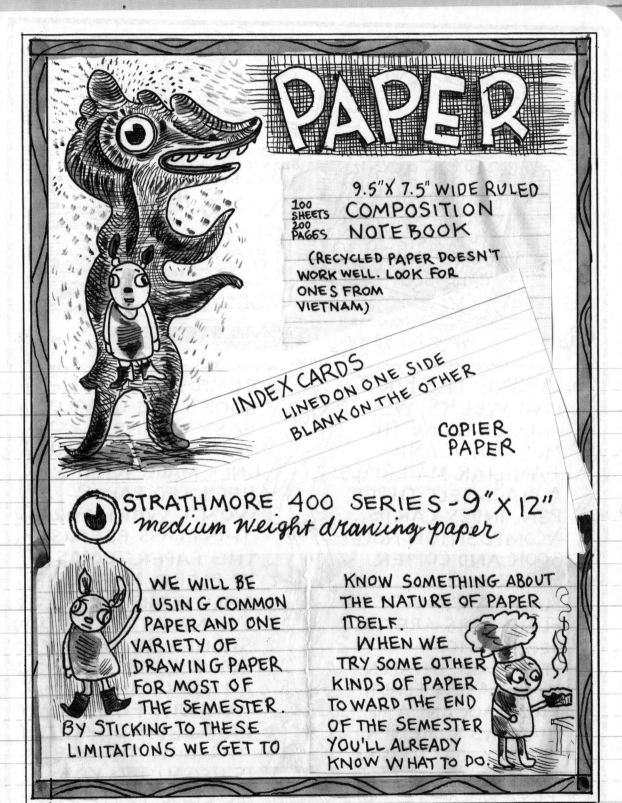

9.5" X 7.5" WIDE RULED COMPOSITION NOTEBOOK

100 SHEETS 200 PAGES

(RECYCLED PAPER DOESN'T WORK WELL. LOOK FOR ONES FROM VIETNAM)

INDEX CARDS LINED ON ONE SIDE BLANK ON THE OTHER

COPIER PAPER

STRATHMORE 400 SERIES - 9" X 12" *medium weight drawing paper*

WE WILL BE USING COMMON PAPER AND ONE VARIETY OF DRAWING PAPER FOR MOST OF THE SEMESTER. BY STICKING TO THESE LIMITATIONS WE GET TO KNOW SOMETHING ABOUT THE NATURE OF PAPER ITSELF.

WHEN WE TRY SOME OTHER KINDS OF PAPER TOWARD THE END OF THE SEMESTER YOU'LL ALREADY KNOW WHAT TO DO.

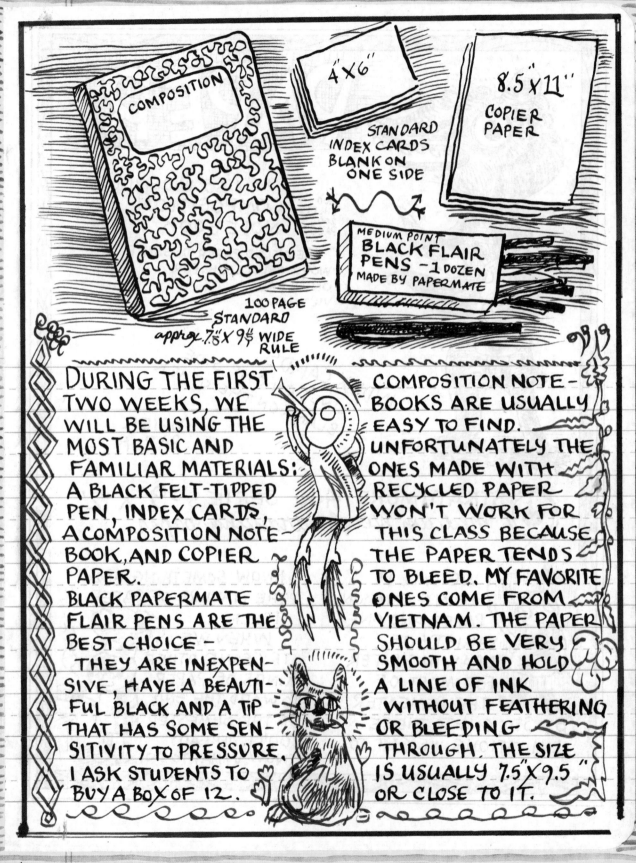

COMPOSITION

4"X6"

STANDARD
INDEX CARDS
BLANK ON
ONE SIDE

8.5"X11"
COPIER
PAPER

MEDIUM POINT
BLACK FLAIR
PENS — 1 DOZEN
MADE BY PAPERMATE

100 PAGE
STANDARD
approx. 7.5"X 9.5" WIDE
RULE

DURING THE FIRST TWO WEEKS, WE WILL BE USING THE MOST BASIC AND FAMILIAR MATERIALS: A BLACK FELT-TIPPED PEN, INDEX CARDS, A COMPOSITION NOTEBOOK, AND COPIER PAPER. BLACK PAPERMATE FLAIR PENS ARE THE BEST CHOICE —

THEY ARE INEXPENSIVE, HAVE A BEAUTIFUL BLACK AND A TIP THAT HAS SOME SENSITIVITY TO PRESSURE. I ASK STUDENTS TO BUY A BOX OF 12.

COMPOSITION NOTEBOOKS ARE USUALLY EASY TO FIND. UNFORTUNATELY THE ONES MADE WITH RECYCLED PAPER WON'T WORK FOR THIS CLASS BECAUSE THE PAPER TENDS TO BLEED. MY FAVORITE ONES COME FROM VIETNAM. THE PAPER SHOULD BE VERY SMOOTH AND HOLD A LINE OF INK WITHOUT FEATHERING OR BLEEDING THROUGH. THE SIZE IS USUALLY 7.5"X 9.5" OR CLOSE TO IT.

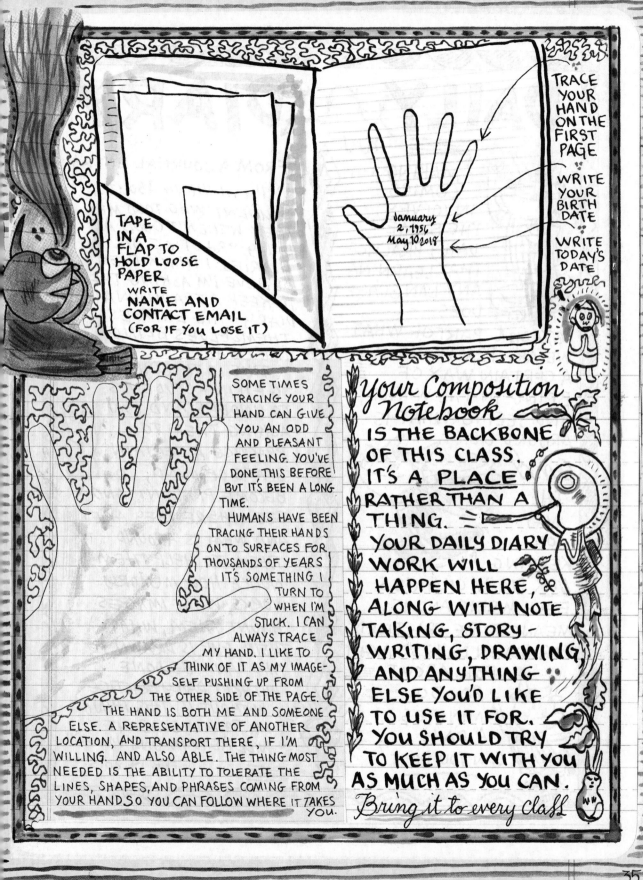

TAPE IN A FLAP TO HOLD LOOSE PAPER
WRITE **NAME AND CONTACT EMAIL** (FOR IF YOU LOSE IT)

TRACE YOUR HAND ON THE FIRST PAGE

WRITE YOUR BIRTH DATE

WRITE TODAY'S DATE

January 2, 1956
May 10 2018

SOME TIMES TRACING YOUR HAND CAN GIVE YOU AN ODD AND PLEASANT FEELING. YOU'VE DONE THIS BEFORE BUT IT'S BEEN A LONG TIME.

HUMANS HAVE BEEN TRACING THEIR HANDS ONTO SURFACES FOR THOUSANDS OF YEARS IT'S SOMETHING I TURN TO WHEN I'M STUCK. I CAN ALWAYS TRACE MY HAND, I LIKE TO THINK OF IT AS MY IMAGE-SELF PUSHING UP FROM THE OTHER SIDE OF THE PAGE. THE HAND IS BOTH ME AND SOMEONE ELSE. A REPRESENTATIVE OF ANOTHER LOCATION, AND TRANSPORT THERE, IF I'M WILLING. AND ALSO ABLE. THE THING MOST NEEDED IS THE ABILITY TO TOLERATE THE LINES, SHAPES, AND PHRASES COMING FROM YOUR HAND SO YOU CAN FOLLOW WHERE IT TAKES YOU.

Your Composition Notebook IS THE BACKBONE OF THIS CLASS. IT'S A <u>PLACE</u> RATHER THAN A THING. YOUR DAILY DIARY WORK WILL HAPPEN HERE, ALONG WITH NOTE TAKING, STORY-WRITING, DRAWING, AND ANYTHING ELSE YOU'D LIKE TO USE IT FOR. YOU SHOULD TRY TO KEEP IT WITH YOU AS MUCH AS YOU CAN. *Bring it to every class*

DAILY DIARY

MAKING COMICS INVOLVES THE SAME DAILY PRACTICE THAT LEARNING ANY LANGUAGE DOES — — *except* PART OF WHAT WE ARE PRACTICING IS A CERTAIN WAY OF BEING IN THE WORLD AND SEEING WHAT IS AROUND US.

And THE WAY OF KEEPING OUR DIARY CHANGES EACH WEEK AND IS MEANT TO BE PRACTICED FOR SEVEN DAYS STRAIGHT FOR ABOUT 20-30 MINUTES A DAY. CAN YOU DO IT?

FROM A JOURNAL ENTRY:

"I'M THINKING ABOUT A STUDENT WHO TOLD ME THEY WEREN'T GOOD AT DAILY PRACTICE OR DIARIES. I THINK THEY BELIEVE I'M ASKING THEM TO KEEP A TRADITIONAL DIARY — THE ENTRIES THEMSELVES BEING THE GOAL.

THIS IS THE DIFFICULTY — GETTING STUDENTS TO UNDERSTAND I'M ASKING THEM TO PRACTICE A CERTAIN STATE OF MIND, TO BECOME PRESENT AND SEE WHERE THEY ARE AND WHAT IS AROUND THEM. TO HELP THEM NOTICE HOW MEMORY WORKS, WHAT IMAGES HAUNT THEM, WHAT THEIR EYE IS DRAWN TO. THIS CAN'T BE DONE WITHOUT DAILY PRACTICE. WITHOUT IT, THIS THING I'M TALKING ABOUT WILL REMAIN UNKNOWN"

— FEB 14, 2015

THE DIARY ISN'T ABOUT WHAT YOU SEE, IT'S ABOUT BEING IN A STATE OF SEEING. DIFFERENT METHODS OF SEEING THE WORLD YOU ARE IN WILL MAKE YOUR COMICS MORE ALIVE. THE DAILY DIARY EXERCISE IS MEANT TO BE A FORM OF PHYSICAL PRACTICE FOR BOTH YOUR REAL EYES AND YOUR MIND'S EYE. IT'S ABOUT INCREASING YOUR CAPACITY TO GAZE AND TO LISTEN AND MOST IMPORTANTLY, TO NOTICE WHAT YOU NOTICE.

THIS WAY OF KEEPING A DIARY ALSO HELPS YOU THINK OF YOUR COMP BOOK AS A PLACE RATHER THAN AN OBJECT. IT'S WHERE YOU GO TO PRACTICE THE LANGUAGE OF THE IMAGE WORLD.

#1603

THE GOING FROM A
WORLD WE KNOW
TO ONE A WONDER
STILL
IS LIKE THE CHILD'S
ADVERSITY
WHOSE VISTA IS
A HILL,
BEHIND THE HILL IS
SORCERY
AND EVERYTHING
UNKNOWN,
BUT WILL THE SECRET
COMPENSATE
FOR CLIMBING IT
ALONE?

EMILY DICKINSON

This POEM IS SOMETHING I THINK OF WHEN I DON'T WANT TO DO MY DIARY PRACTICE. WILL IT BE WORTH THE EFFORT? THE PART OF ME THAT WILL NOT GO WILL EVER-NEVER KNOW.

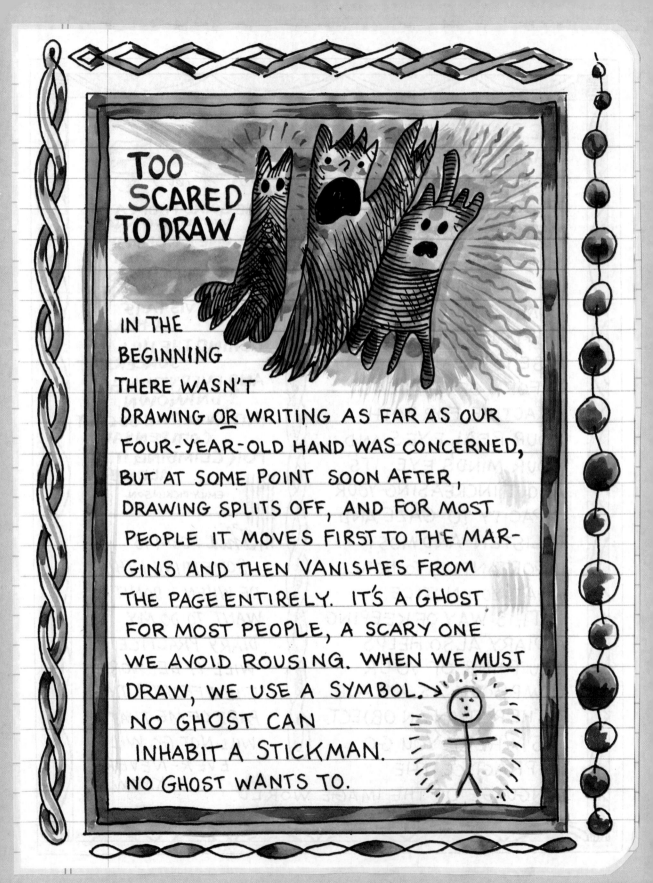

TOO SCARED TO DRAW

IN THE BEGINNING THERE WASN'T DRAWING OR WRITING AS FAR AS OUR FOUR-YEAR-OLD HAND WAS CONCERNED, BUT AT SOME POINT SOON AFTER, DRAWING SPLITS OFF, AND FOR MOST PEOPLE IT MOVES FIRST TO THE MARGINS AND THEN VANISHES FROM THE PAGE ENTIRELY. IT'S A GHOST FOR MOST PEOPLE, A SCARY ONE WE AVOID ROUSING. WHEN WE MUST DRAW, WE USE A SYMBOL. NO GHOST CAN INHABIT A STICKMAN. NO GHOST WANTS TO.

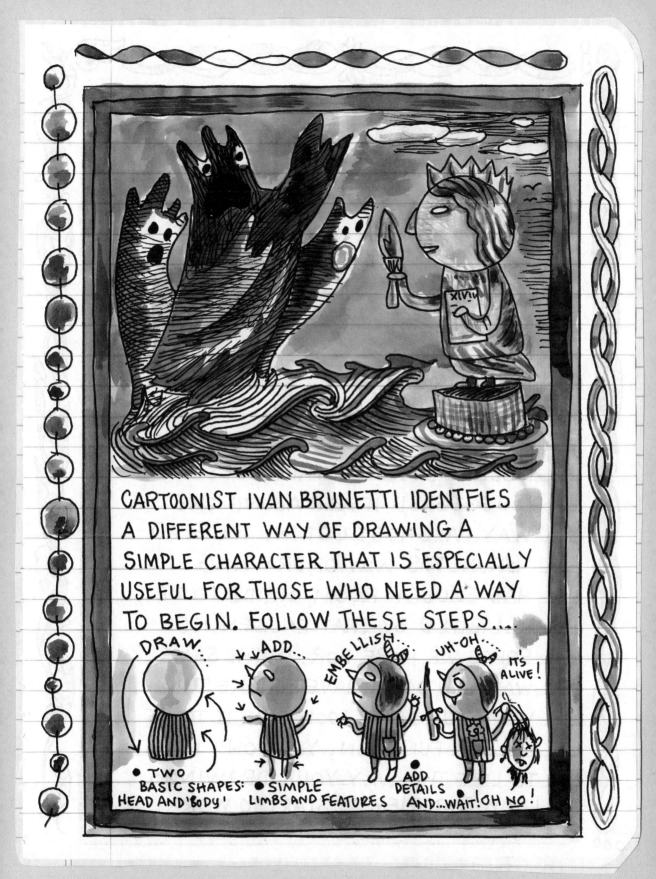

CARTOONIST IVAN BRUNETTI IDENTFIES A DIFFERENT WAY OF DRAWING A SIMPLE CHARACTER THAT IS ESPECIALLY USEFUL FOR THOSE WHO NEED A WAY TO BEGIN. FOLLOW THESE STEPS...

DRAW... • TWO BASIC SHAPES: HEAD AND 'BODY'

ADD... • SIMPLE LIMBS AND FEATURES

EMBELLISH... ADD DETAILS AND...

UH-OH... WAIT! OH NO! IT'S ALIVE!

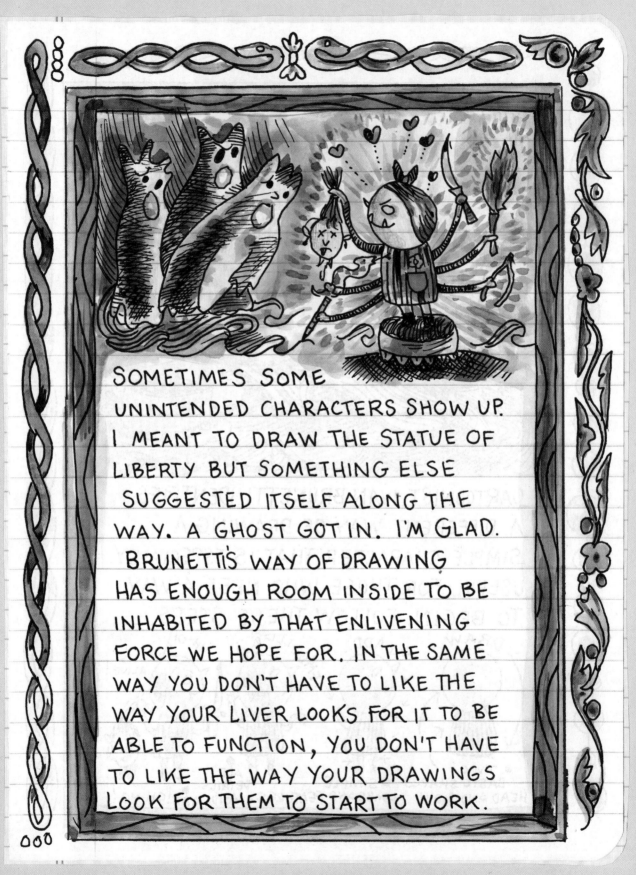

SOMETIMES SOME
UNINTENDED CHARACTERS SHOW UP.
I MEANT TO DRAW THE STATUE OF
LIBERTY BUT SOMETHING ELSE
SUGGESTED ITSELF ALONG THE
WAY. A GHOST GOT IN. I'M GLAD.
BRUNETTI'S WAY OF DRAWING
HAS ENOUGH ROOM INSIDE TO BE
INHABITED BY THAT ENLIVENING
FORCE WE HOPE FOR. IN THE SAME
WAY YOU DON'T HAVE TO LIKE THE
WAY YOUR LIVER LOOKS FOR IT TO BE
ABLE TO FUNCTION, YOU DON'T HAVE
TO LIKE THE WAY YOUR DRAWINGS
LOOK FOR THEM TO START TO WORK.

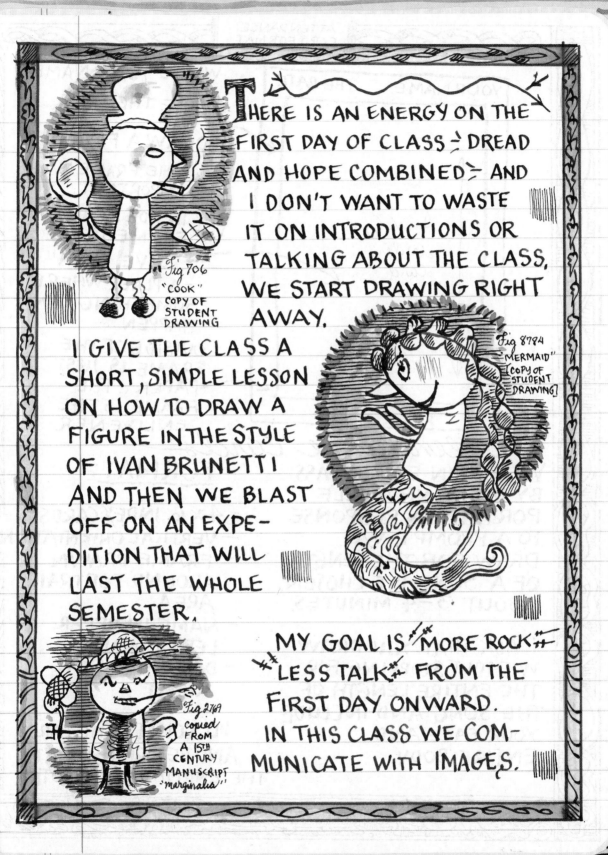

THERE IS AN ENERGY ON THE FIRST DAY OF CLASS — DREAD AND HOPE COMBINED — AND I DON'T WANT TO WASTE IT ON INTRODUCTIONS OR TALKING ABOUT THE CLASS, WE START DRAWING RIGHT AWAY.

Fig 706
"COOK"
COPY OF STUDENT DRAWING

I GIVE THE CLASS A SHORT, SIMPLE LESSON ON HOW TO DRAW A FIGURE IN THE STYLE OF IVAN BRUNETTI AND THEN WE BLAST OFF ON AN EXPEDITION THAT WILL LAST THE WHOLE SEMESTER.

Fig 8784
"MERMAID"
[COPY OF STUDENT DRAWING]

Fig 2769
copied FROM A 15TH CENTURY MANUSCRIPT "marginalia"

MY GOAL IS "MORE ROCK LESS TALK" FROM THE FIRST DAY ONWARD. IN THIS CLASS WE COMMUNICATE WITH IMAGES.

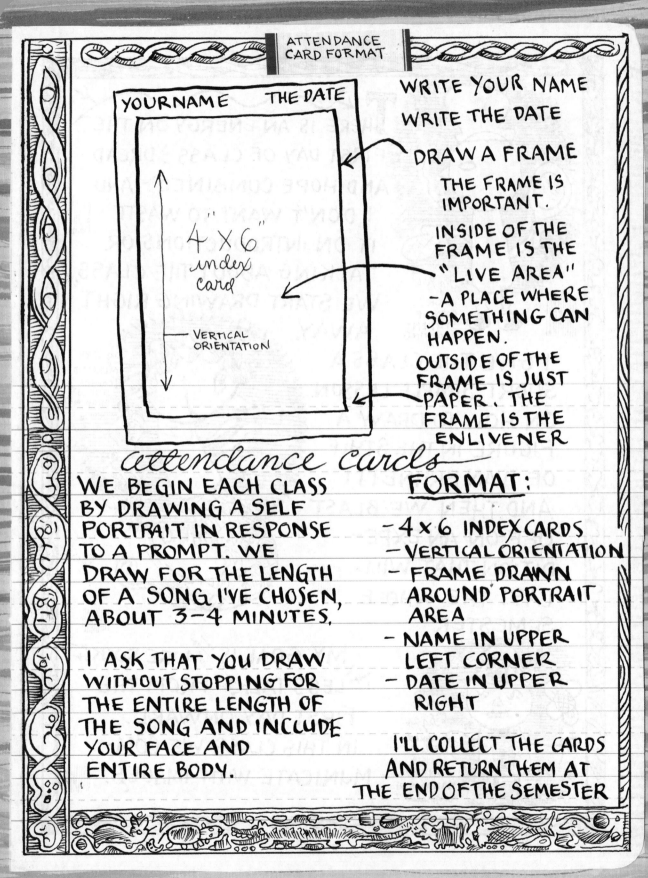

YOURNAME THE DATE

4" x 6"
index
card

VERTICAL
ORIENTATION

WRITE YOUR NAME

WRITE THE DATE

DRAW A FRAME

THE FRAME IS
IMPORTANT.

INSIDE OF THE
FRAME IS THE
"LIVE AREA"
—A PLACE WHERE
SOMETHING CAN
HAPPEN.

OUTSIDE OF THE
FRAME IS JUST
PAPER. THE
FRAME IS THE
ENLIVENER

attendance cards

WE BEGIN EACH CLASS
BY DRAWING A SELF
PORTRAIT IN RESPONSE
TO A PROMPT. WE
DRAW FOR THE LENGTH
OF A SONG I'VE CHOSEN,
ABOUT 3-4 MINUTES.

I ASK THAT YOU DRAW
WITHOUT STOPPING FOR
THE ENTIRE LENGTH OF
THE SONG AND INCLUDE
YOUR FACE AND
ENTIRE BODY.

FORMAT:

- 4 x 6 INDEX CARDS
- VERTICAL ORIENTATION
- FRAME DRAWN
 AROUND PORTRAIT
 AREA
- NAME IN UPPER
 LEFT CORNER
- DATE IN UPPER
 RIGHT

I'LL COLLECT THE CARDS
AND RETURN THEM AT
THE END OF THE SEMESTER

ADAPTED from
an *Ivan Brunetti*
EXERCISE

NAME HERE DATE HERE

Fig 1:
The big head

Fig. 2

BODY SHAPE
and LIVELY
ARMS + LEG
lines

Fig. 3

SNOÏBALL
HANDS

NOODLE
ARMS AND
LEGS

SIMPLE SHOES

Fig 4

SIMPLE FACIAL
FEATURES and
CHARACTERISTIC
DETAILS

EXERCISE

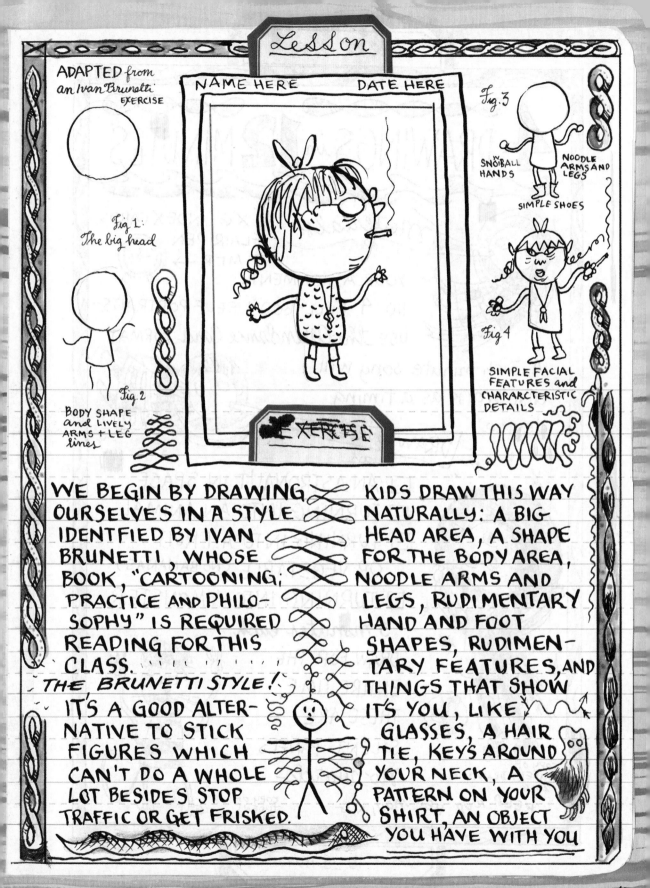

WE BEGIN BY DRAWING
OURSELVES IN A STYLE
IDENTFIED BY IVAN
BRUNETTI, WHOSE
BOOK, "CARTOONING;
PRACTICE AND PHILO-
SOPHY" IS REQUIRED
READING FOR THIS
CLASS.
THE BRUNETTI STYLE!
IT'S A GOOD ALTER-
NATIVE TO STICK
FIGURES WHICH
CAN'T DO A WHOLE
LOT BESIDES STOP
TRAFFIC OR GET FRISKED.

KIDS DRAW THIS WAY
NATURALLY: A BIG
HEAD AREA, A SHAPE
FOR THE BODY AREA,
NOODLE ARMS AND
LEGS, RUDIMENTARY
HAND AND FOOT
SHAPES, RUDIMEN-
TARY FEATURES, AND
THINGS THAT SHOW
IT'S YOU, LIKE
GLASSES, A HAIR
TIE, KEYS AROUND
YOUR NECK, A
PATTERN ON YOUR
SHIRT, AN OBJECT
YOU HAVE WITH YOU

43

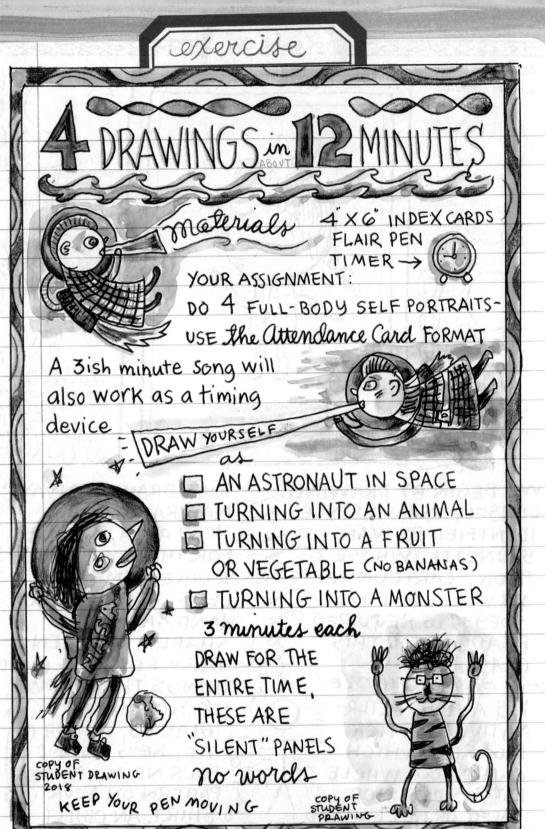

4 DRAWINGS in ABOUT 12 MINUTES

materials 4" × 6" INDEX CARDS
FLAIR PEN
TIMER →

YOUR ASSIGNMENT:

DO 4 FULL-BODY SELF PORTRAITS-
USE the Attendance Card FORMAT

A 3ish minute song will
also work as a timing
device

= DRAW YOURSELF as

☐ AN ASTRONAUT IN SPACE
☐ TURNING INTO AN ANIMAL
☐ TURNING INTO A FRUIT
 OR VEGETABLE (NO BANANAS)
☐ TURNING INTO A MONSTER

3 minutes each
DRAW FOR THE
ENTIRE TIME,
THESE ARE
"SILENT" PANELS
no words

COPY OF
STUDENT DRAWING
2018

KEEP YOUR PEN MOVING

COPY OF
STUDENT
DRAWING

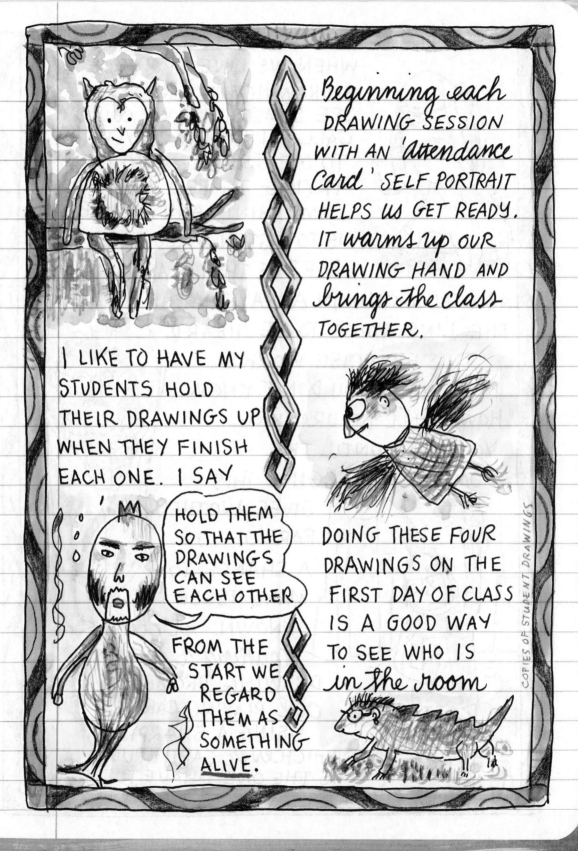

Beginning each DRAWING SESSION WITH AN 'attendance Card' SELF PORTRAIT HELPS US GET READY. IT warms up OUR DRAWING HAND AND brings the class TOGETHER.

I LIKE TO HAVE MY STUDENTS HOLD THEIR DRAWINGS UP WHEN THEY FINISH EACH ONE. I SAY

HOLD THEM SO THAT THE DRAWINGS CAN SEE EACH OTHER

FROM THE START WE REGARD THEM AS SOMETHING ALIVE.

DOING THESE FOUR DRAWINGS ON THE FIRST DAY OF CLASS IS A GOOD WAY TO SEE WHO IS in the room

COPIES OF STUDENT DRAWINGS

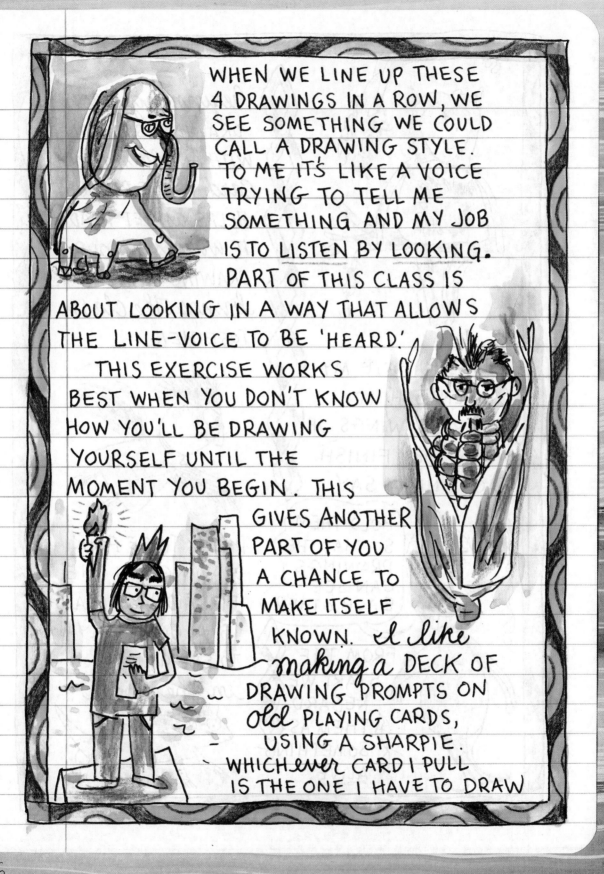

WHEN WE LINE UP THESE 4 DRAWINGS IN A ROW, WE SEE SOMETHING WE COULD CALL A DRAWING STYLE. TO ME IT'S LIKE A VOICE TRYING TO TELL ME SOMETHING AND MY JOB IS TO LISTEN BY LOOKING. PART OF THIS CLASS IS ABOUT LOOKING IN A WAY THAT ALLOWS THE LINE-VOICE TO BE 'HEARD.' THIS EXERCISE WORKS BEST WHEN YOU DON'T KNOW HOW YOU'LL BE DRAWING YOURSELF UNTIL THE MOMENT YOU BEGIN. THIS GIVES ANOTHER PART OF YOU A CHANCE TO MAKE ITSELF KNOWN. I like making a DECK OF DRAWING PROMPTS ON old PLAYING CARDS, USING A SHARPIE. WHICHever CARD I PULL IS THE ONE I HAVE TO DRAW

DRAW YOURSELF

- SURFING WITH A SHARK
- AS A STATUE IN A MUSEUM
- IN THE HOSPITAL
- DOING SOMETHING YOU WOULD NEVER DO
- AS CONJOINED TWINS
- EATING FRIED CHICKEN
- IN THE DEEP DEEP SEA
- AT THE BEAUTY PARLOR
- AS A VIKING
- AS THE GOD OF FIRE
- IN A MARCHING BAND
- AS A FRENCH PERSON
- TUNNELING TO FREEDOM

- RIDING AN INSECT
- AS A CAVE PERSON WITH A PAL
- GETTING ARRESTED
- AS A BEARDED LADY
- SHOOTING OUT OF A VOLCANO
- DANCING WITH A POTATO
- TIGHT ROPE WALKER
- VOMITING
- RUNNING FROM A GIANT SNOWBALL
- RIDING A BIRD
- DANCING SADLY
- AS GOD OF SPRING (DESS)

- CLIMBING A ROPE
- AS A LOVELY FOUNTAIN
- ENCOUNTER WITH SQUIRREL
- ESCAPING FROM JAIL
- PLAYING IN A BAD JAZZ BAND
- BEING CARRIED BY AN ALIEN
- AS A PIRATE
- AS A KID IN A COSTUME
- WITH 3 CATS
- LOST AT SEA
- AS A FRY COOK
- IN LOVE

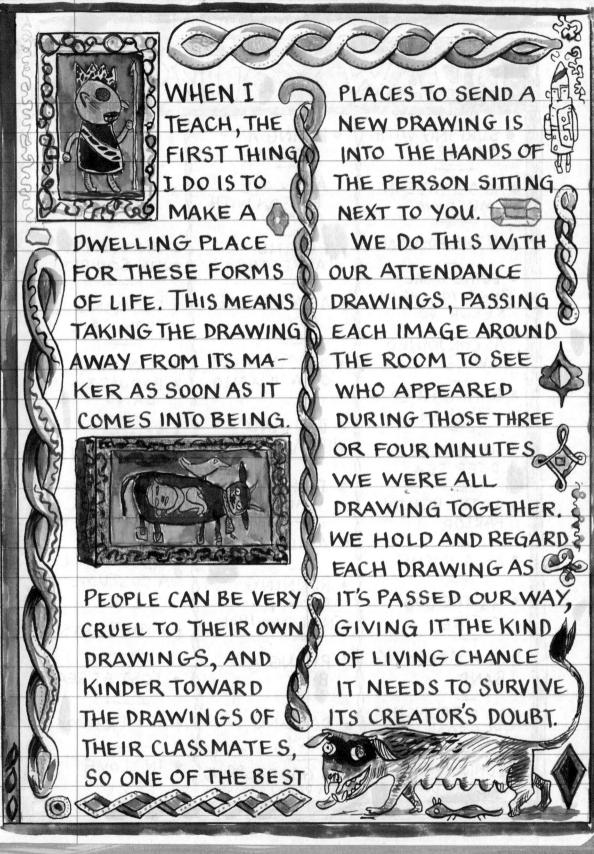

WHEN I TEACH, THE FIRST THING I DO IS TO MAKE A DWELLING PLACE FOR THESE FORMS OF LIFE. THIS MEANS TAKING THE DRAWING AWAY FROM ITS MAKER AS SOON AS IT COMES INTO BEING.

PEOPLE CAN BE VERY CRUEL TO THEIR OWN DRAWINGS, AND KINDER TOWARD THE DRAWINGS OF THEIR CLASSMATES, SO ONE OF THE BEST PLACES TO SEND A NEW DRAWING IS INTO THE HANDS OF THE PERSON SITTING NEXT TO YOU.

WE DO THIS WITH OUR ATTENDANCE DRAWINGS, PASSING EACH IMAGE AROUND THE ROOM TO SEE WHO APPEARED DURING THOSE THREE OR FOUR MINUTES WE WERE ALL DRAWING TOGETHER. WE HOLD AND REGARD EACH DRAWING AS IT'S PASSED OUR WAY, GIVING IT THE KIND OF LIVING CHANCE IT NEEDS TO SURVIVE ITS CREATOR'S DOUBT.

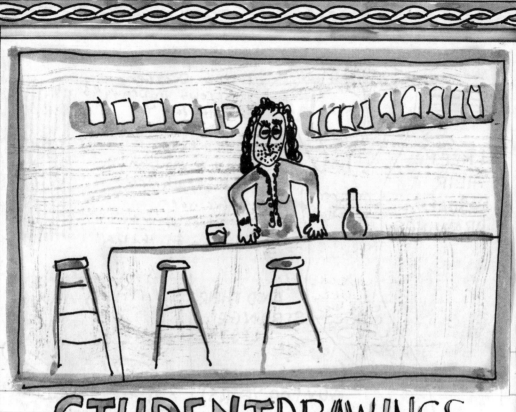

STUDENTDRAWINGS

NOT A SINGLE DRAWING OR LINE OF MY HANDWRITING SURVIVED MY CHILDHOOD. I SOMETIMES WONDER IF THAT'S WHY I HANG ONTO THE DRAWINGS MY STUDENTS LEAVE BEHIND.

THEY ARE SO ALIVE TO ME.

THEY GIVE ME SOMETHING IN THE WAY A SONG I LOVE GIVES ME SOMETHING I CAN'T QUITE EXPLAIN. SOMETIMES I COPY THEM. SOMETIMES I DRAW ON THEM, COLOR THEM, CUT THEM OUT. ALMOST ALL OF THE PICTURES IN THIS BOOK ARE RESCUED IMAGES BY STUDENTS

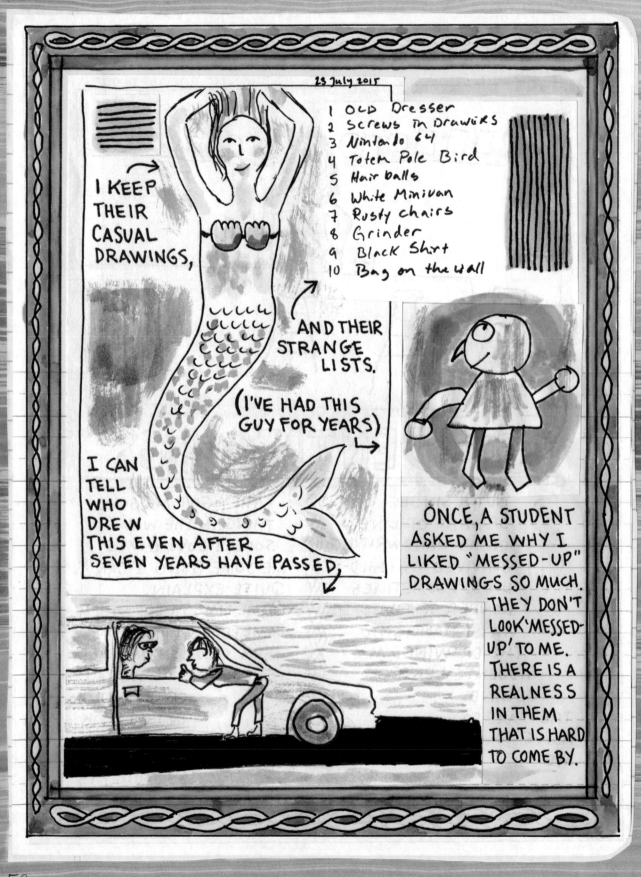

23 July 2015

I KEEP THEIR CASUAL DRAWINGS,

AND THEIR STRANGE LISTS.

1 Old Dresser
2 Screws In Drawers
3 Nintendo 64
4 Totem Pole Bird
5 Hair balls
6 White Minivan
7 Rusty chairs
8 Grinder
9 Black Shirt
10 Bag on the Wall

(I'VE HAD THIS GUY FOR YEARS)

I CAN TELL WHO DREW THIS EVEN AFTER SEVEN YEARS HAVE PASSED.

ONCE, A STUDENT ASKED ME WHY I LIKED "MESSED-UP" DRAWINGS SO MUCH. THEY DON'T LOOK 'MESSED-UP' TO ME. THERE IS A REALNESS IN THEM THAT IS HARD TO COME BY.

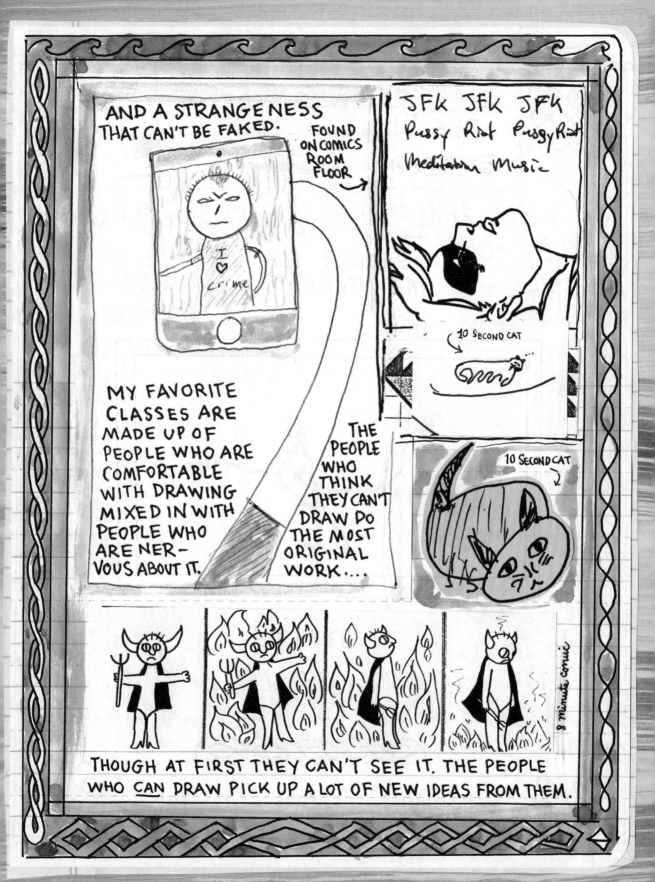

AND A STRANGENESS THAT CAN'T BE FAKED.

FOUND ON COMICS ROOM FLOOR →

I ♥ Crime

JFK JFK JFK
Pussy Riot Pussy Riot
Meditation Music

10 SECOND CAT →

10 SECOND CAT →

MY FAVORITE CLASSES ARE MADE UP OF PEOPLE WHO ARE COMFORTABLE WITH DRAWING MIXED IN WITH PEOPLE WHO ARE NERVOUS ABOUT IT.

THE PEOPLE WHO THINK THEY CAN'T DRAW DO THE MOST ORIGINAL WORK....

8 minute comic

THOUGH AT FIRST THEY CAN'T SEE IT. THE PEOPLE WHO CAN DRAW PICK UP A LOT OF NEW IDEAS FROM THEM.

Once upon a time there
was a ~~poor~~ ~~little~~ man. He
lived in ~~a~~ ~~small~~ ~~cabin~~ in a
valley.

THE FORLE YOU
ARE INTERESTED
IN

Is Interested in you

It's HERE

she saw ~~the~~ man, she
got som ~~e~~ gave it
to the man, and from that
day till this he has been thank
ing her.

answer: THE FIRST KID

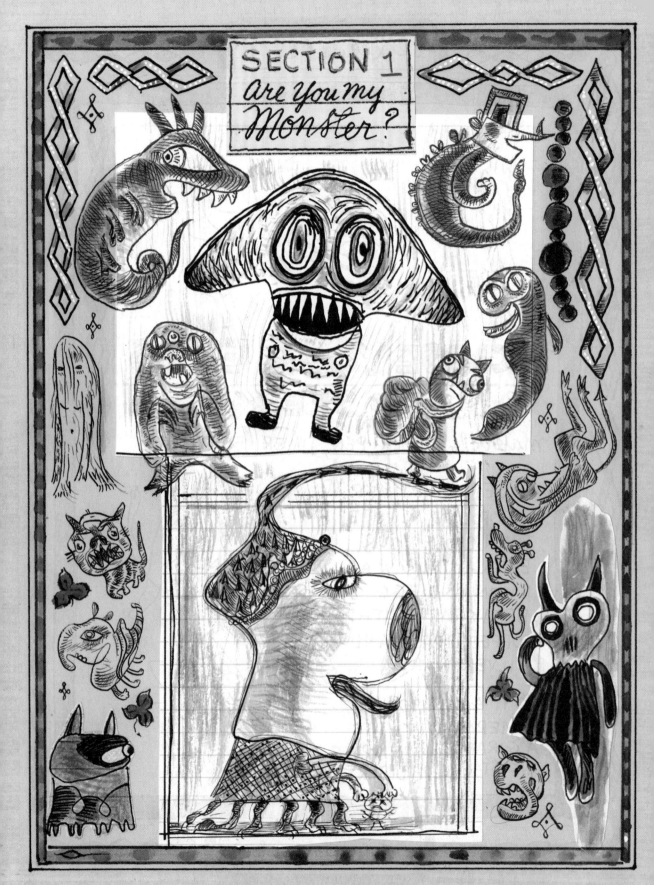

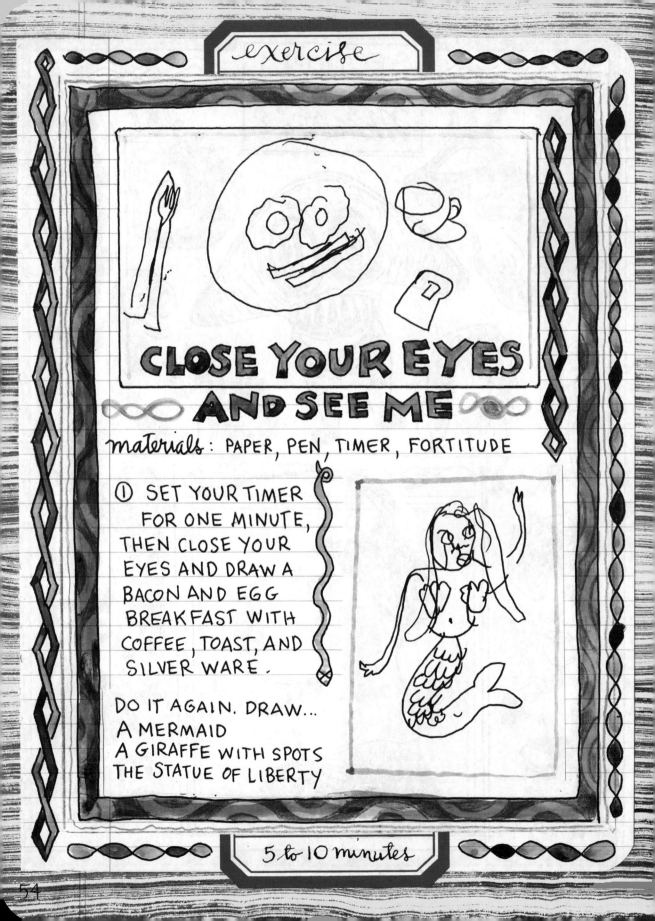

CLOSE YOUR EYES AND SEE ME

materials: PAPER, PEN, TIMER, FORTITUDE

① SET YOUR TIMER FOR ONE MINUTE, THEN CLOSE YOUR EYES AND DRAW A BACON AND EGG BREAKFAST WITH COFFEE, TOAST, AND SILVER WARE.

DO IT AGAIN. DRAW...
A MERMAID
A GIRAFFE WITH SPOTS
THE STATUE OF LIBERTY

WE TEND TO LAUGH
AS WE DO THIS
EXERCISE AND
LAUGH HARDER
WHEN WE OPEN
OUR EYES, SUR-
PRISED BY WHAT
WE SEE. THERE IS
SOME RELIABLE
CHARM TO DRAWINGS
MADE THIS WAY, AND
MOST OF US CAN
SEE IT.

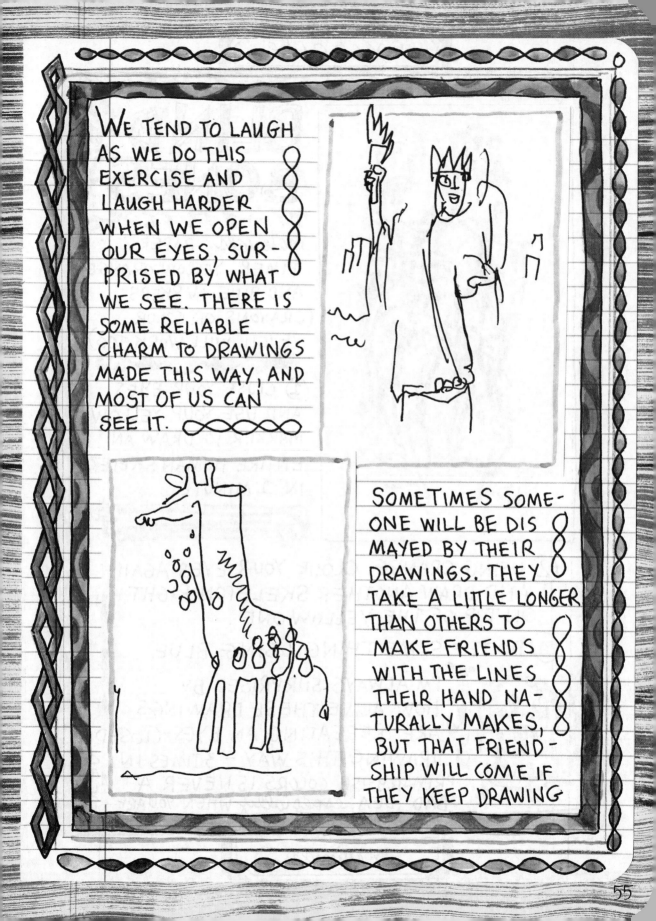

SOMETIMES SOME-
ONE WILL BE DIS
MAYED BY THEIR
DRAWINGS. THEY
TAKE A LITTLE LONGER
THAN OTHERS TO
MAKE FRIENDS
WITH THE LINES
THEIR HAND NA-
TURALLY MAKES,
BUT THAT FRIEND-
SHIP WILL COME IF
THEY KEEP DRAWING

BLIND BONES

materials : PAPER, TIMER, YELLOW, ORANGE AND BLUE MARKERS, (CRAYONS OR COLOR PENCIL WILL WORK TOO)

① CLOSE YOUR EYES AND USE YOUR YELLOW MARKER TO DRAW AN ENTIRE HUMAN SKELETON IN 1 MINUTE.

② USING ORANGE, CLOSE YOUR EYES AGAIN AND DRAW ANOTHER SKELETON RIGHT ON TOP OF THE YELLOW ONE.

③ DO THE SAME THING USING BLUE.

I'M ALWAYS SURPRISED BY HOW ALIVE THESE DRAWINGS ARE. REPEATING AN EYES-CLOSED DRAWING THIS WAY — 3 TIMES IN PRIMARY-ISH COLORS IS NEVER A BAD IDEA, *especially* WHEN YOU ARE ↑ STUCK.

5 minutes

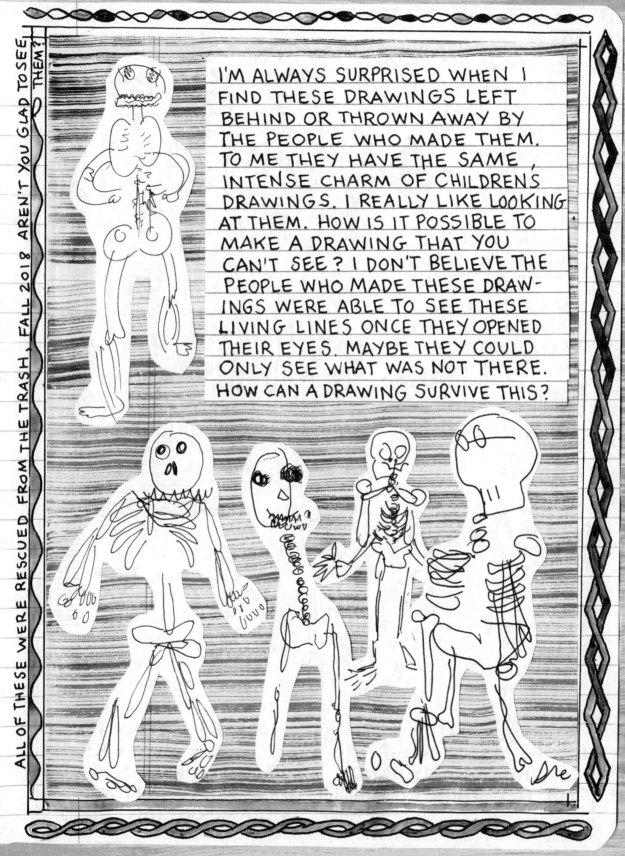

I'M ALWAYS SURPRISED WHEN I FIND THESE DRAWINGS LEFT BEHIND OR THROWN AWAY BY THE PEOPLE WHO MADE THEM. TO ME THEY HAVE THE SAME, INTENSE CHARM OF CHILDRENS DRAWINGS. I REALLY LIKE LOOKING AT THEM. HOW IS IT POSSIBLE TO MAKE A DRAWING THAT YOU CAN'T SEE? I DON'T BELIEVE THE PEOPLE WHO MADE THESE DRAWINGS WERE ABLE TO SEE THESE LIVING LINES ONCE THEY OPENED THEIR EYES. MAYBE THEY COULD ONLY SEE WHAT WAS NOT THERE. HOW CAN A DRAWING SURVIVE THIS?

ALL OF THESE WERE RESCUED FROM THE TRASH, FALL 2018. AREN'T YOU GLAD TO SEE THEM?

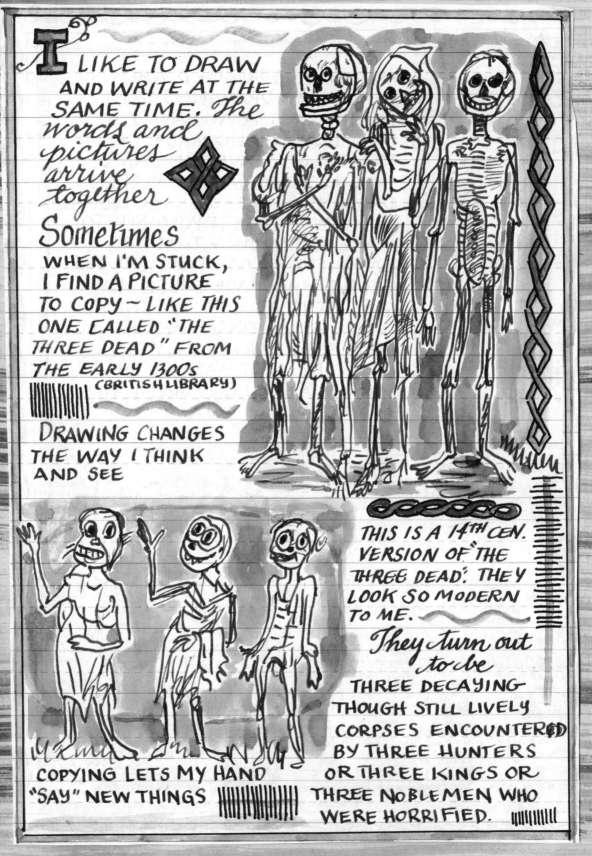

I LIKE TO DRAW AND WRITE AT THE SAME TIME. The words and pictures arrive together

Sometimes WHEN I'M STUCK, I FIND A PICTURE TO COPY — LIKE THIS ONE CALLED "THE THREE DEAD" FROM THE EARLY 1300s (BRITISH LIBRARY)

DRAWING CHANGES THE WAY I THINK AND SEE

COPYING LETS MY HAND "SAY" NEW THINGS

THIS IS A 14TH CEN. VERSION OF "THE THREE DEAD". THEY LOOK SO MODERN TO ME.

They turn out to be THREE DECAYING THOUGH STILL LIVELY CORPSES ENCOUNTERED BY THREE HUNTERS OR THREE KINGS OR THREE NOBLEMEN WHO WERE HORRIFIED.

AND JUST HERE I THINK OF FAIRY TALES, THE MANY STORIES OF A MISUNDERSTOOD CREATURE OF HIDEOUS FORM THAT IS CHASED AWAY BY THOSE WHO ENCOUNTER IT. — ITS <u>TRUE</u> FORM REMAINS UNSEEN BY RIGID SOULS, WHICH IS THE TRAGEDY.

IT REMINDS ME OF THE HORROR SOME PEOPLE EXPERIENCE WHEN THEY DRAW THEIR FIRST PICTURES AS ADULTS. THERE IS AN URGE TO COVER THEM UP, OR DESTROY THEM COMPLETELY. PERHAPS, LIKE WITH 'THE THREE DEAD' ◆ THE ALIVENESS OF THE DRAWING IS SO AT ODDS WITH EXPECTATION AND INTENT THAT IT SEEMS GHASTLY AND MALFORMED

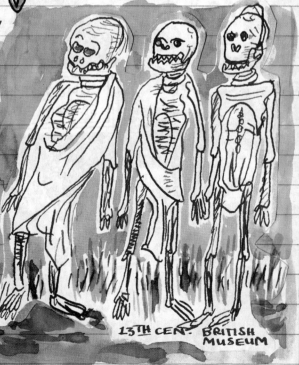

13TH CENT. BRITISH MUSEUM

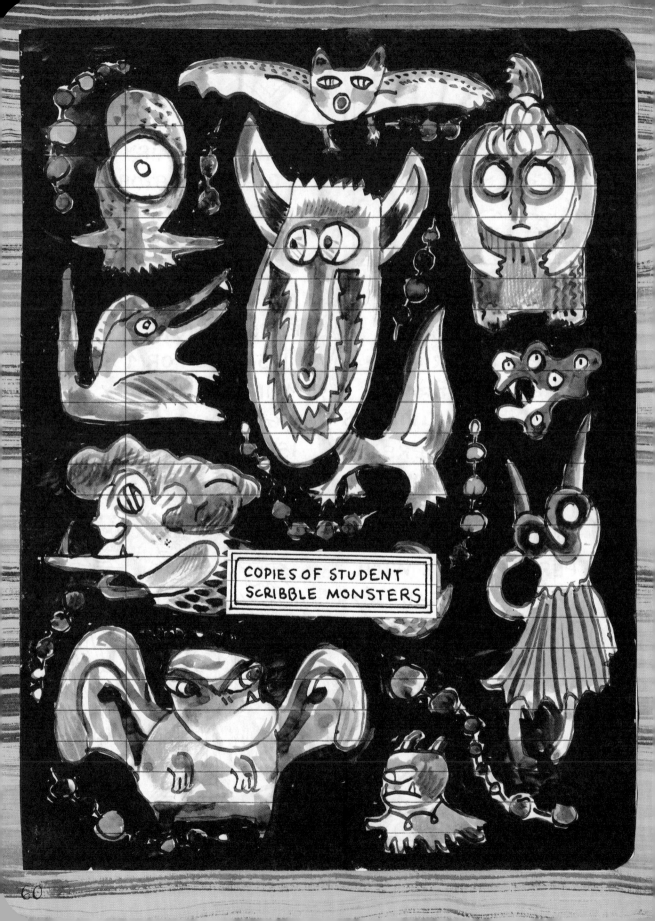

COPIES OF STUDENT
SCRIBBLE MONSTERS

Scribble MONSTER JAM

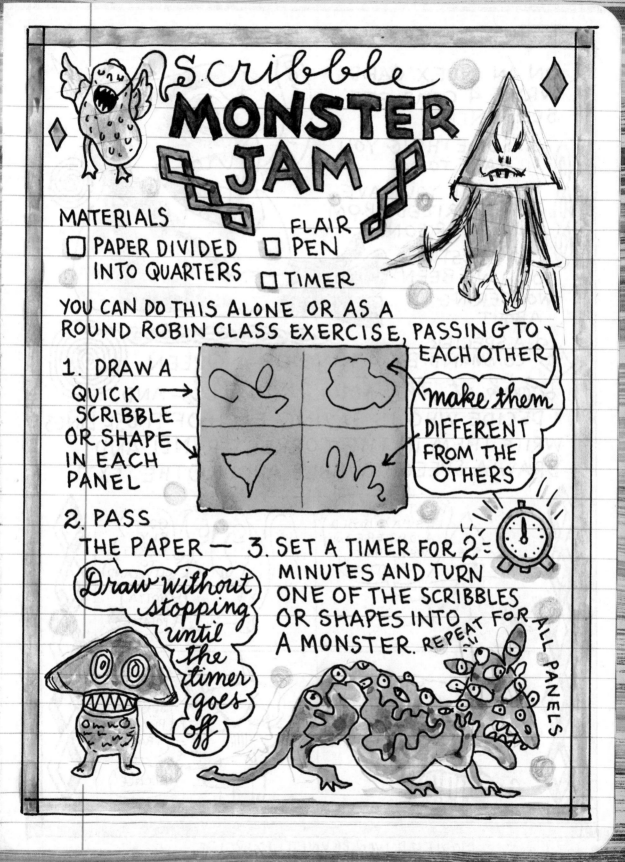

MATERIALS
- ☐ PAPER DIVIDED INTO QUARTERS
- ☐ FLAIR PEN
- ☐ TIMER

YOU CAN DO THIS ALONE OR AS A ROUND ROBIN CLASS EXERCISE, PASSING TO EACH OTHER

1. DRAW A QUICK SCRIBBLE OR SHAPE IN EACH PANEL

make them DIFFERENT FROM THE OTHERS

2. PASS THE PAPER —

Draw without stopping until the timer goes off

3. SET A TIMER FOR 2 MINUTES AND TURN ONE OF THE SCRIBBLES OR SHAPES INTO A MONSTER. REPEAT FOR ALL PANELS

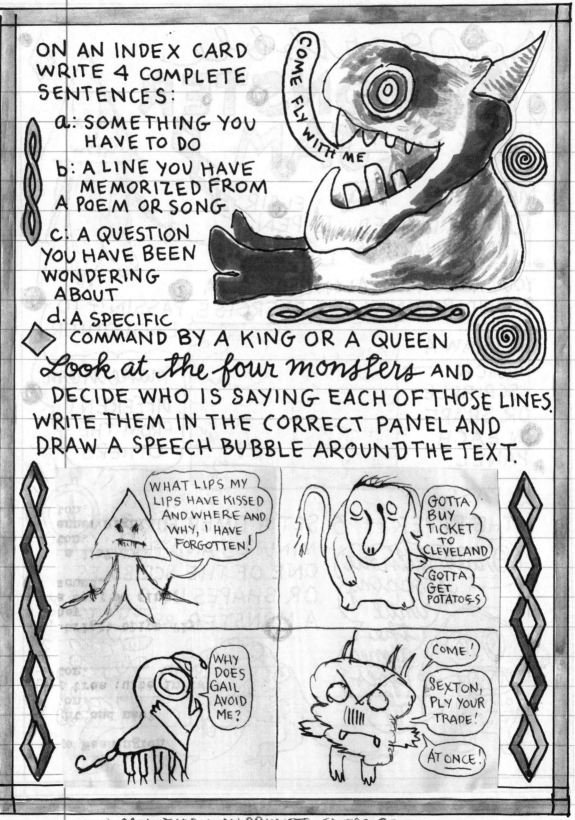

ON AN INDEX CARD WRITE 4 COMPLETE SENTENCES:

a: SOMETHING YOU HAVE TO DO

b: A LINE YOU HAVE MEMORIZED FROM A POEM OR SONG

c: A QUESTION YOU HAVE BEEN WONDERING ABOUT

d. A SPECIFIC COMMAND BY A KING OR A QUEEN

Look at the four monsters AND DECIDE WHO IS SAYING EACH OF THOSE LINES. WRITE THEM IN THE CORRECT PANEL AND DRAW A SPEECH BUBBLE AROUND THE TEXT.

MODIFIED IVAN BRUNETTI EXERCISE

MONSTER, DRAW NEAR

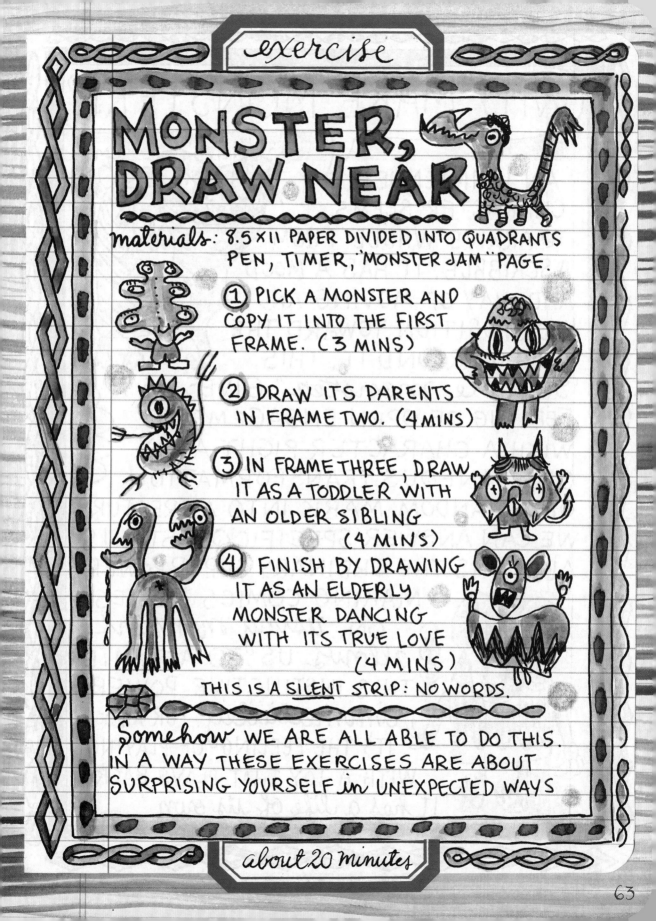

materials: 8.5 × 11 PAPER DIVIDED INTO QUADRANTS PEN, TIMER, "MONSTER JAM" PAGE.

1. PICK A MONSTER AND COPY IT INTO THE FIRST FRAME. (3 MINS)

2. DRAW ITS PARENTS IN FRAME TWO. (4 MINS)

3. IN FRAME THREE, DRAW IT AS A TODDLER WITH AN OLDER SIBLING (4 MINS)

4. FINISH BY DRAWING IT AS AN ELDERLY MONSTER DANCING WITH ITS TRUE LOVE (4 MINS)

THIS IS A <u>SILENT</u> STRIP: NO WORDS.

Somehow WE ARE ALL ABLE TO DO THIS. IN A WAY THESE EXERCISES ARE ABOUT SURPRISING YOURSELF in UNEXPECTED WAYS

about 20 minutes

WHY MAKE MONSTERS?

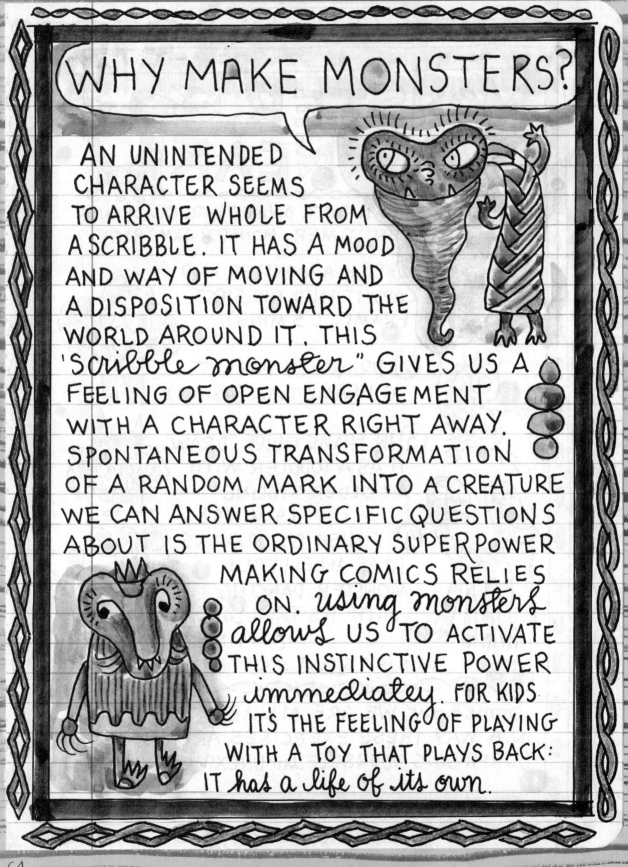

AN UNINTENDED CHARACTER SEEMS TO ARRIVE WHOLE FROM A SCRIBBLE. IT HAS A MOOD AND WAY OF MOVING AND A DISPOSITION TOWARD THE WORLD AROUND IT. THIS "*scribble monster*" GIVES US A FEELING OF OPEN ENGAGEMENT WITH A CHARACTER RIGHT AWAY. SPONTANEOUS TRANSFORMATION OF A RANDOM MARK INTO A CREATURE WE CAN ANSWER SPECIFIC QUESTIONS ABOUT IS THE ORDINARY SUPERPOWER MAKING COMICS RELIES ON. *using monsters allows* US TO ACTIVATE THIS INSTINCTIVE POWER *immediately.* FOR KIDS IT'S THE FEELING OF PLAYING WITH A TOY THAT PLAYS BACK: *it has a life of its own.*

MONSTER, THIS IS YOUR LIFE

materials: PAPER DIVIDED into SIX FRAMES
PEN, TIMER, MONSTER
EACH FRAME WILL
TAKE 3 MINUTES

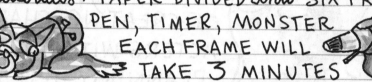

YOU WILL BE JUMPING AROUND THE PAGE
DRAWING IN THIS ORDER: FRAME 1, 6, 3, 4, 2, 5

① DRAW THE MONSTER AS A NEWBORN IN A CERTAIN SETTING

WHERE WAS THIS?

WHO WAS THERE?

⑤ AS A KID ENGAGED IN SOME KIND OF ACTIVITY

SOMETHING YOU DID AS A KID

③ AS A DIS-GRUNTLED TEEN DOING SOMETHING YOU DID AS A TEEN

WITH A PARTICULAR OBJECT

④ AS A YOUNG ADULT EN-JOYING THEMSELVES

THE HAPPIEST TIME - YOUNG WILD & FREE

⑥ MIDDLE-AGED, AT WORK

INCLUDE SETTING

② AT ITS FUNERAL. IT LIVED TO BE OLD. WE CAN SEE ITS BODY IN THIS PICTURE

SOME RITUAL

THIS IS A SILENT STRIP, NO WORDS ANYWHERE
BUT SOMEHOW A LIFE STORY COMES ANYWAY

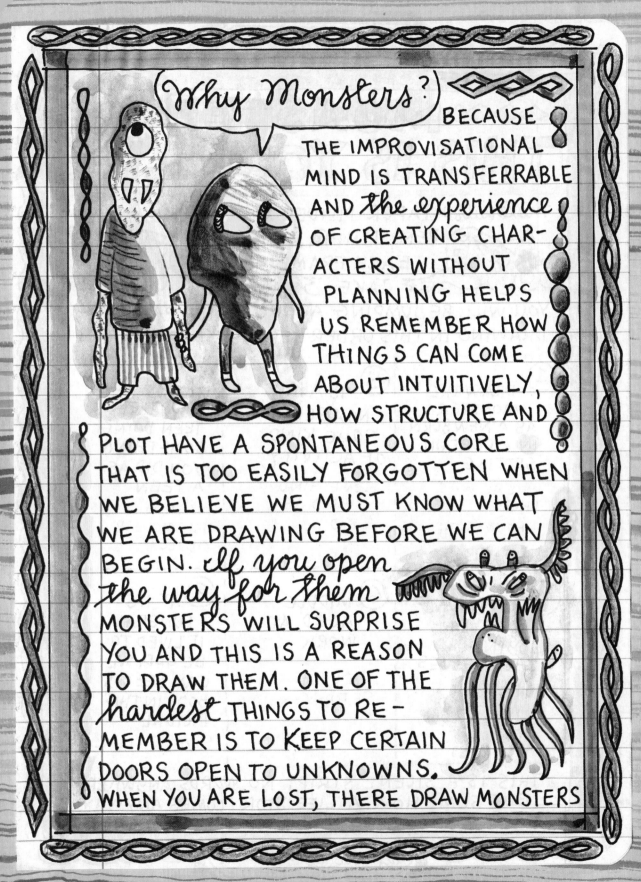

Why Monsters?

BECAUSE THE IMPROVISATIONAL MIND IS TRANSFERRABLE AND *the experience* OF CREATING CHARACTERS WITHOUT PLANNING HELPS US REMEMBER HOW THINGS CAN COME ABOUT INTUITIVELY, HOW STRUCTURE AND PLOT HAVE A SPONTANEOUS CORE THAT IS TOO EASILY FORGOTTEN WHEN WE BELIEVE WE MUST KNOW WHAT WE ARE DRAWING BEFORE WE CAN BEGIN. *If you open the way for them* MONSTERS WILL SURPRISE YOU AND THIS IS A REASON TO DRAW THEM. ONE OF THE *hardest* THINGS TO REMEMBER IS TO KEEP CERTAIN DOORS OPEN TO UNKNOWNS. WHEN YOU ARE LOST, THERE DRAW MONSTERS

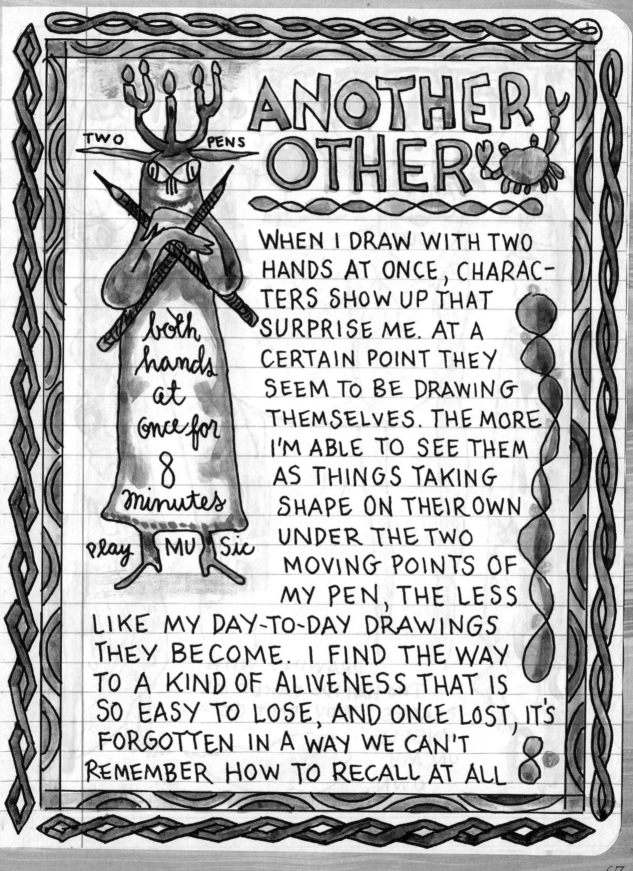

ANOTHER OTHER

TWO PENS

both hands at once for 8 minutes

play MU sic

WHEN I DRAW WITH TWO HANDS AT ONCE, CHARACTERS SHOW UP THAT SURPRISE ME. AT A CERTAIN POINT THEY SEEM TO BE DRAWING THEMSELVES. THE MORE I'M ABLE TO SEE THEM AS THINGS TAKING SHAPE ON THEIR OWN UNDER THE TWO MOVING POINTS OF MY PEN, THE LESS LIKE MY DAY-TO-DAY DRAWINGS THEY BECOME. I FIND THE WAY TO A KIND OF ALIVENESS THAT IS SO EASY TO LOSE, AND ONCE LOST, IT'S FORGOTTEN IN A WAY WE CAN'T REMEMBER HOW TO RECALL AT ALL

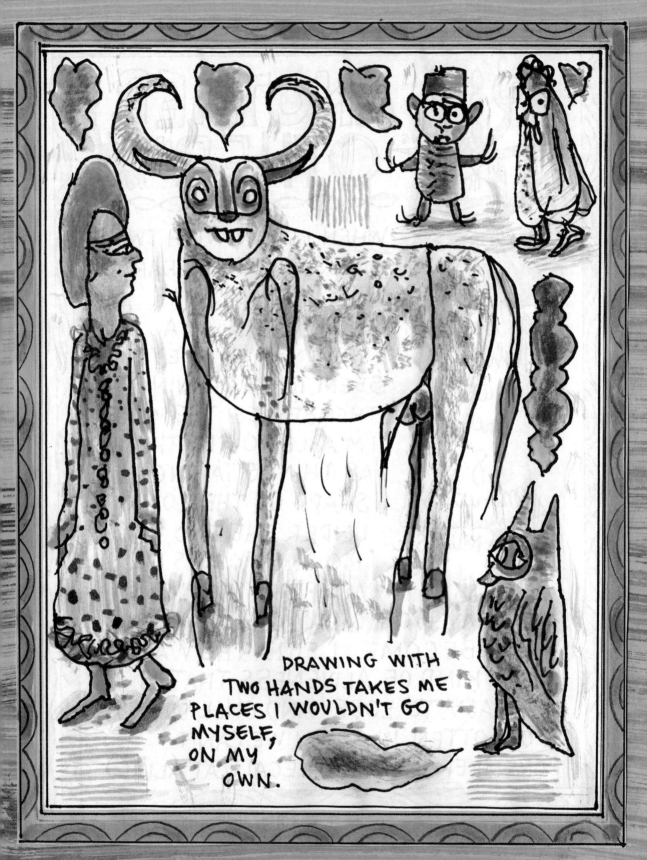

DRAWING WITH TWO HANDS TAKES ME PLACES I WOULDN'T GO MYSELF, ON MY OWN.

TWO HANDS AT ONCE

materials

- KIDS COLOR MARKERS
- LARGE NEWSPRINT
- COPIER PAPER
- FLAIR PENS
- MUSIC

Most People don't

KNOW THEY CAN DRAW WITH BOTH HANDS AT ONCE — UNTIL THEY TRY IT. MOST OF US CAN DO THIS.

1. WITH TWO DIFFERENT COLORED MARKERS DRAW A HEAD TO TOE SELF PORTRAIT FOR THE LENGTH OF A THREE MINUTE SONG. BOTH HANDS MUST BE DRAWING AT THE SAME TIME

2. REPEAT THIS BUT SWITCH COLORS AND *IMPORTANTLY* BEGIN WITH YOUR FEET

3. WALK AROUND THE ROOM TO SEE ALL OF THE DRAWINGS **TAKE A LOOK**

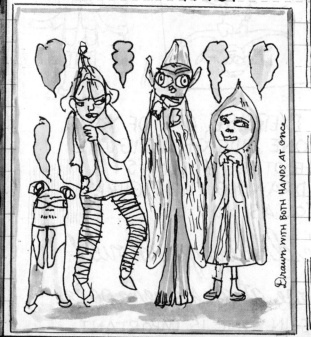

Drawn with Both Hands At Once

TANDEM DRAWING

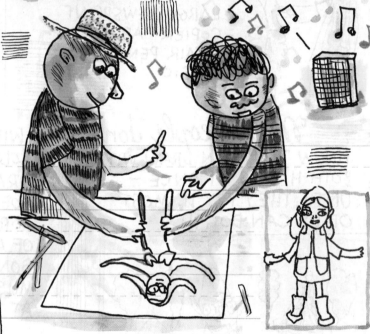

Materials

MARKERS
NEWSPRINT
MUSIC
A PARTNER

IN THIS EXERCISE, ONE OF YOU DRAWS ONE SIDE OF A FIGURE AND THE OTHER FOLLOWS ALONG, DRAWING THE FIGURE WITH YOU AS YOU GO.

These drawings should be done at a slower pace

STAYING IN SYNC IS IMPORTANT

VARIATIONS

TRY DIFFERENT METHODS

THIS IS A FLEXIBLE EXERCISE THAT CAN BE REVISITED ANY TIME YOU NEED TO LOOSEN IT UP.

- SWITCH LEADERS
- SWITCH SIDES
- SWITCH PARTNERS
- DRAW ON SEPARATE PAGES AND COPY YOUR PARTNER DRAWING A MERMAID, A COOK, A STRONG MAN.

- USE YOUR NON-DOMINANT HAND
- COPY WITHOUT LOOKING AT YOUR PAPER
- SWITCH LEADERS DURING SAME DRAWING
- TRY SUGGESTING DRAWING SUBJECTS

FLAIRS

CAN BE USED FOR SMALLER TWO-HANDED DRAWINGS. I LIKE THIS WAY OF WORKING WHEN I FEEL STUCK AND I LIKE THE UNEXPECTED CHARACTERS THAT SHOW UP. THIS IS ESPECIALLY GOOD FOR RELIEF FROM DRAWING RUTS.
IT'S HARD TO DISCOVER SOMETHING NEW WHEN YOU ALREADY KNOW WHAT YOU ARE DOING. UNCERTAINTY HELPS.

Two handed drawings.

Fig 477
COPY OF
STUDENT
DRAWING

THE DAILY DIARY

Fig 199
COPY OF
STUDENT
DRAWING

MATERIALS: FLAIR PEN, COMPBOOK, TIMER
about 20 minutes *use* LEFT HAND PAGE

1. ON A CLEAN PAGE OF YOUR COMPBOOK, DRAW A "REVIEW FRAME" THAT LOOKS LIKE THIS →

2. SET A TIMER FOR 3 MINUTES. IN THE FIRST COLUMN, WRITE 7 OR SO THINGS YOU DID IN THE LAST 24 HOURS.

WRITE TODAY'S DATE	
DID	**SAW**
1	1
2	2
3 3 MINUTES	3 3 MINUTES
4	4
5	5
6	6
7	7
HEARD SOMEONE SAY 30 SECONDS	QUESTION ABOUT THE DAY 30 SECONDS

here you

3. *REPEAT THIS* IN THE SECOND COLUMN BUT

THIS TIME WRITE DOWN THINGS YOU SAW.

4. WRITE SOMETHING YOU HEARD SOMEONE SAY

5. WRITE A QUESTION THAT CAME UP FOR YOU IN THE LAST BOX – SOMETHING YOU'VE BEEN WONDERING ABOUT.

THESE LAST TWO BOXES SHOULD TAKE ABOUT 30 SECONDS EACH

6. READ OVER YOUR 7 MINUTE DIARY AND CHOOSE AN IMAGE FROM EITHER THE DID OR SAW LIST, THINKING OF EACH THING AS A SCENE. EVERYTHING ON THOSE LISTS INVOLVES THE SETTING AND SOMETHING YOU WERE DOING: SOME KIND OF ACTION

use right hand page

DRAWING OF YOUR-SELF IN THE SCENE, INCLUDING YOUR WHOLE BODY, ENGAGED IN SOME ACTION 5 MINUTES

SETTING:
APPROX TIME:

 5 MINUTES

7. DRAW A FRAME THAT TAKES UP ABOUT HALF A PAGE

8. BELOW IT WRITE THE PLACE WHERE THIS SCENE HAPPENED AND THE APPROXIMATE TIME IT TOOK PLACE

9. SET THE TIMER FOR FIVE MINUTES AND WRITE THIS SCENE IN THE FIRST PERSON PRESENT TENSE – LIKE IT'S HAPPENING RIGHT NOW. KEEP YOUR PEN MOVING THE WHOLE TIME –

10. DRAW YOURSELF IN THE SCENE USING THE 'BRUNETTI STYLE' FOR 5 MINUTES WITHOUT STOPPING

ALTERNATE between BEGINNING WITH the DRAWING every other day. REVERSE STEPS 9 AND 10.

note: you can always spend more than the suggested time, but not less.

DID

1. WOKE UP BECAUSE OF SIRENS - SOUNDED LIKE THEY WERE FROM SEVERAL TOWNSHIPS ALL HEADING SOUTH. ABOUT 4 AM

2. WENT BY THE AMISH, GOT GAS + GAS STATION CHICKEN, WENT TO ALBANY.

3. READ "WARTRASH" IN THE BATHTUB FOR TWO HOURS

4. WORKED ON MC1 BOOK WITH BRITISH PERIOD DRAMAS PLAYING ON YOU TUBE

5. WALKED THE GROVE LISTENING TO THE MC1S18 PLAYLIST

6. DREW A 12 PANEL 12 MINUTE COMIC STRIP ABOUT A GUY GETTING ATTACKED BY A CAT

7. WATCHED 'NASHVILLE' UNTIL RAYNA DIED AND DECIDED I WAS DONE WITH IT.

SAW

1. ALL OF THE DOGS TOYS SCATTERED ON THE BACK PORCH. THE HULKS HEAD HAS BEEN CHEWED OFF.

2. CHURCH VAN WITH 8 PEOPLE GETTING OUT OF IT. ADULTS WITH DISABILITIES BUYING GROCERIES TOGETHER.

3. BARN SWALLOW ON HER NEST LOOKING DOWN AT ME FROM FRONT PORCH CROSS BEAM

4. RIPLEY'S RALLY T-SHIRT WITH FLAMING SKELETON AS THE BODY OF THE MOTOR CYCLE.

5. THE HORROR HAIRBALL

6. WHAT HA JIN LOOKS LIKE

7. EVERYTHING TURNING THAT DEEP BLUE AFTER SUNSET - THE FIELD TO THE WEST OF THE HOUSE

"OH, I DRIVE FOR THE AMISH. I DRIVE THE ONES FROM UP NORTH A WAYS. I DON'T SUPPOSE YOU WOULD KNOW ANY OF THEM?"

OVER HEARD

I WONDER IF ANYONE HAS EVER DOCUMENTED THE OBJECTS LEFT BEHIND BY POWS. — ESPECIALLY THE THINGS THEY FASHIONED TO MAKE THEIR SITUATIONS MORE COMFORTABLE.

QUESTION

GOT GAS GOT GAS STATION CHICKEN

I'M AT PUMP FOUR AT THE ALBANY MOBILE STATION FINISHING FILLING UP AND TRYING TO TALK MYSELF OUT OF GOING INSIDE TO GET SOME FRIED CHICKEN AND ICED TEA. A YOUNG WOMAN IN SHORTS AND PRETTY SANDALS GOES IN BEFORE ME, HOLDS THE DOOR SO IT DOESN'T SHUT ON ME AND SMILES: A FLOWERED SUMMER BLOUSE, SHORT BLONDE HAIR IN KIND OF A MOM CUT, SHE LOOKS PRETTY STRAIGHT, HAS A CUTE HAND BAG, I WATCH HER B-LINE FOR THE CHICKEN COUNTER. THERE IS A SIGN FEATURING THE FRANCHISE LOGO HANGING ABOVE THE VERY SHY GIRL WHO IS TAKING HER ORDER. IT'S A DRAWING OF A SORT OF 'RISKY BUSINESS' ERA-TOM CRUISE-WITH SUNGLASSES-AND-CHEF'S-HAT LINE DRAWING. THE GIRL HAS A WORD TATTOOED ON BOTH ARMS BUT I CANT READ IT.

75

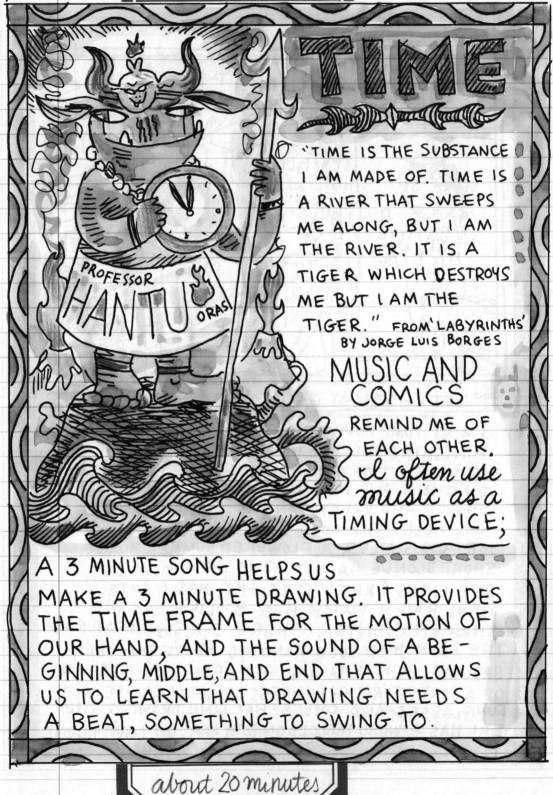

TIME

PROFESSOR HANTU ORASI

"TIME IS THE SUBSTANCE I AM MADE OF. TIME IS A RIVER THAT SWEEPS ME ALONG, BUT I AM THE RIVER. IT IS A TIGER WHICH DESTROYS ME BUT I AM THE TIGER." FROM 'LABYRINTHS' BY JORGE LUIS BORGES

MUSIC AND COMICS REMIND ME OF EACH OTHER. I often use music as a TIMING DEVICE;

A 3 MINUTE SONG HELPS US MAKE A 3 MINUTE DRAWING. IT PROVIDES THE TIME FRAME FOR THE MOTION OF OUR HAND, AND THE SOUND OF A BEGINNING, MIDDLE, AND END THAT ALLOWS US TO LEARN THAT DRAWING NEEDS A BEAT, SOMETHING TO SWING TO.

about 20 minutes

ALMOST ALL OF OUR EXERCISES INVOLVE WORKING WITHIN A SPECIFIC TIME FRAME. IVAN BRUNETTI HAS AN EXERCISE THAT ASKS US TO DRAW SOMETHING OVER AND OVER IN LESS AND LESS TIME WHICH MAKES US DRAW FASTER WITH LESS CONTROL, ALLOWING FOR OUR HAND TO DO THINGS THAT SURPRISE US, AND INTRODUCE US TO SPONTANEOUS GESTURES THAT MAKE FOR ORIGINAL LINES AND SHAPES THAT CAN'T REVEAL THEMSELVES OTHERWISE.

"FASTER, FASTER IVAN BRUNETTI!" IS WHAT I CALL MY ADAPTATION OF HIS EXERCISE.

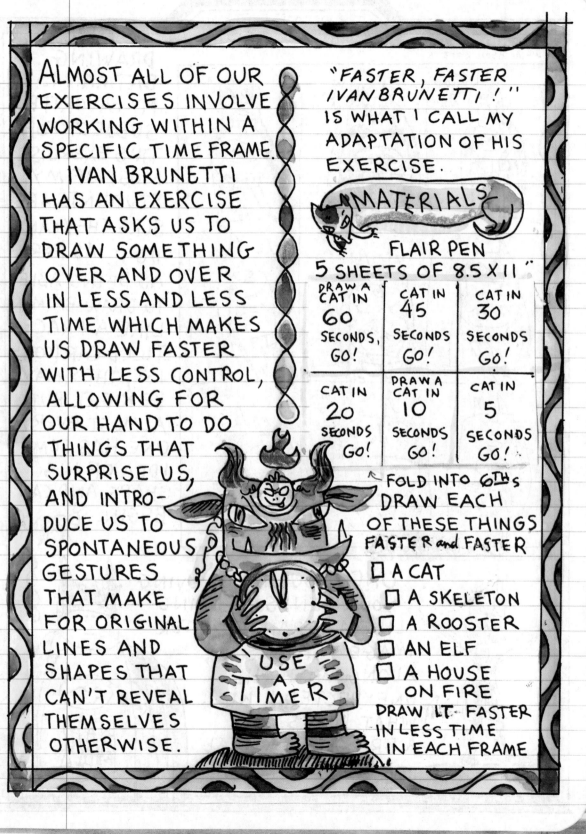

MATERIALS

FLAIR PEN
5 SHEETS OF 8.5 X 11"

DRAW A CAT IN 60 SECONDS, GO!	CAT IN 45 SECONDS GO!	CAT IN 30 SECONDS GO!
CAT IN 20 SECONDS GO!	DRAW A CAT IN 10 SECONDS GO!	CAT IN 5 SECONDS GO!

← FOLD INTO 6THs

DRAW EACH OF THESE THINGS FASTER and FASTER

☐ A CAT
☐ A SKELETON
☐ A ROOSTER
☐ AN ELF
☐ A HOUSE ON FIRE

DRAW IT FASTER IN LESS TIME IN EACH FRAME

USE A TIMER

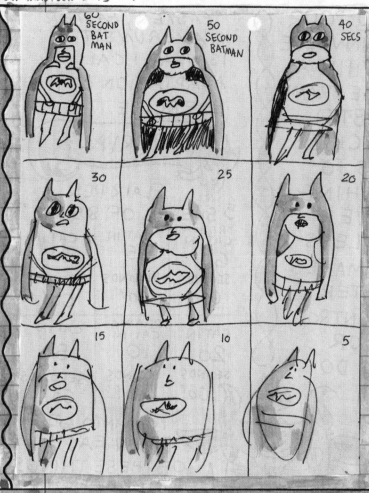

STUDENT DRAWING → UW-MADISON 2013 ✓

60 SECOND BAT MAN | 50 SECOND BATMAN | 40 SECS

30 | 25 | 20

15 | 10 | 5

DRAWING BATMAN IS MY FAVORITE SUBJECT FOR THIS EXERCISE. MOST OF MY STUDENTS ARE SURE THEY CAN'T DO IT. AS FAR AS BEING ABLE TO DRAW BATMAN LIKE A PRACTICED CARTOONIST, THEY MAY BE RIGHT. BUT ALMOST EVERYONE HAS <u>SOME</u> IDEA OF HIS SHAPE AND CAN BEGIN.

ONCE YOU START MOVING YOUR PEN, SOMETHING LIKE A STRANGE "AFTER-IMAGE" SHOWS UP, ALONG WITH THE UNEXPECTED, LIKE WHAT LOOKS LIKE A BRA OR AN ACTUAL SIX-PACK →

DRAW YOURSELF AS BATMAN

THIS IS NEVER A BAD IDEA

YOUR PROFESSOR

OK CLASS, GOOD MORNING, FOR TODAY'S ATTENDANCE CARD, YOU'LL BE DRAWING YOURSELF AS BATMAN DOING SOMETHING YOU DID IN THE LAST 24 HOURS. INCLUDE YOUR ENTIRE BODY AND WE NEED TO BE ABLE TO SEE YOUR FACE.

YOU HAVE 3 MINUTES. DON'T FORGET TO DRAW YOUR FRAME, WRITE YOUR NAME IN THE UPPER LEFT CORNER AND TODAYS DATE IN THE UPPER RIGHT.

DRAW WITHOUT STOPPING. READY, GO.

REPEAT THIS 3 MORE TIMES

DRAW YOUR SELF AS BATMAN

a. SCREAMING
b. DEPRESSED
c. VOMITING
d. PASSED OUT

INCLUDE SETTINGS

THIS WEEK'S DIARY ASSIGNMENT: DRAW YOURSELF AS BATMAN IN FOUR SCENES FROM YOUR DAY, 5 MINUTES PER FRAME. THIS IS A 'SILENT' DIARY, NO WORDS (FOR NOW)

ABOUT 35 minutes

YOU CAN DRAW YOURSELF WITH BATMAN'S
ATTITUDE OR HE CAN HAVE YOUR ATTITUDE
ABOUT THE DAY. TRY
TO INCLUDE YOUR
WHOLE BODY.

FORMATS:
are flexible

A
SIMPLE 4 FRAME
DOUBLE PAGE SPREAD
IN COMP BOOK →
OR
FOUR 4"x6" INDEXCARDS
THAT CAN BE MADE INTO
AN ACCORDION - STYLE ↔
BOOK AT THE END OF
THE WEEK,
OR
TRIANGLE DIARY STYLE
→ TO CHANGE - UP COMPOSITION HABITS

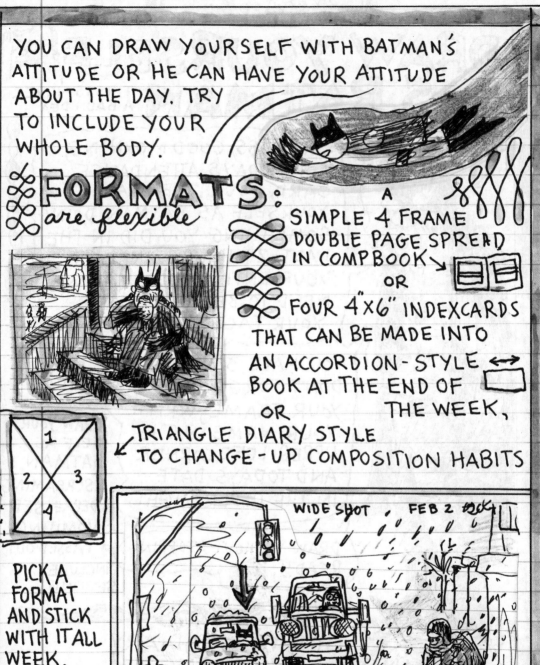

1
2 3
4

PICK A
FORMAT
AND STICK
WITH IT ALL
WEEK.
TRY THE
OTHER
FORMATS
LATER

WIDE SHOT FEB 2

8:45 AM

CHANGE "CAMERA ANGLES"

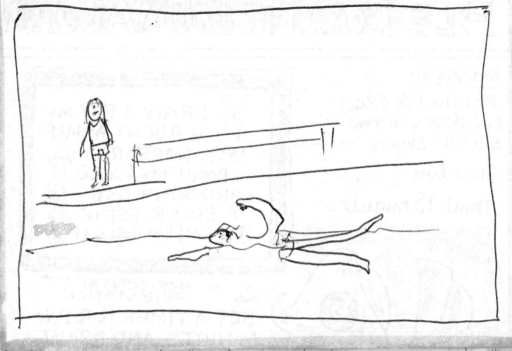

NO MATTER HOW RUDIMENTARY THE DRAWING, WHOLE BODIES IN A SETTING WILL GIVE YOU THE MOST INFORMATION ABOUT YOUR CHARACTERS.

THE DRAWING ABOVE WAS MADE IN ONE MINUTE. THE LINES ARE SPARE AND NOT ESPECIALLY PRACTICED BUT THAT PERSON IS SWIMMING, TAKING A BREATH, GOING FAST I THINK. AND THAT GIRL, WATCHING. 100 DIFFERENT STORIES CAN LIVE IN THIS IMAGE

WHOLE BODIES

IN MOTION CONJURE STORIES IN WAYS FACES ALONE CAN NOT. IN THE UPCOMING WEEKS WE WILL ALWAYS DRAW WHOLE BODIES SHOWING A FACE OR PROFILE. THE IVAN BRUNETTI STYLE IS IDEAL FOR THIS AND A RELIABLE FALL BACK IF YOU GET STUCK

FILE FOLDER ANIMAL JAM

Materials

Manila file folder cut down to two 8.5" x 11" sheets →

flair pen

about 15 minutes

IT'S OK IF YOU invent AN ANIMAL

1. DRAW A FRAME WITH ABOUT A HALF-INCH BORDER. DON'T MEASURE AND DON'T USE A RULER. SEE IF YOU CAN EYE BALL IT

2. ← HORIZONTAL ORIENTATION →
SET A TIMER FOR TWO MINUTES AND DRAW A SIMPLE OUTLINE OF ANY ANIMAL, DON'T MAKE IT TOO SMALL. IT SHOULD BE AT LEAST THE SIZE OF YOUR HAND.

you'll draw on each others PICTURES

3. SWITCH DRAWINGS WITH SOME ONE AND DRAW A SMALLER COMPANION - IT'S THE SAME ANIMAL. → NOW THERE ARE TWO OF THEM.

KEEP the SHAPES simple

JUST make up THE PARTS you are unsure of 2 MINS

4. SWITCH AGAIN. NOW ADD SOME SIMPLE VEGETATION AND/OR OTHER SCENERY

THREE PEOPLE HAVE DRAWN ON EACH PAGE 2 MINS

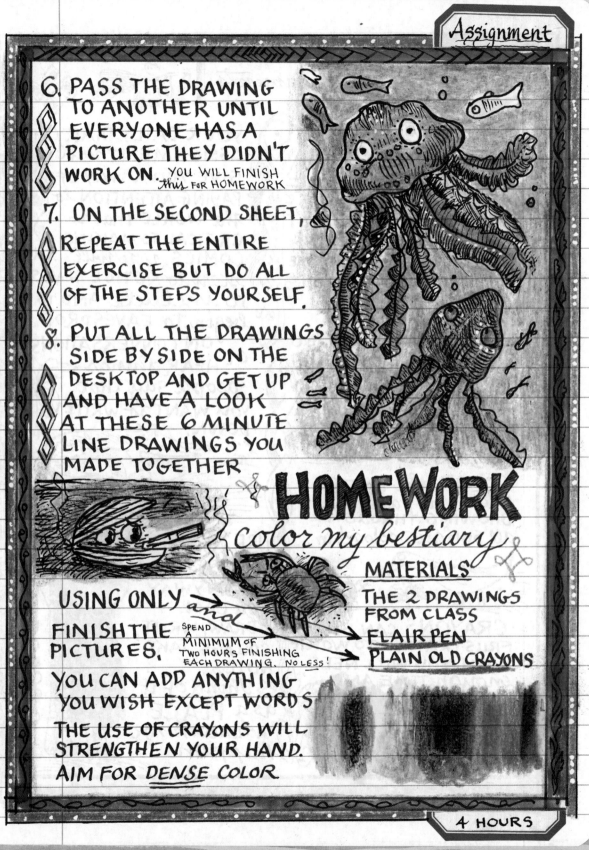

6. PASS THE DRAWING TO ANOTHER UNTIL EVERYONE HAS A PICTURE THEY DIDN'T WORK ON. YOU WILL FINISH this FOR HOMEWORK

7. ON THE SECOND SHEET, REPEAT THE ENTIRE EXERCISE BUT DO ALL OF THE STEPS YOURSELF.

8. PUT ALL THE DRAWINGS SIDE BY SIDE ON THE DESKTOP AND GET UP AND HAVE A LOOK AT THESE 6 MINUTE LINE DRAWINGS YOU MADE TOGETHER

HOMEWORK
color my bestiary

MATERIALS

USING ONLY and

FINISH THE PICTURES. SPEND A MINIMUM OF TWO HOURS FINISHING EACH DRAWING. NO LESS!

THE 2 DRAWINGS FROM CLASS
FLAIR PEN
PLAIN OLD CRAYONS

YOU CAN ADD ANYTHING YOU WISH EXCEPT WORDS

THE USE OF CRAYONS WILL STRENGTHEN YOUR HAND. AIM FOR DENSE COLOR

4 HOURS

BEFORE you color YOUR ANIMAL DRAWINGS, SPEND ABOUT 20-30 MINS. ADDING SOME Linework DETAILS WITH YOUR FLAIR PEN. You SHOULD ADD ANYTHING YOU WANT _except words_. THESE ARE SILENT DRAWINGS

COLOR the ENTIRE PAGE - no paper SHOWING THROUGH - all surfaces colored in.

CRAYONS CAN BE FRUSTRATING TO WORK WITH, YOU WILL NEED enough TIME AND HAND STRENGTH to GET DEEP, DENSE COLOR. This can't be done in a hurry.

YOUR DAILY DIARY ASSIGNMENT will GIVE YOU A WAY OF PAYING ATTENTION to the WORLD that is CRITICAL TO MAKING COMICS. You will start to NOTICE THINGS TO include AND TO begin to EAVESDROP ON CONVERSATIONS or HEAR things people say that YOU WANT to WRITE DOWN.

USE your compbook IN ANYWAY you CAN. DRAW, WRITE, COLLAGE, TAKE NOTES. Think of it as a PLACE where things happen

84

FACE JAM

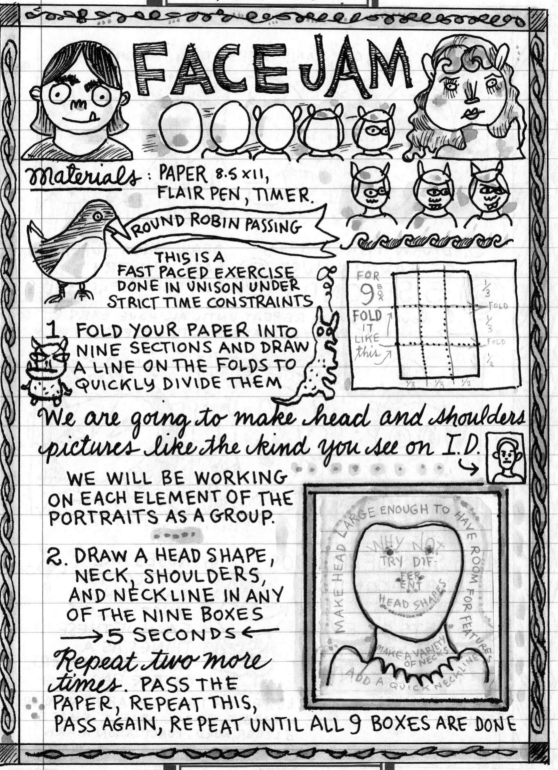

Materials: PAPER 8.5 x11, FLAIR PEN, TIMER.

ROUND ROBIN PASSING

THIS IS A FAST PACED EXERCISE DONE IN UNISON UNDER STRICT TIME CONSTRAINTS

1 FOLD YOUR PAPER INTO NINE SECTIONS AND DRAW A LINE ON THE FOLDS TO QUICKLY DIVIDE THEM

FOR 9 BOX FOLD IT LIKE this
1/3 FOLD
1/3 FOLD
1/3
1/3 1/3 1/3

We are going to make head and shoulders pictures like the kind you see on I.D.

WE WILL BE WORKING ON EACH ELEMENT OF THE PORTRAITS AS A GROUP.

2. DRAW A HEAD SHAPE, NECK, SHOULDERS, AND NECKLINE IN ANY OF THE NINE BOXES
→ 5 SECONDS ←

Repeat two more times. PASS THE PAPER, REPEAT THIS, PASS AGAIN, REPEAT UNTIL ALL 9 BOXES ARE DONE

MAKE HEAD LARGE ENOUGH TO HAVE ROOM FOR FEATURES
WHY NOT TRY DIFFERENT HEAD SHAPES
MAKE A VARIETY OF NECKS
ADD A QUICK NECKLINE

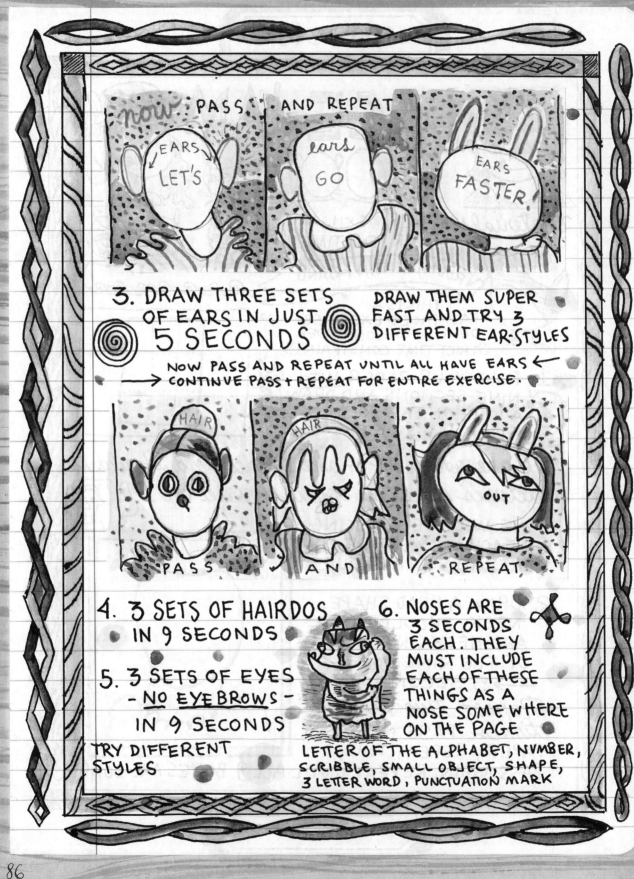

NOW PASS AND REPEAT

EARS LET'S

ears GO

EARS FASTER

3. DRAW THREE SETS OF EARS IN JUST 5 SECONDS

DRAW THEM SUPER FAST AND TRY 3 DIFFERENT EAR-STYLES

NOW PASS AND REPEAT UNTIL ALL HAVE EARS ←
→ CONTINUE PASS + REPEAT FOR ENTIRE EXERCISE.

HAIR

HAIR

OUT

PASS AND REPEAT

4. 3 SETS OF HAIRDOS IN 9 SECONDS

5. 3 SETS OF EYES - NO EYE BROWS - IN 9 SECONDS

TRY DIFFERENT STYLES

6. NOSES ARE 3 SECONDS EACH. THEY MUST INCLUDE EACH OF THESE THINGS AS A NOSE SOME WHERE ON THE PAGE

LETTER OF THE ALPHABET, NUMBER, SCRIBBLE, SMALL OBJECT, SHAPE, 3 LETTER WORD, PUNCTUATION MARK

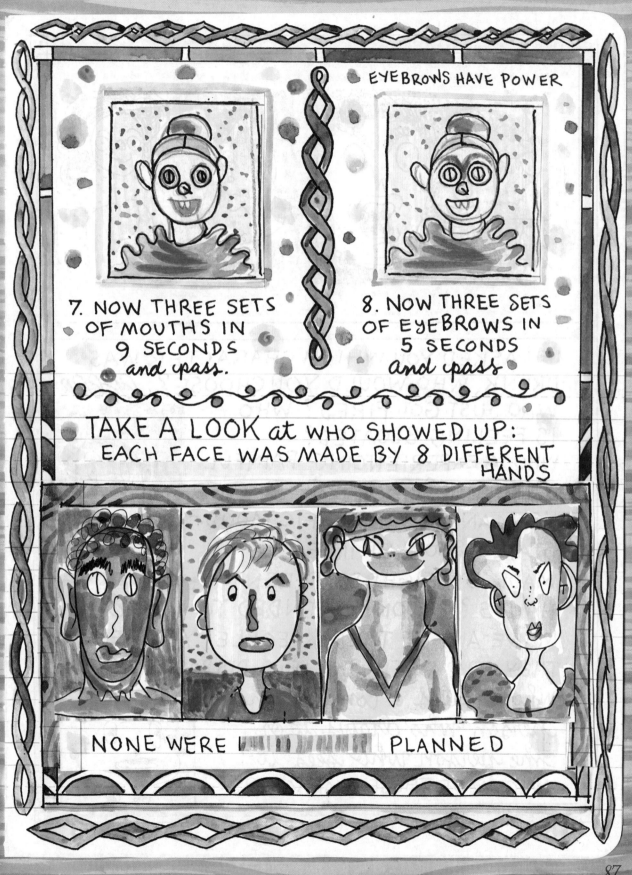

EYEBROWS HAVE POWER

7. NOW THREE SETS OF MOUTHS IN 9 SECONDS *and pass.*

8. NOW THREE SETS OF EYEBROWS IN 5 SECONDS *and pass*

TAKE A LOOK at WHO SHOWED UP: EACH FACE WAS MADE BY 8 DIFFERENT HANDS

NONE WERE I⬛⬛⬛⬛⬛ PLANNED

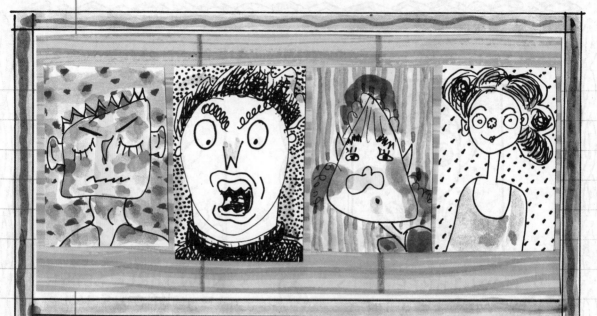

IF I ASKED YOU WHICH CHARACTER WAS
DRUNK, WHO WOULD YOU CHOOSE?
WHO JUST GOT FIRED? WHO
IS FEELING BLOATED?
WHO IS EXPERIENCING PAINFUL
URINATION?
HOW CAN SUCH SPECIFIC MOOD-
STATES SHOW UP IN FACES
MADE BY EIGHT DIFFERENT
HANDS? NO ONE INTENDED TO
MAKE ANY OF THESE PEOPLE, YET HERE
THEY ARE WITH SPECIFIC DISPOSITIONS.
Who creates a comic? The
person who draws it or
the person who sees it?
WHO MADE THESE CHARACTERS?

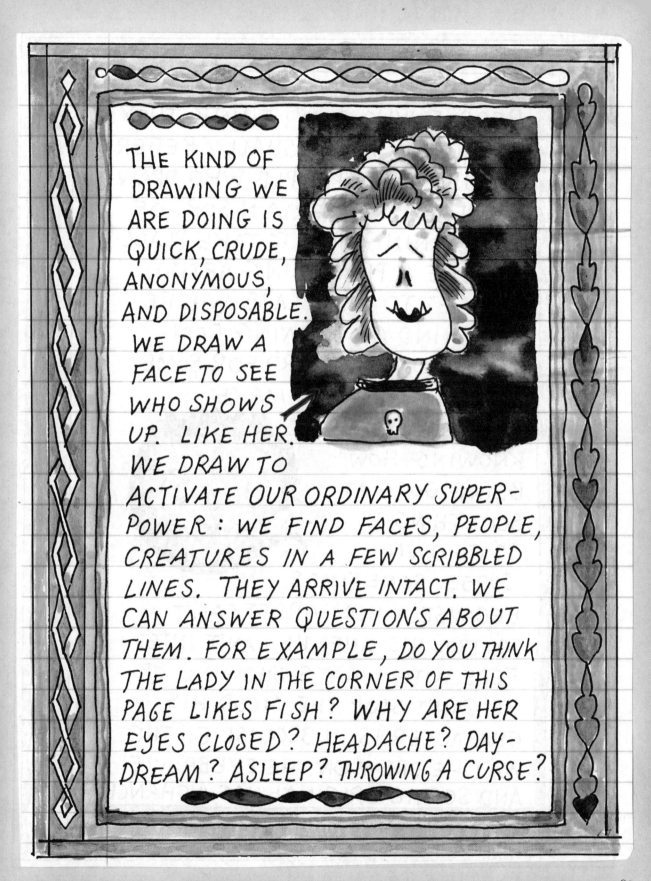

THE KIND OF DRAWING WE ARE DOING IS QUICK, CRUDE, ANONYMOUS, AND DISPOSABLE. WE DRAW A FACE TO SEE WHO SHOWS UP. LIKE HER. WE DRAW TO ACTIVATE OUR ORDINARY SUPER-POWER: WE FIND FACES, PEOPLE, CREATURES IN A FEW SCRIBBLED LINES. THEY ARRIVE INTACT. WE CAN ANSWER QUESTIONS ABOUT THEM. FOR EXAMPLE, DO YOU THINK THE LADY IN THE CORNER OF THIS PAGE LIKES FISH? WHY ARE HER EYES CLOSED? HEADACHE? DAY-DREAM? ASLEEP? THROWING A CURSE?

PEOPLE WHO DON'T THINK THEY
CAN DRAW ARE USUALLY BETTER
AT THIS THAN PEOPLE WHO DRAW
REGULARLY. A CERTAIN SORT OF
UNLEARNING HAS TO TAKE PLACE
BEFORE A PRACTICING ARTIST
CAN GET TO THE PLACE WHERE
THIS KIND OF DRAWING CAN
TAKE YOU. IT'S HARD FOR SOME-
THING ORIGINAL TO MAKE
IT PAST 'ALREADY
KNOWING HOW.'
BEING GOOD AT
SOMETHING
IS ITS OWN
CURSE, SOMETIMES.
BECAUSE A NON-ARTIST CAN'T
CONTROL HIS LINE, HE CAN'T INTER-
FERE WITH WHAT'S SHOWING UP,
HE CAN'T STOP THE MOOD HIS
CHARACTER IS IN BECAUSE OF THE
WAY HE DREW ON THE EYEBROWS,
AND SO THE ORIGINAL HAS A CHANCE.

PATTERN
AND
SOLID BLACK
AND *a little* COLOR

Materials:
FLAIR PEN
"FACE JAM" PAGE
COLOR PENCILS

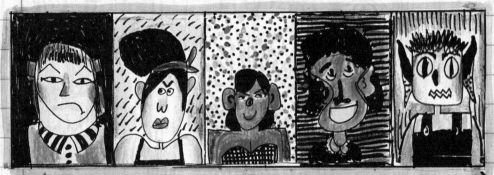

EACH OF *these* CHAR-
ACTERS NEEDS
areas of SOLID
BLACK

and
PATTERNS
and this
is something
you can do
while listening
to something

IT'S OK TO SPACE OUT WHILE YOU DRAW

Then, use your
color pencils
to make
back grounds
and foregrounds
stand out from
each other

PHOTO BOOTH

materials:
8.5"X11" PAPER
FLAIR PEN
"FACE JAM"
PAGE

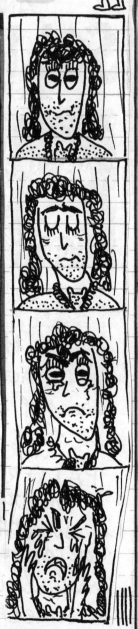

INSTEAD OF LOOKING AT OUR PAGE OF CHARACTERS AS GOOD OR BAD DRAWINGS, WE USE THEM AS STORY ACTIVATORS. THE FACE ON THIS PAGE FOR EXAMPLE. CAN YOU WRITE A SCENE FROM HIS POINT OF VIEW? WHAT IS HE LOOKING AT? WHICH PART OF HIS FACE IS ABOUT TO MOVE NEXT?

IF HE WERE IN A PHOTO BOOTH, WHO WOULD HE BE TAKING THIS PICTURE FOR?

HOW ABOUT THIS PERSON? WHAT'S THE STORY HERE?

ABOUT an HOUR

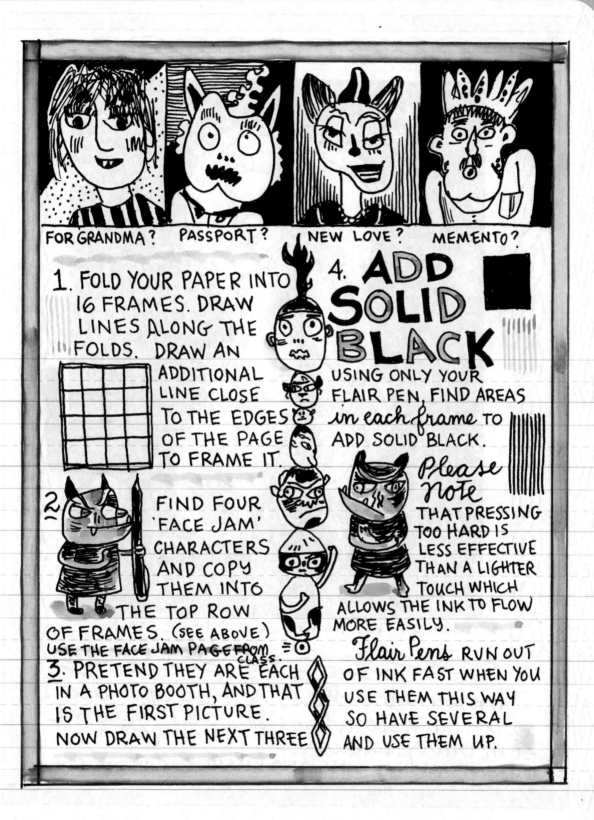

FOR GRANDMA? PASSPORT? NEW LOVE? MEMENTO?

1. FOLD YOUR PAPER INTO 16 FRAMES. DRAW LINES ALONG THE FOLDS. DRAW AN ADDITIONAL LINE CLOSE TO THE EDGES OF THE PAGE TO FRAME IT.

2. FIND FOUR 'FACE JAM' CHARACTERS AND COPY THEM INTO THE TOP ROW OF FRAMES. (SEE ABOVE) USE THE FACE JAM PAGE FROM CLASS.

3. PRETEND THEY ARE EACH IN A PHOTO BOOTH, AND THAT IS THE FIRST PICTURE. NOW DRAW THE NEXT THREE

4. ADD SOLID BLACK

USING ONLY YOUR FLAIR PEN, FIND AREAS in each frame to ADD SOLID BLACK.

Please note THAT PRESSING TOO HARD IS LESS EFFECTIVE THAN A LIGHTER TOUCH WHICH ALLOWS THE INK TO FLOW MORE EASILY.

Flair Pens RUN OUT OF INK FAST WHEN YOU USE THEM THIS WAY SO HAVE SEVERAL AND USE THEM UP.

SPACE BABY LOST HER WAY.

I FOUND THIS IMAGE IN A COFFEE STAIN

These are exercises I go back to when I'm out of ideas

They open doors and windows I'd forgotten

IMPROVISATIONAL LINE AND SHAPE CARRY ME ON

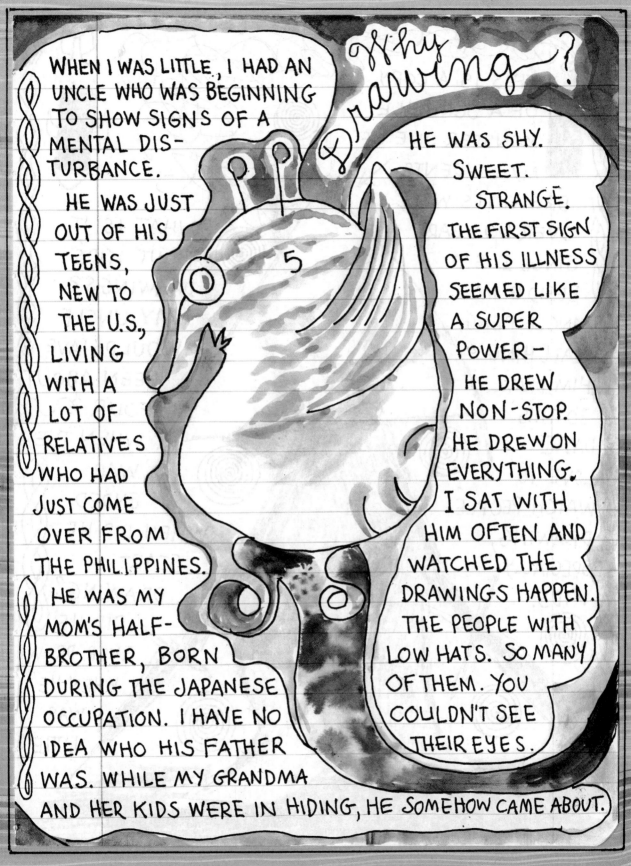

WHEN I WAS LITTLE, I HAD AN UNCLE WHO WAS BEGINNING TO SHOW SIGNS OF A MENTAL DISTURBANCE.

HE WAS JUST OUT OF HIS TEENS, NEW TO THE U.S., LIVING WITH A LOT OF RELATIVES WHO HAD JUST COME OVER FROM THE PHILIPPINES.

HE WAS MY MOM'S HALF-BROTHER, BORN DURING THE JAPANESE OCCUPATION. I HAVE NO IDEA WHO HIS FATHER WAS. WHILE MY GRANDMA AND HER KIDS WERE IN HIDING, HE SOMEHOW CAME ABOUT.

HE WAS SHY. SWEET. STRANGE. THE FIRST SIGN OF HIS ILLNESS SEEMED LIKE A SUPER POWER — HE DREW NON-STOP. HE DREW ON EVERYTHING. I SAT WITH HIM OFTEN AND WATCHED THE DRAWINGS HAPPEN. THE PEOPLE WITH LOW HATS. SO MANY OF THEM. YOU COULDN'T SEE THEIR EYES.

5

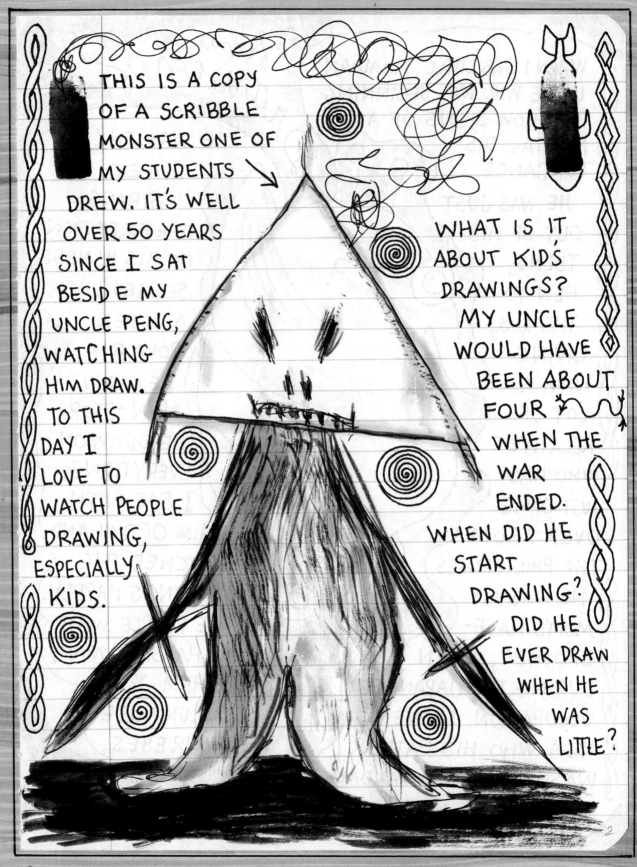

THIS IS A COPY OF A SCRIBBLE MONSTER ONE OF MY STUDENTS DREW. IT'S WELL OVER 50 YEARS SINCE I SAT BESIDE MY UNCLE PENG, WATCHING HIM DRAW. TO THIS DAY I LOVE TO WATCH PEOPLE DRAWING, ESPECIALLY KIDS.

WHAT IS IT ABOUT KID'S DRAWINGS? MY UNCLE WOULD HAVE BEEN ABOUT FOUR WHEN THE WAR ENDED. WHEN DID HE START DRAWING? DID HE EVER DRAW WHEN HE WAS LITTLE?

96

2

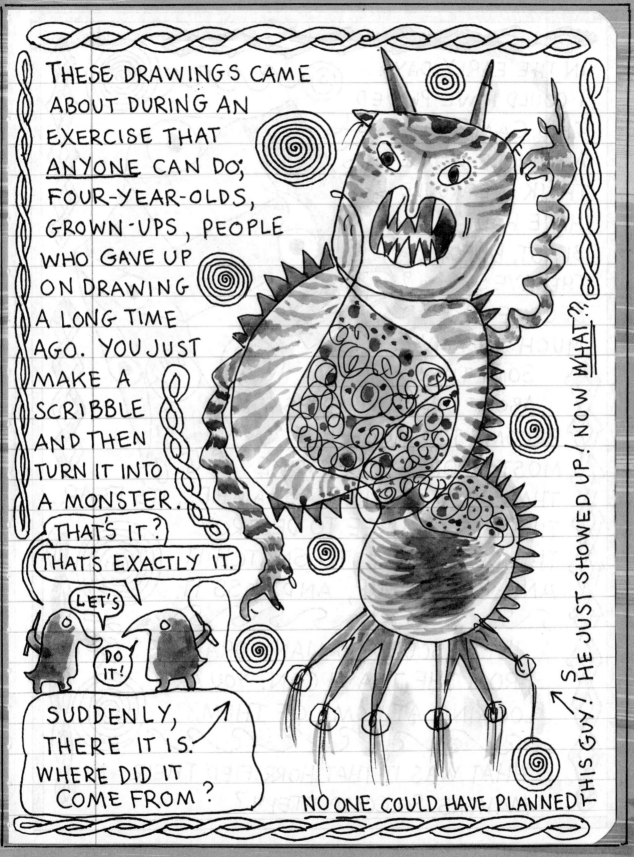

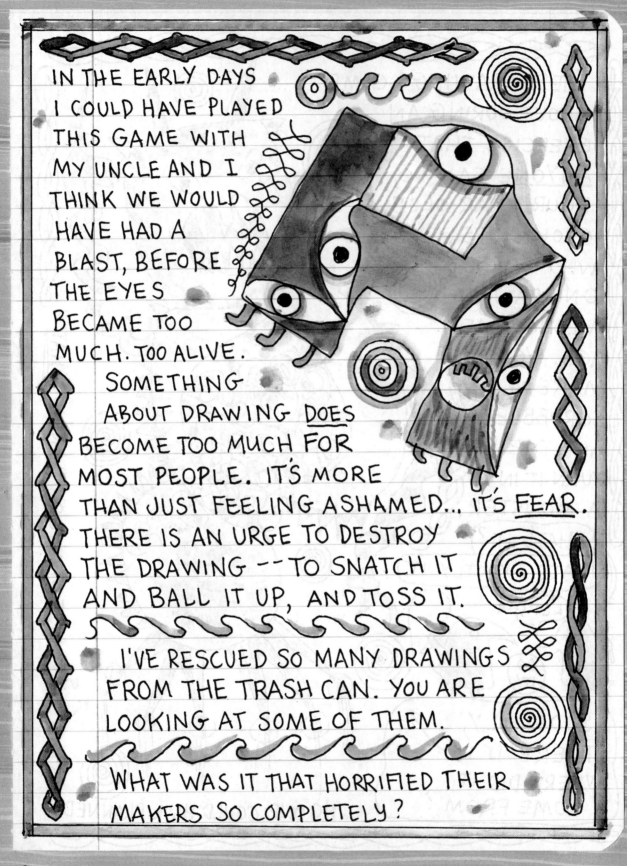

IN THE EARLY DAYS
I COULD HAVE PLAYED
THIS GAME WITH
MY UNCLE AND I
THINK WE WOULD
HAVE HAD A
BLAST, BEFORE
THE EYES
BECAME TOO
MUCH. TOO ALIVE.

SOMETHING
ABOUT DRAWING DOES
BECOME TOO MUCH FOR
MOST PEOPLE. IT'S MORE
THAN JUST FEELING ASHAMED... IT'S FEAR.
THERE IS AN URGE TO DESTROY
THE DRAWING -- TO SNATCH IT
AND BALL IT UP, AND TOSS IT.

I'VE RESCUED SO MANY DRAWINGS
FROM THE TRASH CAN. YOU ARE
LOOKING AT SOME OF THEM.

WHAT WAS IT THAT HORRIFIED THEIR
MAKERS SO COMPLETELY?

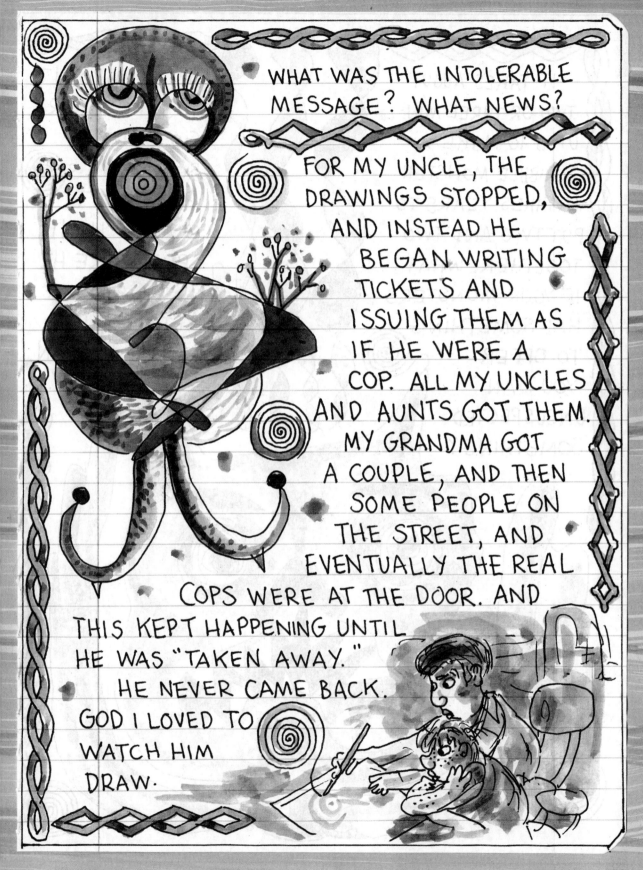

WHAT WAS THE INTOLERABLE MESSAGE? WHAT NEWS?

FOR MY UNCLE, THE DRAWINGS STOPPED, AND INSTEAD HE BEGAN WRITING TICKETS AND ISSUING THEM AS IF HE WERE A COP. ALL MY UNCLES AND AUNTS GOT THEM. MY GRANDMA GOT A COUPLE, AND THEN SOME PEOPLE ON THE STREET, AND EVENTUALLY THE REAL COPS WERE AT THE DOOR. AND THIS KEPT HAPPENING UNTIL HE WAS "TAKEN AWAY." HE NEVER CAME BACK. GOD I LOVED TO WATCH HIM DRAW.

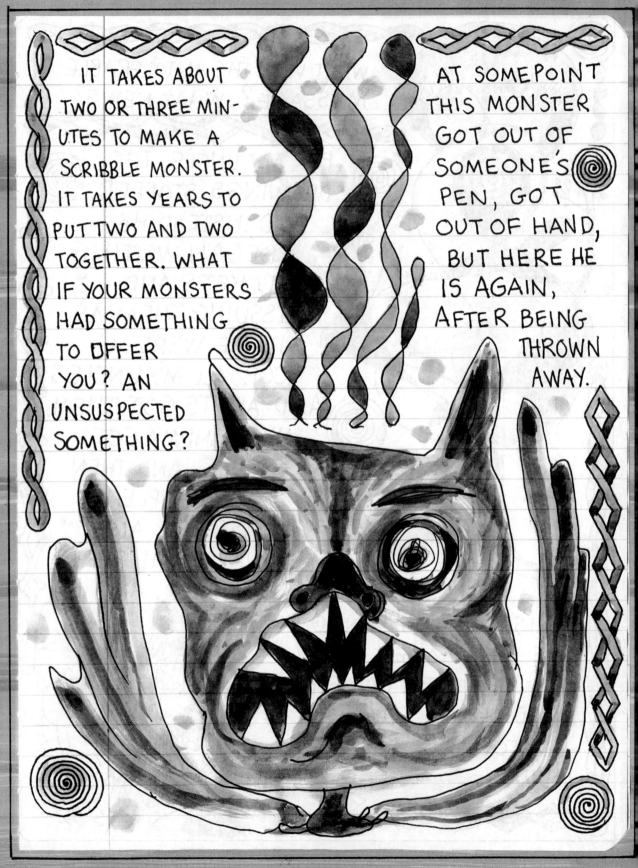

IT TAKES ABOUT TWO OR THREE MINUTES TO MAKE A SCRIBBLE MONSTER. IT TAKES YEARS TO PUT TWO AND TWO TOGETHER. WHAT IF YOUR MONSTERS HAD SOMETHING TO OFFER YOU? AN UNSUSPECTED SOMETHING?

AT SOME POINT THIS MONSTER GOT OUT OF SOMEONE'S PEN, GOT OUT OF HAND, BUT HERE HE IS AGAIN, AFTER BEING THROWN AWAY.

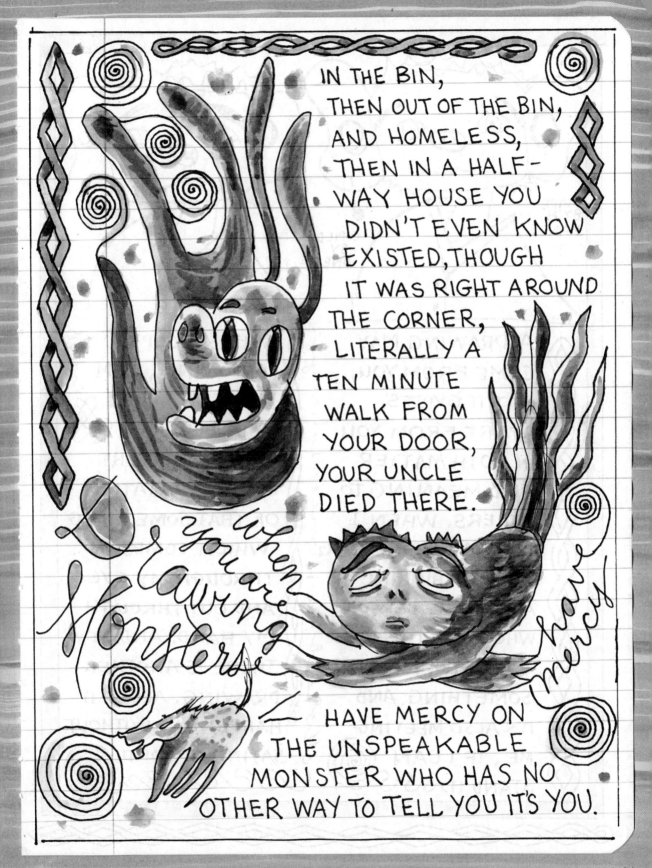

IN THE BIN,
THEN OUT OF THE BIN,
AND HOMELESS,
THEN IN A HALF-
WAY HOUSE YOU
DIDN'T EVEN KNOW
EXISTED, THOUGH
IT WAS RIGHT AROUND
THE CORNER,
LITERALLY A
TEN MINUTE
WALK FROM
YOUR DOOR,
YOUR UNCLE
DIED THERE.

When you are drawing Monsters
have mercy

HAVE MERCY ON
THE UNSPEAKABLE
MONSTER WHO HAS NO
OTHER WAY TO TELL YOU IT'S YOU.

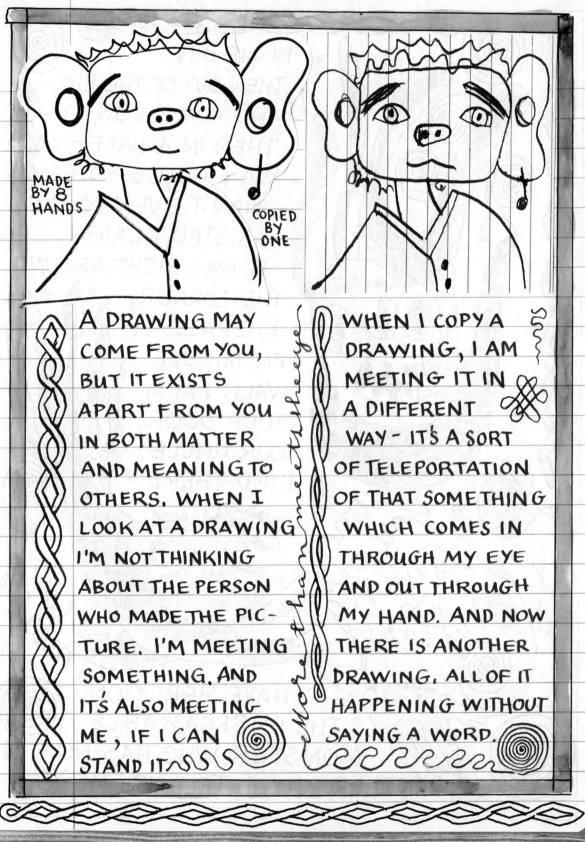

MADE BY 8 HANDS

COPIED BY ONE

A DRAWING MAY COME FROM YOU, BUT IT EXISTS APART FROM YOU IN BOTH MATTER AND MEANING TO OTHERS. WHEN I LOOK AT A DRAWING I'M NOT THINKING ABOUT THE PERSON WHO MADE THE PICTURE. I'M MEETING SOMETHING. AND IT'S ALSO MEETING ME, IF I CAN STAND IT.

WHEN I COPY A DRAWING, I AM MEETING IT IN A DIFFERENT WAY — IT'S A SORT OF TELEPORTATION OF THAT SOMETHING WHICH COMES IN THROUGH MY EYE AND OUT THROUGH MY HAND. AND NOW THERE IS ANOTHER DRAWING. ALL OF IT HAPPENING WITHOUT SAYING A WORD.

More than meets the eye

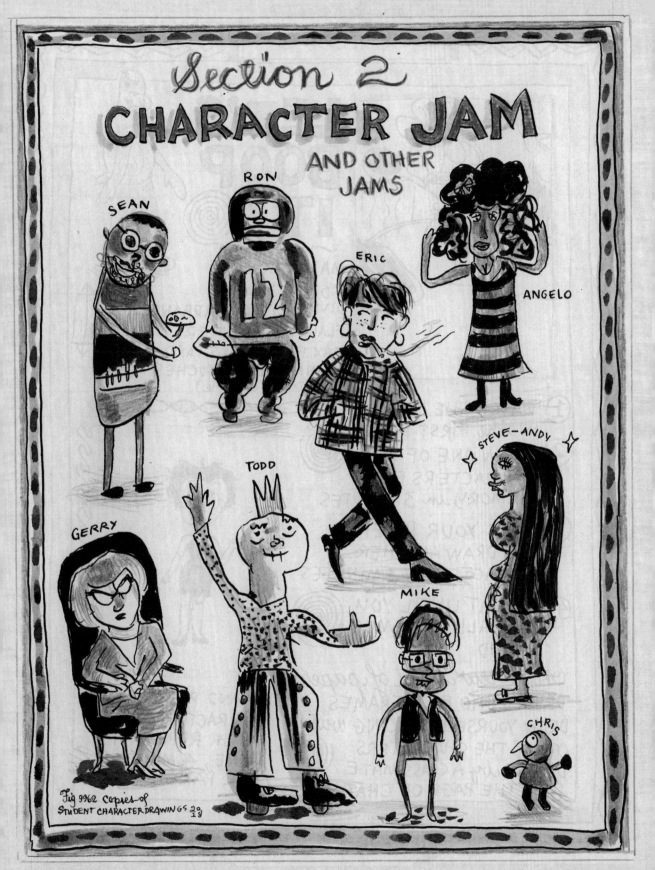

LET'S BOOP IT!

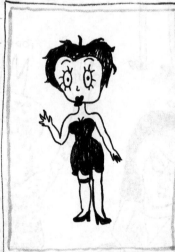

MATERIALS:
8.5" X 11" PAPER
DIVIDED INTO QUADRANTS
FLAIR PEN TIMER
MAX FLEISCHERS CARTOON
"MINNIE THE MOOCHER" (1931)
(easy to find on line)

① WATCH THE CARTOON, IN the FIRST PANEL

② DRAW ONE OF THE CHARACTERS FROM MEMORY in 3 MINUTES.

③ PASS YOUR PAPER AND DRAW ANOTHER CHARACTER IN 3 MINUTES.

④ REPEAT UNTIL YOU HAVE ALL 4 FRAMES FILLED.

On a new sheet of paper DIVIDED INTO FOUR FRAMES DRAW YOURSELF DANCING with one of THE CHARACTERS DRAWN by A CLASS MATE. PASS THE PAGE OF CHARACTERS → AND PICK A NEW CHARACTER TO DANCE WITH. REPEAT 'TIL DONE, 4 MINUTES PER PANEL

ABOUT 30 MINUTES

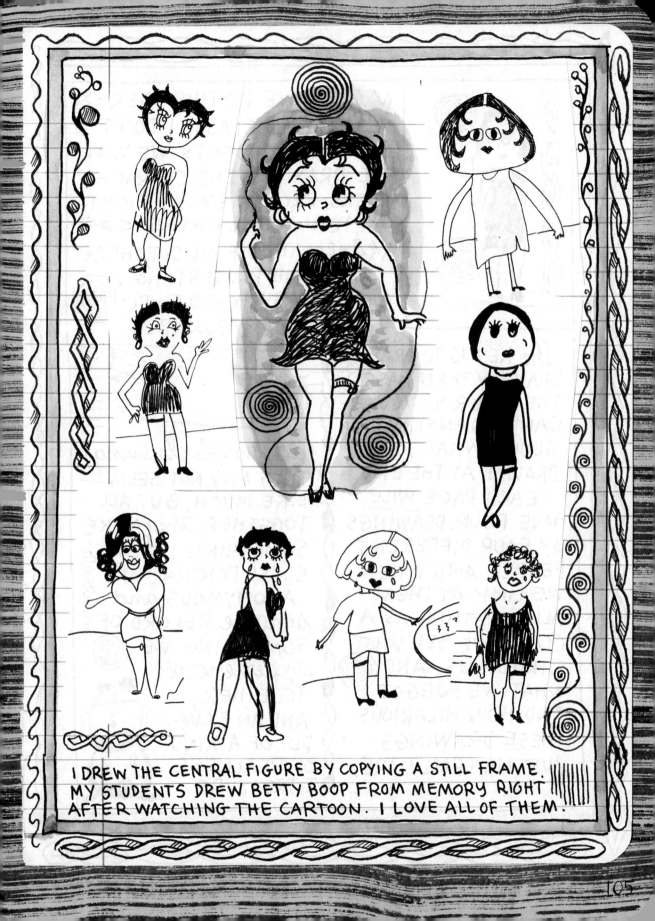

I DREW THE CENTRAL FIGURE BY COPYING A STILL FRAME.
MY STUDENTS DREW BETTY BOOP FROM MEMORY RIGHT
AFTER WATCHING THE CARTOON. I LOVE ALL OF THEM.

WHEN WE DO THIS EXER-CISE IN CLASS, I DON'T TELL MY STUDENTS WE WILL BE DRAWING THE CHARACTERS FROM MEMORY RIGHT AFTERWARD.

WHEN THEY FIND OUT, THERE IS SOME PROTEST. HOW ARE THEY SUPPOSED TO DO IT? IT SEEMS IMPOSSIBLE!

The KEY IS TO DRAW BRAVELY THEN PASS THE PAPER SO YOU CAN'T DO ANYTHING ABOUT WHAT YOU'VE DRAWN. AT THE END, EACH PAGE WILL HAVE FOUR DRAWINGS BY FOUR DIFFERENT PEOPLE AND WHEN WE LOOK AT THEM ALL TOGETHER AS A CLASS WE SEE WHAT STRUCK US, AND WHAT WE FORGOT, AND HOW HILARIOUS THESE DRAWINGS JUST NATURALLY ARE.

as single drawings THEY MAY NOT SEEM LIKE MUCH, BUT ALL TOGETHER they MAKE SOMETHING LIKE A CLASS PORTRAIT, AN ANONYMOUS and sincere RECORD OF SOMETHING WE experienced TOGETHER, AND AN EXAMPLE OF A KIND OF REALNESS I TREASURE.

WHOLE LIFE DIARY

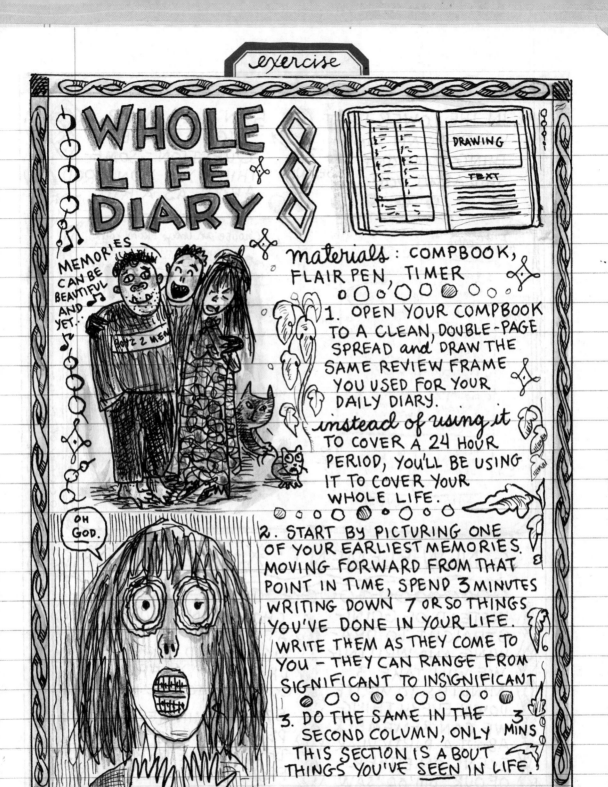

DRAWING

TEXT

MEMORIES CAN BE BEAUTIFUL AND YET...

materials: COMPBOOK, FLAIR PEN, TIMER

1. OPEN YOUR COMPBOOK TO A CLEAN, DOUBLE-PAGE SPREAD and DRAW THE SAME REVIEW FRAME YOU USED FOR YOUR DAILY DIARY. *instead of using it* TO COVER A 24 HOUR PERIOD, YOU'LL BE USING IT TO COVER YOUR WHOLE LIFE.

OH GOD.

2. START BY PICTURING ONE OF YOUR EARLIEST MEMORIES. MOVING FORWARD FROM THAT POINT IN TIME, SPEND 3 MINUTES WRITING DOWN 7 OR SO THINGS YOU'VE DONE IN YOUR LIFE. WRITE THEM AS THEY COME TO YOU - THEY CAN RANGE FROM SIGNIFICANT TO INSIGNIFICANT.

3. DO THE SAME IN THE SECOND COLUMN, ONLY 3 MINS THIS SECTION IS ABOUT THINGS YOU'VE <u>SEEN</u> IN LIFE.

about 45-MINS.

107

4. IN THE LOWER LEFT WRITE DOWN SOMETHING SOMEONE SAID ABOUT YOU ← 30 SECONDS →

5. IN THE LOWER RIGHT, WRITE A QUESTION - SOMETHING YOU WONDERED ABOUT AS A KID.

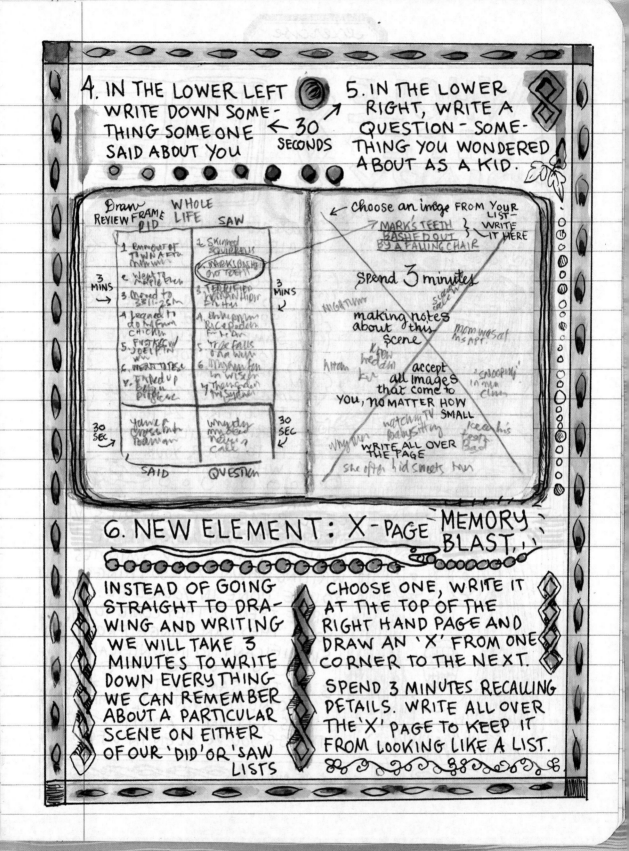

Draw
REVIEW | FRAME | WHOLE | DID | LIFE | SAW

3 MINS →

1. RAN OUT OF TOWN AFTER
2. WENT TO MAPLE FAIR
3. MOVED TO 38 11-25
4. LEARNED TO DO M FROM CHICKS
5. FIRST KISS W/ JOE IFFIN
6. WENT TO
7. FUCKED UP BABY IN DISTRESS

1. SKINNED SQUIRRELS
2. MARKS BASHED OUT TEETH
3. TERRIFIED WOMAN HIDIN IN HER
4. UNKNOWN RACE PEOPLE FOR LUNCH
5. TREE FALLS IN WILL
6. MAYHEM FUN IN WILSON
7. THE GARDEN MR SAGNER

30 SEC →

YOU'LL CROSS INTO INDIAN

WHY DID MY DAD NEVER CALL?

SAID | QUESTION

3 MINS

30 SEC

← Choose an image FROM YOUR LIST →

MARKS TEETH BASHED OUT BY A FALLING CHAIR } WRITE IT HERE

Spend 3 minutes making notes about this scene

accept all images that come to YOU, NO MATTER HOW SMALL

WRITE ALL OVER THE PAGE

mom was at his APT.

"SNOOPING" in my class

watching TV babysitting

keeping teeny bad

Why...

She often hid sweets from

6. NEW ELEMENT: X-PAGE MEMORY BLAST

INSTEAD OF GOING STRAIGHT TO DRAWING AND WRITING WE WILL TAKE 3 MINUTES TO WRITE DOWN EVERYTHING WE CAN REMEMBER ABOUT A PARTICULAR SCENE ON EITHER OF OUR 'DID' OR 'SAW' LISTS

CHOOSE ONE, WRITE IT AT THE TOP OF THE RIGHT HAND PAGE AND DRAW AN 'X' FROM ONE CORNER TO THE NEXT.

SPEND 3 MINUTES RECALLING DETAILS. WRITE ALL OVER THE 'X' PAGE TO KEEP IT FROM LOOKING LIKE A LIST.

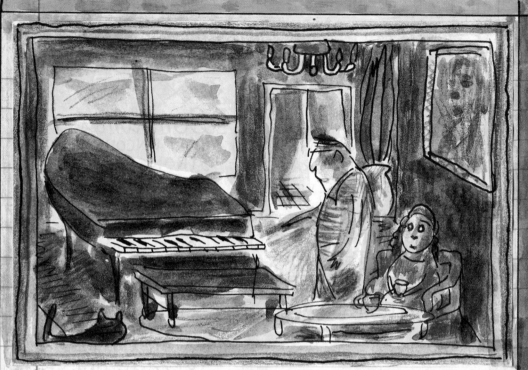

7. DRAW YOURSELF IN THIS SCENE. FIRST DRAW A FRAME THAT TAKES UP ABOUT HALF A COMPBOOK PAGE. INCLUDE YOUR WHOLE BODY AND SOME INDICATION OF SETTING. SPEND ABOUT 5 MINUTES. DRAW THE WHOLE TIME WITHOUT STOPPING.

8. GIVE THIS SCENE A TITLE AND THEN WRITE ABOUT IT FOR 7 MINUTES. START BY TELLING US WHERE YOU ARE AND WRITE IN THE FIRST PERSON, PRESENT TENSE. DON'T STOP WRITING UNTIL THE TIME IS UP. IF YOU GET STUCK, JUST WRITE "TICK, TICK, TICK" UNTIL THE STORY STARTS UP AGAIN.

READING ALOUD
IN CLASS

In this class WHEN WE ARE WRITING AUTOBIOGRAPHICAL STORIES, WE ARE ALWAYS FREE TO FICTIONALIZE PARTS. IN THE SAME WAY, WE ARE FREE TO ADD AUTOBIOGRAPHICAL ELEMENTS WHEN WE ARE WRITING FICTION.

WE MAY BEGIN A STORY FROM AN AUTOBIOGRAPHICAL DETAIL THAT SEEMS TO BECOME FICTION ON ITS OWN, OR A FICTIONAL STORY BECOMES SOMEHOW DEEPLY AUTOBIOGRAPHICAL.

I can say THAT EVERY COMIC MUST CONTAIN ELEMENTS OF BOTH, AND NATURALLY DOES. BOTH ARE AN IMPORTANT PRACTICE.

Sometimes we MAY ENCOUNTER STRONG FEELINGS AND UNEXPECTED MEMORIES. WE ARE FREE TO FOLLOW THEM OR TO TURN AWAY FROM THEM OR TO CHANGE THEM WITH FICTION.

Sometimes we BECOME UNEXPECTEDLY EMOTIONAL WHEN READING OUT LOUD. WE ARE ALWAYS FREE TO STOP OR TO HAVE SOMEONE READ IT FOR US. and unless SOMEONE ASKS, WE LET ANY CLASSMATE RECOVER ON THEIR OWN, ALLOWING THEM THE CHOICE OF PRIVACY IN THE PRESENCE OF CLASSMATES WHO LEND SILENT SUPPORT

DRAWN TOGETHER

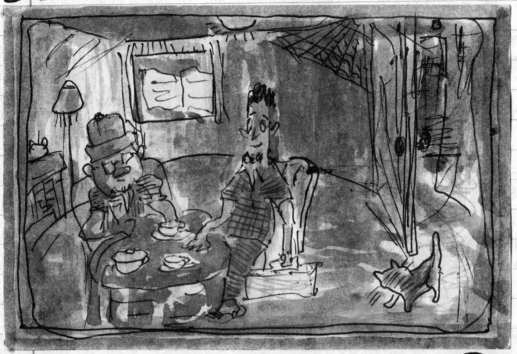

WHEN SOMEONE READS THEIR STORY, WE DRAW A TIGHT SPIRAL SLOWLY WHILE WE LISTEN. WE RESPOND BY DRAWING AN IMAGE FROM WHAT WE HEARD, INCLUDING THE FULL BODY OF AT LEAST ONE OF THE CHARACTERS. THESE 'RESPONSE DRAWINGS' ARE DONE IN THREE MINUTES ON INDEX CARDS.

They are SILENT DRAWINGS AND WE GIVE THEM TO THE READER AFTER WE ALL TAKE A LOOK AT THEM.

This is how WE 'TALK' ABOUT THE STORY TO THE READER AND OUR OTHER CLASSMATES AND ALSO TO OURSELVES.

THEY ARE SCENES
THAT MAKE ME
WONDER WHAT
IS GOING ON.
AND THERE IS
AN EMOTIONAL
'SOMETHING' THAT
IS KIND OF UN-
CLEAR. WHAT IS
CLEAR IS SOME-
THING IS GOING
ON THAT CHARGES
UP SOME SORT
OF STORY IN US.

SOMEHOW THESE DRAWINGS CARRY EMOTION. MY FRIEND DAN CHAON TOLD ME HE THINKS IMAGES DO THIS. THEY CARRY EMOTION THE WAY THE EARTH CARRIES ITS OWN WEATHER PATTERNS, ALWAYS IN MOTION, NEVER FIXED.

ANOTHER THING ABOUT AN IMAGE IS IT IS INDE-PENDENT OF WHAT IS SAID ABOUT IT. ITS MEANING CANNOT BE MORE THAN WHAT STARTS TO HAPPEN WHEN YOU REALLY TAKE A LOOK.

WHEN YOU PUT YOURSELF IN THE IMAGE YOU START TO GET A FEELING FOR WHAT MIGHT BE GOING ON - YET THE STORY THAT THIS DRAWING IS ABOUT DISAPPEARED YEARS AGO. *it doesn't matter.*

THE DRAWING COMMUNICATES WITH SOME PART OF US, *and* STORY-PATTERNS FORM, REGARDLESS.

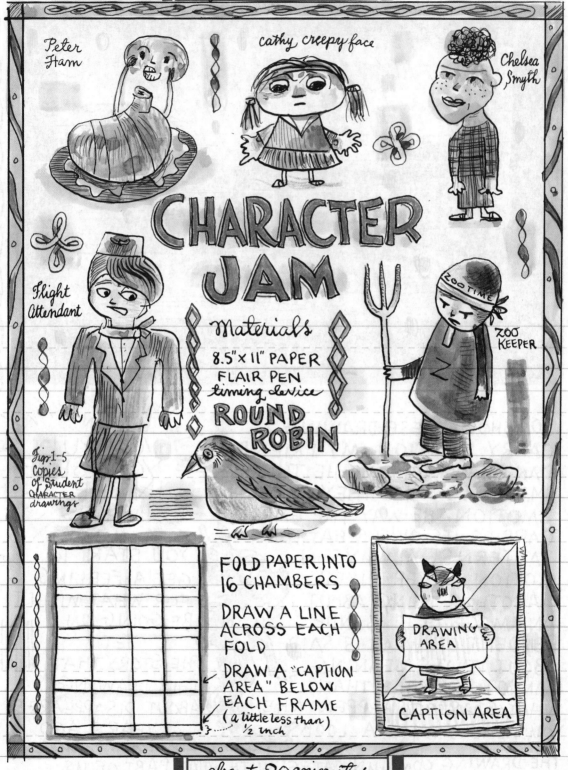

Peter Ham

cathy creepy face

Chelsea Smyth

Flight Attendant

CHARACTER JAM

Materials

8.5" × 11" PAPER
FLAIR PEN
timing device
ROUND ROBIN

Figs. 1-5
copies of Student CHARACTER drawings

ZOO TIME

ZOO KEEPER

FOLD PAPER INTO 16 CHAMBERS

DRAW A LINE ACROSS EACH FOLD

DRAW A "CAPTION AREA" BELOW EACH FRAME (a little less than) 1/2 inch

DRAWING AREA

CAPTION AREA

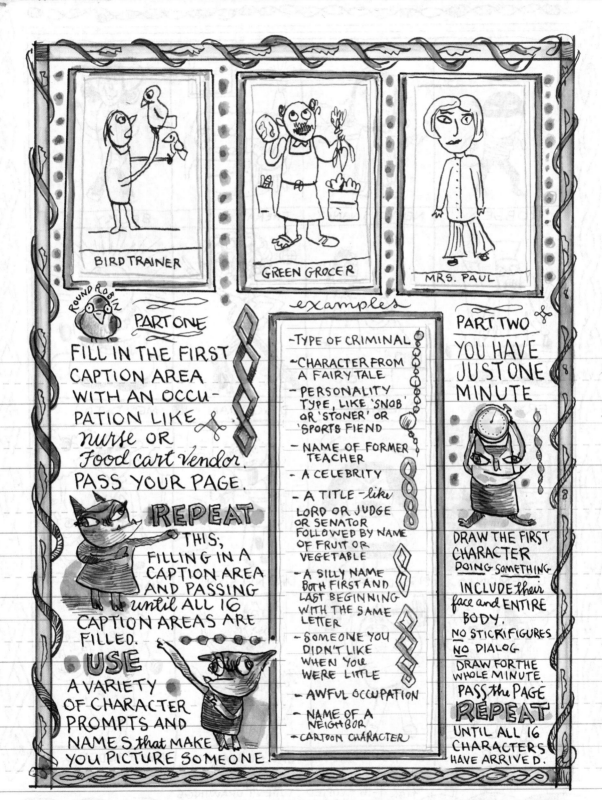

BIRD TRAINER

GREEN GROCER

MRS. PAUL

ROUND ROBIN

examples

PART ONE

FILL IN THE FIRST CAPTION AREA WITH AN OCCUPATION LIKE *nurse* OR *Food cart vendor.* PASS YOUR PAGE.

REPEAT THIS, FILLING IN A CAPTION AREA AND PASSING *until* ALL 16 CAPTION AREAS ARE FILLED.

USE A VARIETY OF CHARACTER PROMPTS AND NAMES *that* MAKE YOU PICTURE SOMEONE

- TYPE OF CRIMINAL
- CHARACTER FROM A FAIRY TALE
- PERSONALITY TYPE, LIKE 'SNOB' OR 'STONER' OR 'SPORTS FIEND'
- NAME OF FORMER TEACHER
- A CELEBRITY
- A TITLE — *like* LORD OR JUDGE OR SENATOR FOLLOWED BY NAME OF FRUIT OR VEGETABLE
- A SILLY NAME BOTH FIRST AND LAST BEGINNING WITH THE SAME LETTER
- SOMEONE YOU DIDN'T LIKE WHEN YOU WERE LITTLE
- AWFUL OCCUPATION
- NAME OF A NEIGHBOR
- CARTOON CHARACTER

PART TWO

YOU HAVE JUST ONE MINUTE

DRAW THE FIRST CHARACTER DOING SOMETHING INCLUDE *their* face *and* ENTIRE BODY. NO STICK FIGURES NO DIALOG DRAW FOR THE WHOLE MINUTE. PASS *the* PAGE **REPEAT** UNTIL ALL 16 CHARACTERS HAVE ARRIVED.

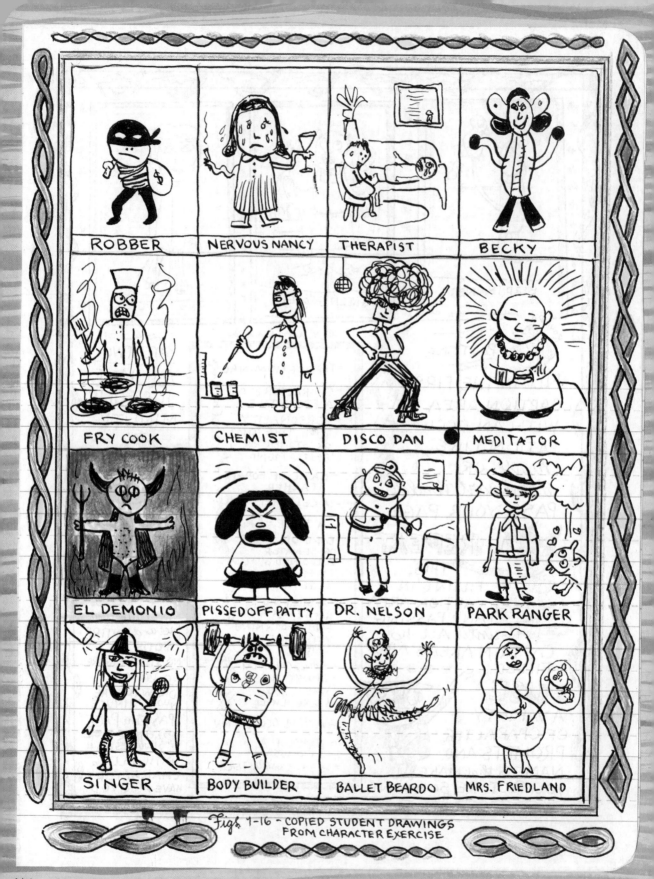

Figs 1–16 – COPIED STUDENT DRAWINGS FROM CHARACTER EXERCISE

The GANG is all HERE

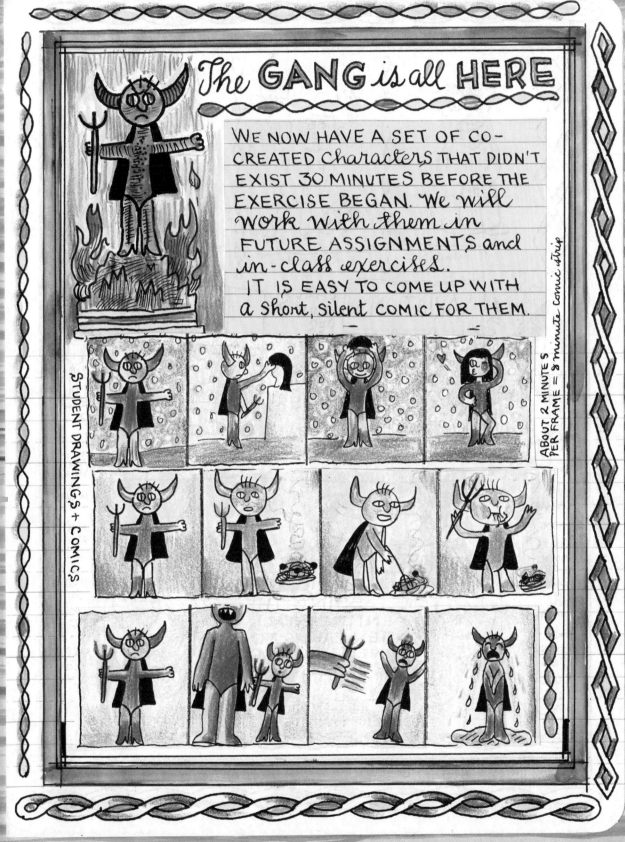

WE NOW HAVE A SET OF CO-CREATED characters, THAT DIDN'T EXIST 30 MINUTES BEFORE THE EXERCISE BEGAN. We will work with them in FUTURE ASSIGNMENTS and in-class exercises.
IT IS EASY TO COME UP WITH a short, silent COMIC FOR THEM.

STUDENT DRAWINGS + COMICS

ABOUT 2 MINUTES PER FRAME = 8 minute comic strip

117

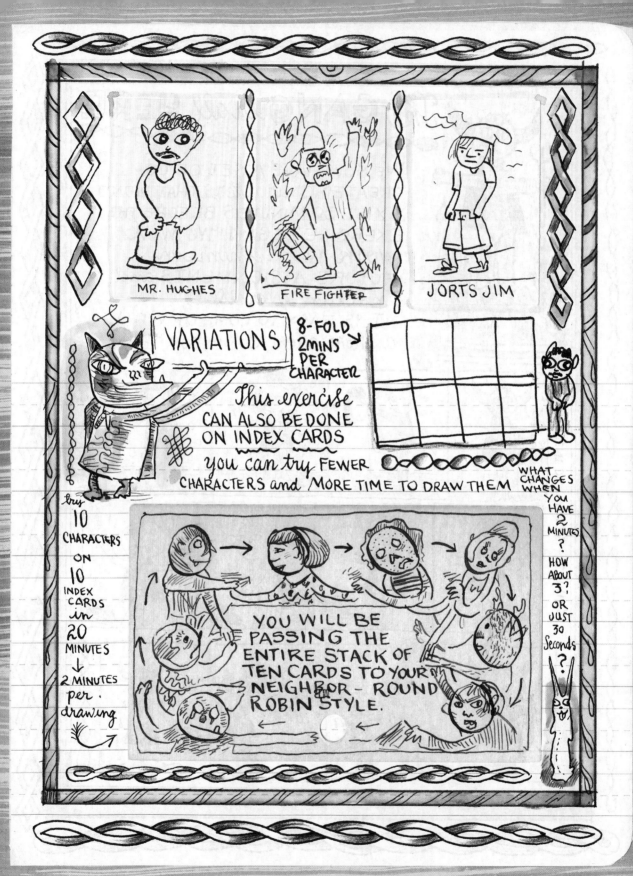

MR. HUGHES

FIRE FIGHTER

JORTS JIM

VARIATIONS

8-FOLD
2 MINS PER
CHARACTER

This exercise CAN ALSO BE DONE ON INDEX CARDS you can try FEWER CHARACTERS and MORE TIME TO DRAW THEM

WHAT CHANGES WHEN YOU HAVE 2 MINUTES? HOW ABOUT 3? OR JUST 30 Seconds?

try 10 CHARACTERS ON 10 INDEX CARDS in 20 MINUTES ↓ 2 MINUTES per drawing

YOU WILL BE PASSING THE ENTIRE STACK OF TEN CARDS TO YOUR NEIGHBOR - ROUND ROBIN STYLE.

Assignment

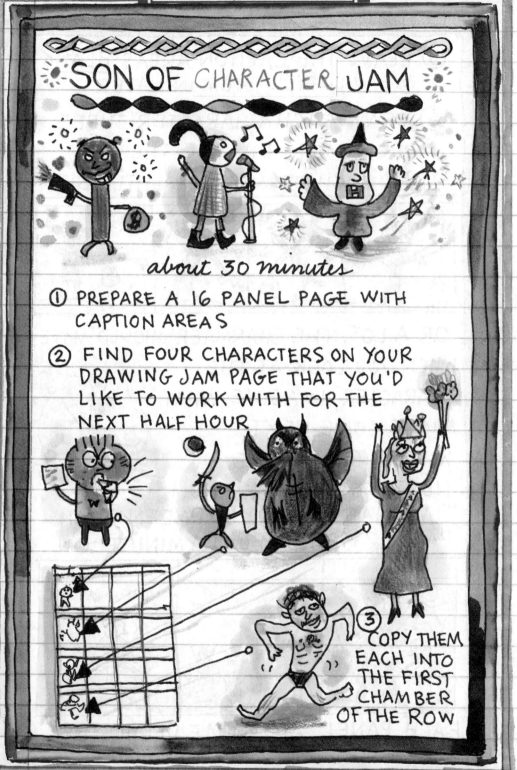

SON OF CHARACTER JAM

about 30 minutes

① PREPARE A 16 PANEL PAGE WITH CAPTION AREAS

② FIND FOUR CHARACTERS ON YOUR DRAWING JAM PAGE THAT YOU'D LIKE TO WORK WITH FOR THE NEXT HALF HOUR

③ COPY THEM EACH INTO THE FIRST CHAMBER OF THE ROW

⑤ LEAVE THE CAPTION AREAS <u>BLANK</u>
WE WILL FILL THEM IN LATER

⑥ DRAW EACH CHARACTER THREE
MORE TIMES, FILLING THE ROW.
VARY EACH DRAWING A LITTLE BIT

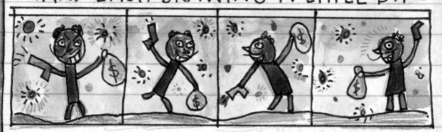

OR A LOT. THE CHARACTER SHOULD "MOVE".
WHEN YOU LOOK AT THE
CHARACTER, IMAGINE WHAT
MIGHT COME NEXT...
WHAT MIGHT BE THE
NEXT MOVE? HOW MUCH
TIME HAS PASSED BETWEEN EACH
PANEL? SPEND ABOUT A MINUTE ON

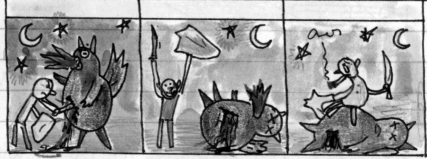

EACH PANEL. ADD SOME DETAILS TOO.

MAKE SOMETHING HAPPEN!

SETTINGS

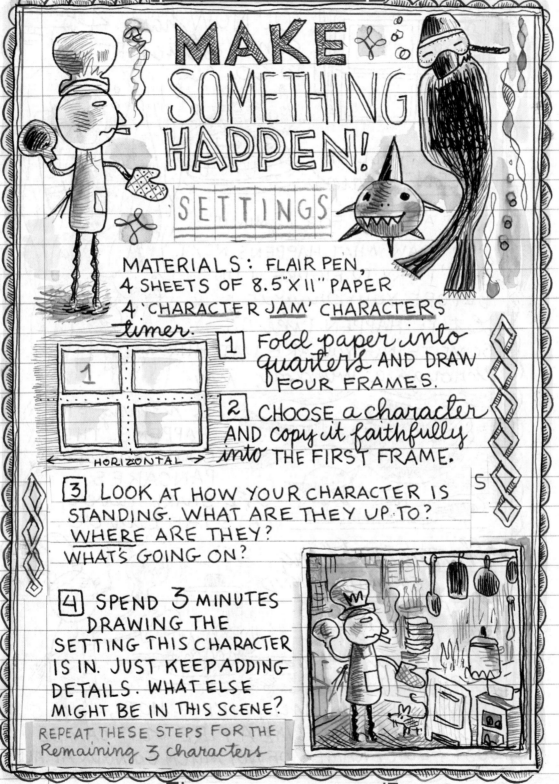

MATERIALS: FLAIR PEN, 4 SHEETS OF 8.5"X 11" PAPER 4 'CHARACTER JAM' CHARACTERS timer.

1. Fold paper into quarters AND DRAW FOUR FRAMES.

2. CHOOSE a character AND copy it faithfully into THE FIRST FRAME.

← HORIZONTAL →

3. LOOK AT HOW YOUR CHARACTER IS STANDING. WHAT ARE THEY UP TO? WHERE ARE THEY? WHAT'S GOING ON?

4. SPEND 3 MINUTES DRAWING THE SETTING THIS CHARACTER IS IN. JUST KEEP ADDING DETAILS. WHAT ELSE MIGHT BE IN THIS SCENE?

REPEAT THESE STEPS FOR THE Remaining 3 characters

ABOUT 90 MINUTES

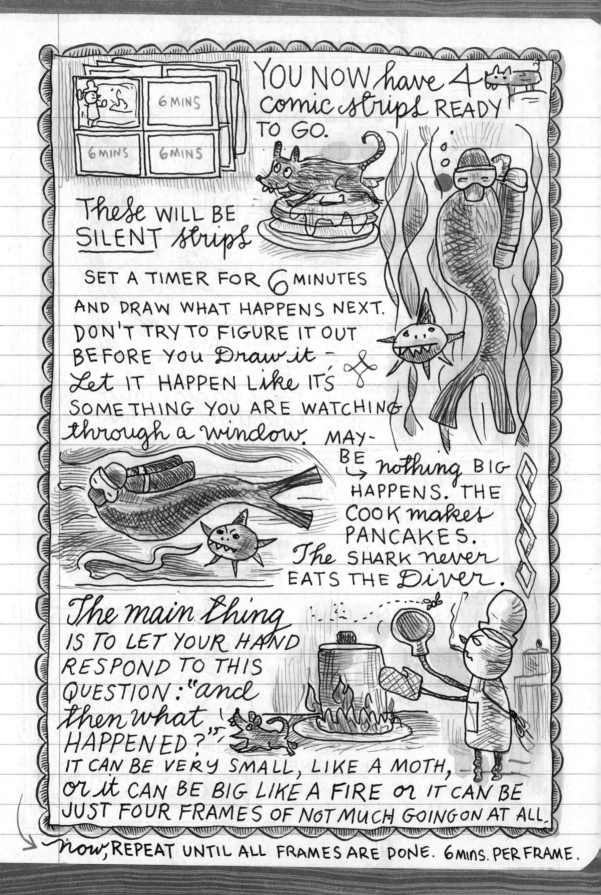

YOU NOW have 4 comic strips READY TO GO.

6 MINS | 6 MINS
6 MINS | 6 MINS

These WILL BE SILENT strips

SET A TIMER FOR 6 MINUTES AND DRAW WHAT HAPPENS NEXT. DON'T TRY TO FIGURE IT OUT BEFORE YOU Draw it — Let IT HAPPEN LiKE IT'S SOMETHING YOU ARE WATCHING through a window. MAY-BE → nothing BIG HAPPENS. THE COOK makes PANCAKES. The SHARK never EATS THE Diver.

The main thing IS TO LET YOUR HAND RESPOND TO THIS QUESTION: "and then what HAPPENED?" IT CAN BE VERY SMALL, LIKE A MOTH, or it CAN BE BIG LIKE A FIRE or IT CAN BE JUST FOUR FRAMES OF NOT MUCH GOING ON AT ALL.

now, REPEAT UNTIL ALL FRAMES ARE DONE. 6 MINS. PER FRAME.

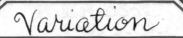

Variation

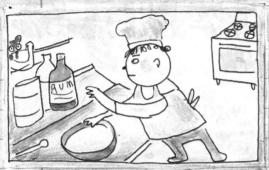
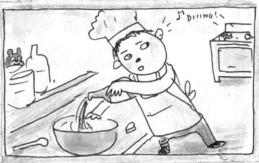
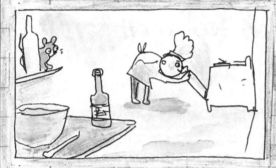

THIS CAN ALSO BE DONE AS A *six* PANEL STRIP. *In this* EXERCISE THERE *is* NO *dialog.* THE 'STORY' COMES ABOUT BY JUST DRAWING WHAT MIGHT *happen* NEXT. THE AIM IS TO JUST FOLLOW YOUR INCLINATION.

The STORY MAY *not* GO ANYWHERE BIG. *For now* JUST ALLOW *it* TO UNFOLD *in* AN UNPLANNED WAY, *sticking to the time* LIMITS AND SEEING WHAT HAPPENS. *If there* IS NO 'PUNCHLINE" DON'T WORRY FOR NOW.

BASIC 4 PANELS

"Those phenomena with which
We have no affinity and which
we are not in some sense ready
to see are often not seen at all"

Th. Kuhn

a note I've carried for years

I've always wondered about the FOUR PANEL STRUCTURE OF comics. Stories AND jokes use A THREE BEAT: Beginning, Middle, End. COMICS use AN ADDITIONAL UNNAMED beat -- the BEAT between beats drummers call THE POCKET. Its a good idea to make 12 minute FOUR PANEL COMICS EVERY -- DAY FOR awhile -- silent ones FEATURING ENTIRE BODIES. Do these in YOUR compbook. START by DRAWING A character -- human, ANIMAL, vegetable, IMAGINARY -- IN A SCENE that SHOWS them ENGAGED in THEIR DAY to DAY LIVES. Then WHAT HAPPENS? AFTER a WEEK or so YOU WILL have AN AFFINITY FOR 4 PANEL BEAT

ABOUT 15 MINS PerDAY

TODAY'S DATE

3 MINUTE "MEMORY BLAST ABOUT THE LAST 24 HOURS.

WHERE WERE YOU?

WHAT WERE YOU DOING?

WHO DID YOU SEE?

WHAT DID YOU WANT?

WHAT FRUSTRATED YOU?

WHAT WAS UNEXPECTED?

Scene 1	Scene 2
Scene 3	Scene 4

FOUR BOX DIARY

1. DRAW AN "X" ON the left SIDE OF A DOUBLE PAGE SPREAD in YOUR compbook DRAW A FOUR FRAME outline on the RIGHT SIDE

2. SET a timer FOR 3 MINUTES AND DO A memory blast ABOUT THE LAST 24 HOURS. Let ONE THOUGHT lead TO THE NEXT. THINK ABOUT IMAGES AS A SCENE

3. PICK A SCENE FROM YESTERDAY AND DRAW YOURSELF IN IT. INCLUDE YOUR WHOLE BODY. THIS IS A 'SILENT' PANEL. DON'T HESITATE TO USE THE IVAN BRUNETTI STYLE WHEN YOU FEEL STUCK. ③ MINUTES

④ AND THEN WHAT HAPPENED? this can be in the same scene OR A DIFFERENT SCENE
⑤ REPEAT 2 MORE TIMES

ABOUT 20 MINUTES

Diary Variation

TODAY'S DATE

IM ON THE COUCH. IT'S 4AM
AND I COULDN'T FALL BACK TO
SLEEP SO I'M READING A BOOK
I LOST TWO YEARS AGO AND
JUST FOUND. THE BOOKMARK
IS A BOARDING PASS — A
FLIGHT TO CLEVELAND.
I PICK UP WHERE I LEFT
OFF AND THE STORY STARTS
UP AGAIN LIKE NO TIME PASSED

SISTER IMAGE Diary

1. DRAW TWO FULL PAGE FRAMES ON A
CLEAN SPREAD IN YOUR COMP BOOK.
DIVIDE THE FRAMES IN HALF SO
YOU HAVE FOUR SECTIONS YOU'LL
BE SPENDING AT LEAST ⑤ MINUTES
ON EACH SECTION.

2. IN THE TOP LEFT FRAME, DRAW YOUR
WHOLE SELF ENGAGED IN DOING
SOMETHING YOU DID THE DAY BEFORE.

3. BELOW THE PICTURE, WRITE ABOUT WHAT
IS HAPPENING IN THE FIRST PERSON, PRESENT
TENSE.

ABOUT 20 MINUTES

TODAY'S DATE

I'M ON THE COUCH. IT'S 4AM AND I COULDN'T FALL BACK TO SLEEP SO I'M READING A BOOK I LOST TWO YEARS AGO AND JUST FOUND. THE BOOKMARK IS A BOARDING PASS — A FLIGHT TO CLEVELAND. I PICK UP WHERE I LEFT OFF AND THE STORY STARTS UP AGAIN LIKE NO TIME PASSED

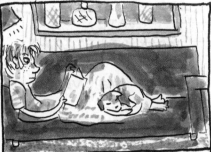

SUMMER 1967

I'M ON THE COUCH WITH MY DOG AND MY BOOK AND THE HOUSE — SOMEHOW — IS QUIET. THE TV IS OFF, BROTHERS ARE OUTSIDE, MOM AT WORK — GRANDMA AT UNCLE DICK'S, — DAD GONE. I'M READING AND LOVING THIS SITUATION, WISHING I COULD HAVE IT WHENEVER I WANTED. MY MOM WOULDN'T ALLOW THIS IF SHE WERE HOME. SHE'D SHOUT, "LAZY!"

④ IN THE UPPER RIGHT FRAME, DRAW YOURSELF AS A KID IN THE SAME POSE. AS YOU DRAW, IMAGINE SOMETHING YOU DID WHEN YOU WERE YOUNG THAT INVOLVED THIS SAME POSE. LET IT COME TO YOU. DRAW THE SETTING.

⑤ WRITE THE SCENE UP LIKE IT'S HAPPENING RIGHT NOW. BE SURE TO INCLUDE WHERE THIS SCENE IS TAKING PLACE. WHEN YOU FINISH, ADD THE SEASON AND APPROXIMATE YEAR AT THE TOP OF THE PAGE.

Remember

SET PHONE TO AIRPLANE MODE BEFORE YOU BEGIN.

THIS IS A SILENT STRIP — NO WORDS IN THE PICTURE FRAME.

DRAW YOUR WHOLE BODY AND FACE.

Keep your pen moving.

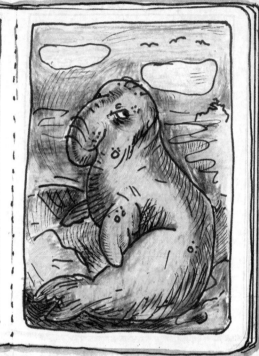

> ⟨DATE⟩
> TODAY I TRIED TO LIS-
> TEN TO "THE END OF
> THE AFFAIR" BUT I
> COULDN'T EVEN MAKE
> IT TO THE MIDDLE OF
> THE AFFAIR, THE
> READER WAS SO BAD.

ANIMAL DIARY

COPY OF student DRAWING

5 MINUTES

1. ON THE LEFT HAND PAGE, SPEND <u>FIVE MINUTES</u> WRITING ABOUT WHAT IS ON YOUR MIND. WRITE IN ALL CAPITAL LETTERS AND SKIP A LINE AS YOU GO SO YOUR PAGE IS "DOUBLE SPACED.

15 MINUTES

2. ON THE RIGHT SIDE, DRAW SOME SORT OF WILD OR EXOTIC ANIMAL IN A SETTING. THIS IS A SILENT DRAWING. <u>NO WORDS</u>

3. COLOR THE PICTURE USING CRAYONS AND/OR COLOR PENCILS <u>NO MARKERS</u>

HINT: CHOOSING AN ANIMAL YOU DON'T QUITE KNOW HOW TO DRAW YEILDS BEST RESULTS.

ABOUT 20 MINUTES

ANIMAL AD LIB

AFTER YOU'VE KEPT YOUR ANIMAL DIARY
FOR A WEEK, YOU WILL HAVE WHAT YOU NEED---

COPIES OF STUDENT DRAWINGS AND SENTENCES

make a SIX PANEL comic by re-
drawing YOUR DIARY ANIMALS saying
THE FIRST sentence OF the WRITTEN PART
of that days DIARY. Work FAST. 5 mins
per panel

about 30 mins

129

YOU SEE IT WHEN IT SEES YOU

MATERIALS:
PAPER OR COMPBOOK
DRAWING UTENSIL
OBJECT YOU WANT TO
DRAW (TOYS WORK WELL
FOR THIS EXERCISE)
TIMING DEVICE

THIS EXERCISE PLAYS
WITH SHIFTING POINTS
OF VIEW FROM REAL
EYES TO MIND'S EYE
AND FROM REAL WORLD
TO IMAGINARY WORLD.

SPEND FIVE
MINUTES
DRAWING
THE OBJECT
HERE.
PRETEND
IT CAN
SEE YOU AND
IS VERY AWARE
OF YOU.

WRITE ABOUT
THE OBJECT
HERE.
3 MINS
DRAW
5 MINS
DRAW
5 MINS
OBJECT
WRITES
ABOUT YOU
HERE
3 MINS

SPEND FIVE
MINUTES
DRAWING
YOURSELF
FROM THE
OBJECT'S
POINT OF
VIEW. WHAT
DOES IT
SEE?

SOMETIMES JUST PRETENDING
THE OBJECT YOU ARE DRAWING
IS WATCHING YOU BACK CAN
CHANGE YOUR AWARENESS
AS YOU DRAW AND SOMETHING
LIKE A PORTRAIT BEGINS TO
APPEAR THAT CONTAINS AN
ODD REFLECTION OF YOU
SEEING IT AS IT IS SEEING YOU.

NOT QUITE 20 MINS

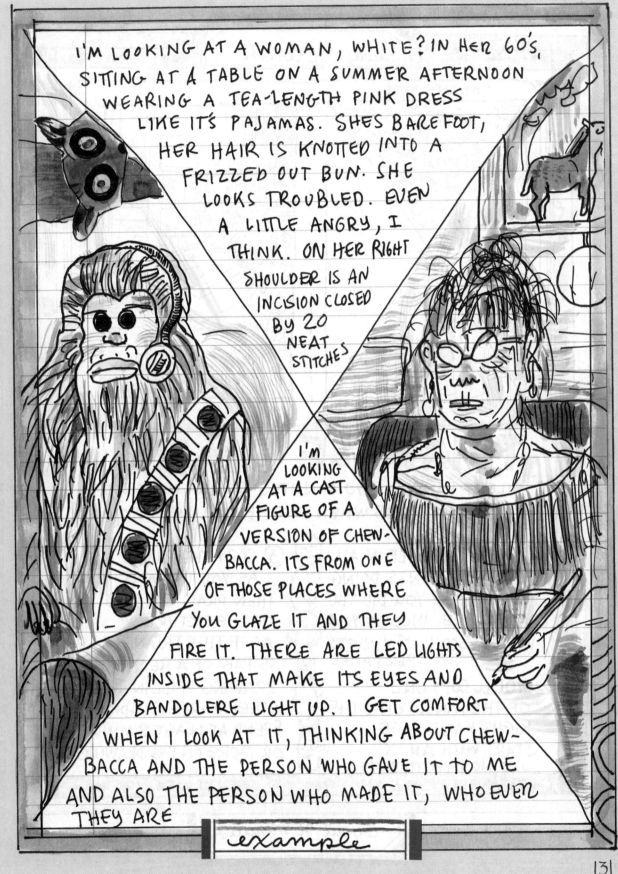

I'M LOOKING AT A WOMAN, WHITE? IN HER 60'S, SITTING AT A TABLE ON A SUMMER AFTERNOON WEARING A TEA-LENGTH PINK DRESS LIKE IT'S PAJAMAS. SHE'S BAREFOOT, HER HAIR IS KNOTTED INTO A FRIZZED OUT BUN. SHE LOOKS TROUBLED. EVEN A LITTLE ANGRY, I THINK. ON HER RIGHT SHOULDER IS AN INCISION CLOSED BY 20 NEAT STITCHES

I'M LOOKING AT A CAST FIGURE OF A VERSION OF CHEW-BACCA. ITS FROM ONE OF THOSE PLACES WHERE YOU GLAZE IT AND THEY FIRE IT. THERE ARE LED LIGHTS INSIDE THAT MAKE ITS EYES AND BANDOLERE LIGHT UP. I GET COMFORT WHEN I LOOK AT IT, THINKING ABOUT CHEW-BACCA AND THE PERSON WHO GAVE IT TO ME AND ALSO THE PERSON WHO MADE IT, WHOEVER THEY ARE

example

131

TODAY'S DATE

TRIANGLE DIARY

SILENT PANELS - 40 MINUTES TOTAL - WHOLE BODY
→ WHAT HAPPENS WHEN THE 'PANEL' ISN'T SQUARE?

① DRAW YOURSELF IN ALL FOUR QUADRANTS DOING FOUR THINGS YOU DID THE DAY BEFORE. INCLUDE YOUR WHOLE BODY. 5 MINUTES PER PANEL

② YOU'LL COPY ONE OF THE PANELS ONTO THE RIGHT HAND PAGE. START WITH AN 'X' USE NON-PHOTO BLUE.

③ COPY THE PANEL AS YOU DREW IT — THEN DRAW 'THE REST OF THE PICTURE' — AS IF THIS TRIANGLE IS PART OF A RECTANGULAR DRAWING. FILL IN THE OTHER THREE QUADRANTS. SPEND AT LEAST 8 MINUTES OR MORE ON THIS DRAWING.

about 40 minutes

CHECKER DIARY

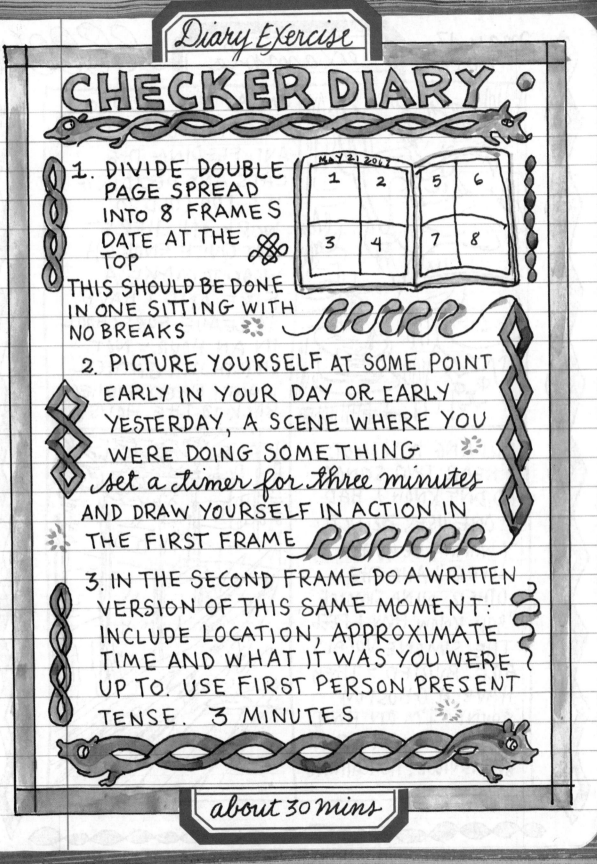

1. DIVIDE DOUBLE PAGE SPREAD INTO 8 FRAMES DATE AT THE TOP

MAY 21 2007

| 1 | 2 | 5 | 6 |
| 3 | 4 | 7 | 8 |

THIS SHOULD BE DONE IN ONE SITTING WITH NO BREAKS

2. PICTURE YOURSELF AT SOME POINT EARLY IN YOUR DAY OR EARLY YESTERDAY, A SCENE WHERE YOU WERE DOING SOMETHING *set a timer for three minutes* AND DRAW YOURSELF IN ACTION IN THE FIRST FRAME

3. IN THE SECOND FRAME DO A WRITTEN VERSION OF THIS SAME MOMENT: INCLUDE LOCATION, APPROXIMATE TIME AND WHAT IT WAS YOU WERE UP TO. USE FIRST PERSON PRESENT TENSE. 3 MINUTES

about 30 mins

example

I'M AT THE STUDIO WATERING MY PLANTS AND FEEDING THE CATS AND DECIDING IT'S TOO COLD TO WORK IN HERE- NOT QUITE ENOUGH WOOD TO MAKE A FIRE AND I HAVE TO LEAVE FOR SCHOOL IN AN HOUR- NOT WORTH IT. I GATHER WHAT I NEED AND HEAD BACK TO THE HOUSE

DRIVING TO SCHOOL I HEAR TWO SONGS I DIDN'T KNOW I HAD - ONE USES PRINCE: "I WANNA BE YOUR LOVER" AND THE OTHER NINA SIMONE "YOU KNOW HOW I FEEL." THE SIMONE VOCALS ARE BURIED - THEY HAVE A GHOSTLY SOUND. I'M ON HWY 273, COMING INTO EVANSVILLE. ITS RAINING

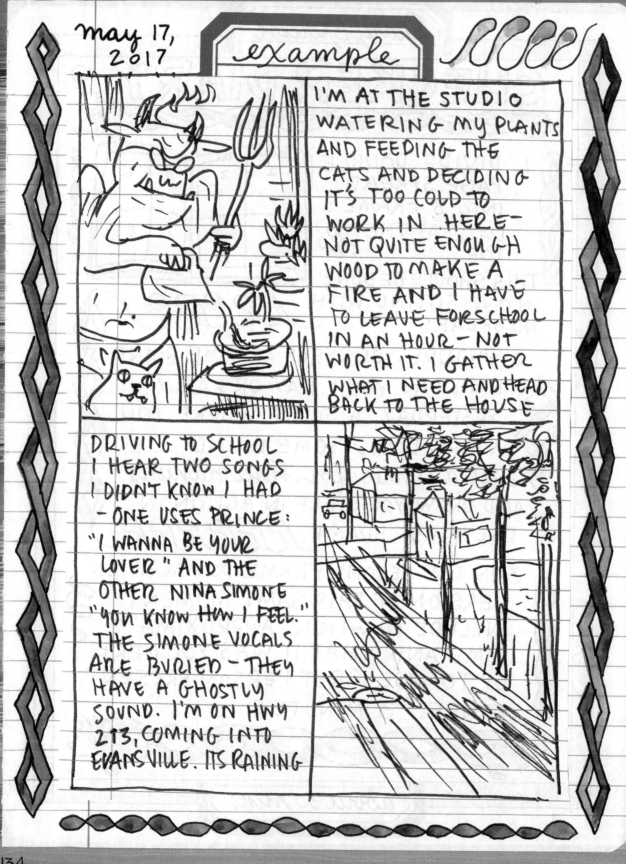

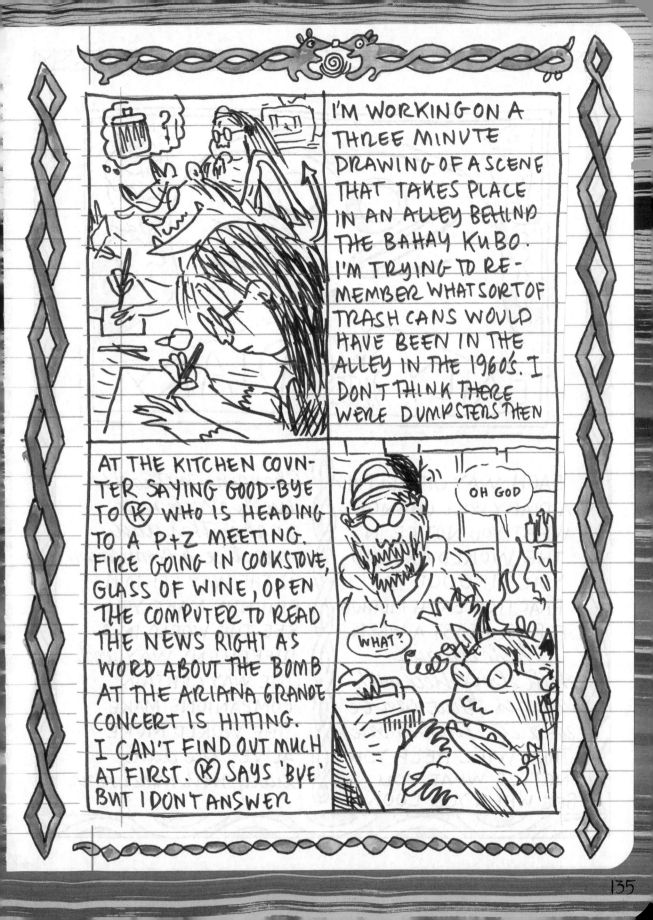

I'M WORKING ON A THREE MINUTE DRAWING OF A SCENE THAT TAKES PLACE IN AN ALLEY BEHIND THE BAHAY KUBO. I'M TRYING TO RE-MEMBER WHAT SORT OF TRASH CANS WOULD HAVE BEEN IN THE ALLEY IN THE 1960'S. I DON'T THINK THERE WERE DUMPSTERS THEN

AT THE KITCHEN COUN-TER SAYING GOOD-BYE TO Ⓚ WHO IS HEADING TO A P+Z MEETING. FIRE GOING IN COOKSTOVE, GLASS OF WINE, OPEN THE COMPUTER TO READ THE NEWS RIGHT AS WORD ABOUT THE BOMB AT THE ARIANA GRANDE CONCERT IS HITTING. I CAN'T FIND OUT MUCH AT FIRST. Ⓚ SAYS 'BYE' BUT I DON'T ANSWER

OH GOD

WHAT?

DAILY **20 MINUTES a day** DIARY

EACH WAY OF KEEPING
A DIARY WILL CHANGE
WHAT YOU NOTICE IN
THE WORLD AROUND
YOU. IT'S GOOD TO
PRACTICE EACH METHOD
FOR AT LEAST A WEEK.
These diaries
will be filled with
images that can be
used to find stories.
THEY WILL HELP YOU
NOTICE WHAT YOU
SEE WHEN YOU LOOK

Changing methods
every week will
make this daily
practice a companion.
IN THE WAY CERTAIN
FRIENDS MAKE YOU
SEE THE WORLD IN A
DIFFERENT WAY, *and*
THE WAY CERTAIN
COMPANIONS MAKE
THE WORLD MORE
ALIVE, *the daily*
diary will wake you up.

Come to Me

STUDENT DRAWING RESCUED FROM THE TRASH

STORY TIME

Come to Me

Come to Me

DRAW ME A STORY

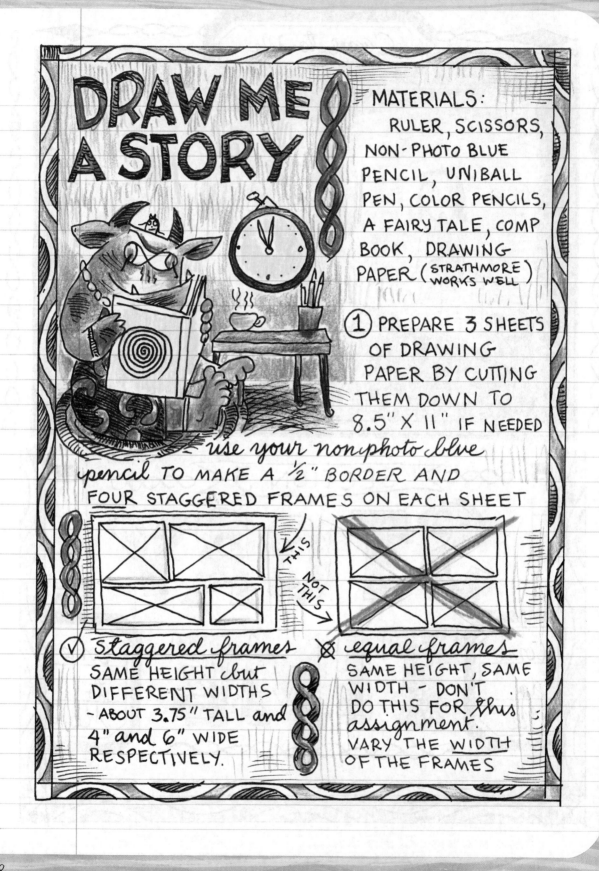

MATERIALS:
RULER, SCISSORS, NON-PHOTO BLUE PENCIL, UNIBALL PEN, COLOR PENCILS, A FAIRY TALE, COMP BOOK, DRAWING PAPER (STRATHMORE) WORKS WELL

① PREPARE 3 SHEETS OF DRAWING PAPER BY CUTTING THEM DOWN TO 8.5" X 11" IF NEEDED

use your non photo blue pencil TO MAKE A ½" BORDER AND FOUR STAGGERED FRAMES ON EACH SHEET

→ THIS

NOT THIS →

✓ staggered frames
SAME HEIGHT but DIFFERENT WIDTHS - ABOUT 3.75" TALL and 4" and 6" WIDE RESPECTIVELY.

✗ equal frames
SAME HEIGHT, SAME WIDTH - DON'T DO THIS FOR this assignment. VARY THE WIDTH OF THE FRAMES

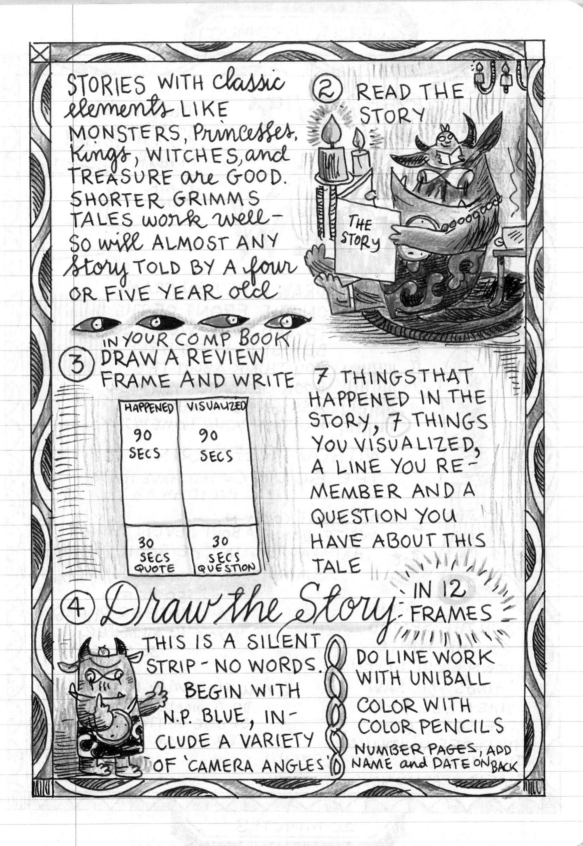

STORIES WITH *classic elements* LIKE MONSTERS, *Princesses*, *Kings*, WITCHES, and TREASURE are GOOD. SHORTER GRIMMS TALES *work well* — SO *will* ALMOST ANY *story* TOLD BY A *four* OR FIVE YEAR *old*

② READ THE STORY

THE STORY

③ IN YOUR COMP BOOK DRAW A REVIEW FRAME AND WRITE

HAPPENED	VISUALIZED
90 SECS	90 SECS
30 SECS QUOTE	30 SECS QUESTION

7 THINGS THAT HAPPENED IN THE STORY, 7 THINGS YOU VISUALIZED, A LINE YOU RE-MEMBER AND A QUESTION YOU HAVE ABOUT THIS TALE

④ *Draw the Story* IN 12 FRAMES

THIS IS A SILENT STRIP - NO WORDS. BEGIN WITH N.P. BLUE, IN-CLUDE A VARIETY OF 'CAMERA ANGLES'

DO LINE WORK WITH UNIBALL

COLOR WITH COLOR PENCILS

NUMBER PAGES, ADD NAME and DATE ON BACK

INSTANT BOOK REVIEW

materials
PAPER
8.5 x 11" folded
in half

FLAIR
PEN.

1. DRAW A 'REVIEW FRAME' ON THE FRONT OF THE FOLDED PAGE. WE WILL BE USING IT TO HELP YOU THINK ABOUT THE BOOK OF COMICS YOU WERE ASSIGNED TO READ AS PART OF YOUR HOMEWORK

WITHOUT REFERRING TO THE BOOK (IF YOU HAVE IT OUT, PUT IT AWAY)

2. IN THE FIRST COLUMN, WRITE DOWN ABOUT SEVEN THINGS THAT HAPPEN IN THE BOOK — 3 MINUTES

3. IN THE SECOND COLUMN, WRITE DOWN ABOUT SEVEN THINGS YOU 'SAW' WHEN YOU READ THE BOOK. (THIS INCLUDES ANYTHING THAT HAPPENS "OFF SCREEN" THAT YOU SAW IN YOUR MIND'S EYE. 3 MINS.

4. LOWER LEFT: A QUOTE OR PHRASE YOU REMEMBER 30 SECS

5. new element: LOWER RIGHT DO A SMALL DRAWING OF ONE OF THE CHARACTERS FROM MEMORY 30 SECS.

20 MINUTES

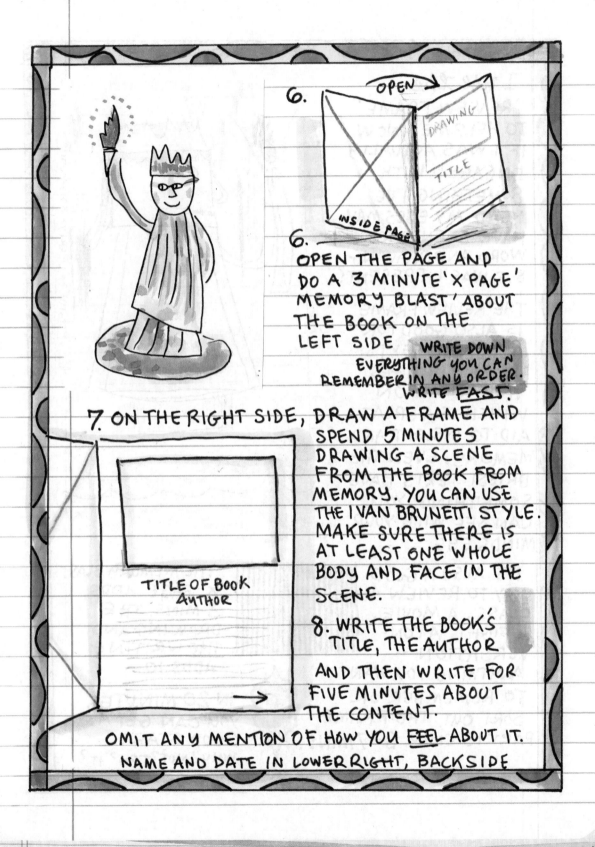

6.

OPEN ⟶

DRAWING

TITLE

INSIDE PAGE

6.
OPEN THE PAGE AND
DO A 3 MINUTE 'X PAGE'
MEMORY BLAST' ABOUT
THE BOOK ON THE
LEFT SIDE WRITE DOWN
EVERYTHING YOU CAN
REMEMBER IN ANY ORDER.
WRITE FAST.

7. ON THE RIGHT SIDE, DRAW A FRAME AND
SPEND 5 MINUTES
DRAWING A SCENE
FROM THE BOOK FROM
MEMORY. YOU CAN USE
THE IVAN BRUNETTI STYLE.
MAKE SURE THERE IS
AT LEAST ONE WHOLE
BODY AND FACE IN THE
SCENE.

TITLE OF BOOK
AUTHOR

8. WRITE THE BOOK'S
TITLE, THE AUTHOR

AND THEN WRITE FOR
FIVE MINUTES ABOUT
THE CONTENT.

OMIT ANY MENTION OF HOW YOU FEEL ABOUT IT.

NAME AND DATE IN LOWER RIGHT, BACKSIDE

I use the "REVIEW FRAME" TO HELP ME KNOW IF I WAS ACTUALLY ENGAGED WITH SOMETHING I'VE READ. MY EYES MAY HAVE SEEN EACH WORD AND DRAWING BUT WAS I PRESENT?

THE REVIEW FRAME IS ALSO GOOD FOR ACADEMIC TEXTS. IT ENCOURAGES VISUALIZATION WHICH IS A GREAT AID TO INSIGHT AND MEMORY. EVEN THE DRIEST TEXTS HAVE SOMETHING YOU CAN SEE WITH YOUR MIND'S EYE.

student drawing - STATUE OF LIBERTY - 30 seconds

IT'S ALSO A GOOD WAY TO REVIEW A CLASS, A MOVIE, A FIGHT, A CONVERSATION — ANYTHING YOU WANT TO REMEMBER OR SORT OUT. THE FRAME PART IS ONLY 6-7 MINS.

THE MEMORY BLAST X-PAGE ADDS 3 MINS. THE DRAWING AND THE WRITING ADDS 10.

IN 20 MINUTES YOU CAN GET A GOOD START. WHY? NOT? TRY? IT?

COPY BOOK CAT REVIEW

MATERIALS

BLACK FLAIR PEN

12 4"x6" INDEX CARDS

A BOOK OF COMICS BY A SINGLE AUTHOR

1 ON THE UNLINED SIDE OF AN INDEX CARD COPY A FRAME FROM THE BOOK. CHOOSE A "MEDIUM CLOSE-UP" DRAW YOUR FRAME TO MATCH THE SHAPE OF THE FRAME YOU ARE COPYING. USE COPYING TO HELP YOU SEE ALL PARTS OF THE PICTURE

→ IMPORTANT: LEAVE OUT ALL WORDS AND DIALOG BALLOONS-

YOU HAVE EXACTLY 10 MINUTES. IF YOU FINISH, DRAW IT AGAIN.

2. REPEAT THIS FIVE MORE TIMES. YOU'LL NEED TO COPY:

☐ AN EXTREME CLOSE-UP

☐ A CLOSE-UP

☐ A FULL BODY

☐ TWO OR MORE FULL BODIES IN A MEDIUM SHOT

☐ A WIDE SHOT SHOWING YOUR CHARACTERS IN A SETTING

USE COPYING TO PICK UP NEW WAYS OF DRAWING BODY TYPES, GESTURES, EXTREMITIES, AND FACIAL FEATURES.

THESE ARE SILENT DRAWINGS— AND SHOULD BE DONE IN ONE SITTING

PART OF THIS ASSIGNMENT IS TO UNDERSTAND WHAT CAN BE DONE IN 10 MINUTES OF DRAWING

ABOUT 75 MINUTES

BASIC X-PAGE

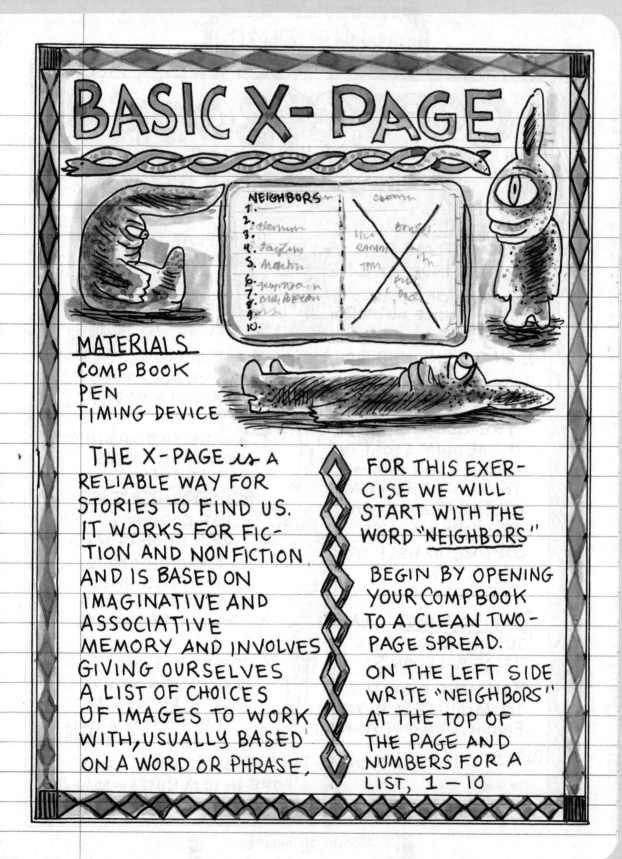

NEIGHBORS
1.
2.
3.
4.
5.
6.
7.
8.
9.
10.

MATERIALS
COMP BOOK
PEN
TIMING DEVICE

THE X-PAGE is A RELIABLE WAY FOR STORIES TO FIND US. IT WORKS FOR FICTION AND NONFICTION AND IS BASED ON IMAGINATIVE AND ASSOCIATIVE MEMORY AND INVOLVES GIVING OURSELVES A LIST OF CHOICES OF IMAGES TO WORK WITH, USUALLY BASED ON A WORD OR PHRASE.

FOR THIS EXERCISE WE WILL START WITH THE WORD "NEIGHBORS"

BEGIN BY OPENING YOUR COMPBOOK TO A CLEAN TWO-PAGE SPREAD.

ON THE LEFT SIDE WRITE "NEIGHBORS" AT THE TOP OF THE PAGE AND NUMBERS FOR A LIST, 1 — 10

1. WRITE A LIST OF NEIGHBORS YOU'VE HAD IN YOUR LIFE. TRY TO GET 10 IN 90 SECONDS.

2. CHOOSE ONE THAT SEEMS VIVID TO YOU OR HAS A BIT OF TROUBLE IN THE RELATIONSHIP, CIRCLE THE NAME AND WRITE IT AT THE TOP OF THE NEXT PAGE AND DRAW AN "X" FROM CORNER TO CORNER.

The 'X-PAGE'

ORIENTS US IN THE SPACE AND TIME OF THE IMAGE WE ARE WORKING WITH BEFORE WE WRITE BY ASKING A SERIES OF QUESTIONS ABOUT A SCENE WE ARE PICTURING. *now...*

PICTURE <u>YOURSELF</u> WITH YOUR NEIGHBOR

3. WRITE YOUR ANSWERS RAPIDLY ANYWHERE ON THE X-PAGE. YOU'LL HAVE ABOUT 20-30 SECONDS FOR EACH ANSWER.

<u>THE QUESTIONS</u>

. WHEN YOU PICTURE THE SCENE YOU ARE IN WITH THIS NEIGHBOR....

1. WHERE ARE YOU?

2. WHAT TIME OF DAY OR NIGHT DOES IT SEEM TO BE IN THIS IMAGE?

3. WHAT SEASON IS IT?

4. WHERE IS THE LIGHT COMING FROM AND WHAT KIND OF LIGHT IS IT?

5. WHAT'S GOING ON?

6. WHAT'S THE WEATHER LIKE?

7. WHAT DOES THE AIR SMELL LIKE?

8. ABOUT HOW OLD ARE YOU?

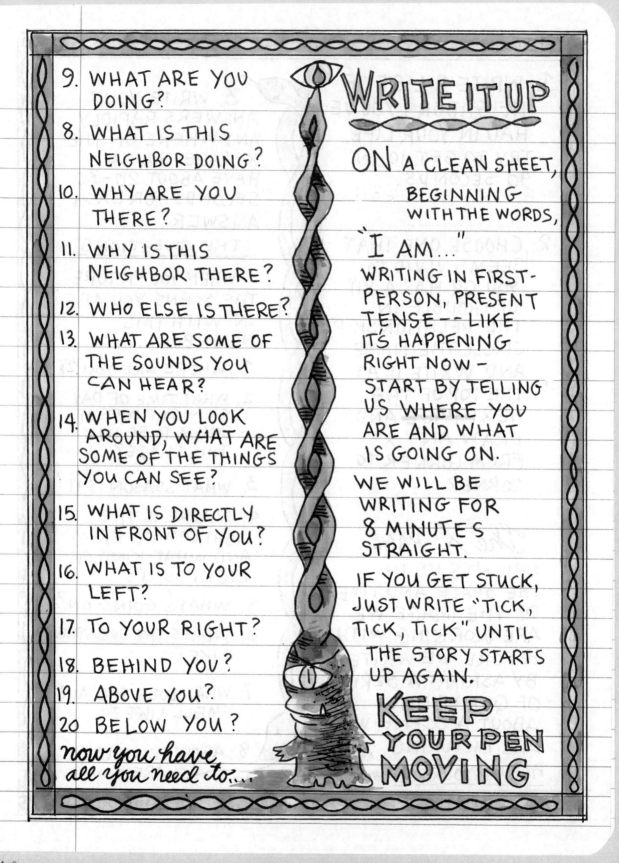

9. WHAT ARE YOU DOING?

8. WHAT IS THIS NEIGHBOR DOING?

10. WHY ARE YOU THERE?

11. WHY IS THIS NEIGHBOR THERE?

12. WHO ELSE IS THERE?

13. WHAT ARE SOME OF THE SOUNDS YOU CAN HEAR?

14. WHEN YOU LOOK AROUND, WHAT ARE SOME OF THE THINGS YOU CAN SEE?

15. WHAT IS DIRECTLY IN FRONT OF YOU?

16. WHAT IS TO YOUR LEFT?

17. TO YOUR RIGHT?

18. BEHIND YOU?

19. ABOVE YOU?

20. BELOW YOU?

now you have all you need to...

WRITE IT UP

ON A CLEAN SHEET, BEGINNING WITH THE WORDS,

"I AM..." WRITING IN FIRST-PERSON, PRESENT TENSE -- LIKE IT'S HAPPENING RIGHT NOW - START BY TELLING US WHERE YOU ARE AND WHAT IS GOING ON.

WE WILL BE WRITING FOR 8 MINUTES STRAIGHT.

IF YOU GET STUCK, JUST WRITE "TICK, TICK, TICK" UNTIL THE STORY STARTS UP AGAIN.

KEEP YOUR PEN MOVING

WORDS AND PHRASES

ONE OF THE CORNERSTONES OF THIS WAY OF WRITING IS A SET OF PROMPTS WRITTEN ON A STACK OF CARDS THAT WE PUT TOGETHER OURSELVES OVER TIME. INDEX CARDS CUT IN HALF AND KEPT TOGETHER WITH A RUBBER BAND OR IN AN ENVELOPE WORK WELL. IT'S GOOD TO HAVE AT LEAST A HUNDRED OF THEM. THE WORDS DON'T HAVE TO BE THOSE WE THINK OF AS EVOCATIVE. ALMOST ANY NOUN OR GERUND (OUR -'ING' WORDS, LIKE COLORING, SCREAMING, SQUATTING) WILL WORK. A GOOD PLACE TO FIND THEM IS IN STORIES YOU'VE WRITTEN.

FOR NOW, USE THIS
LIST. COPY IT BY HAND
AND HAVE IT NEARBY
WHILE YOU WORK YOUR
WAY THROUGH THIS BOOK.
YOU CAN ADD TO YOUR
'WORDS AND PHRASES' AS YOU WISH.

WILD LIFE	HOLE	WINTER
FIRST CARS	WAITING ROOM	HERO
FIRST JOBS	THIEF	FORGOTTEN
OLD PEOPLE	INJECTION	SHOUTING
STORE	DOG	RULES
KITCHEN	DARKNESS	BREAKFAST
BLOOD	AIRPORT	WINNER
DRUGS	INSECT	SONG
JEWELRY	STRANGER	HAIR
FIGHT	HOUSE PLANT	ALCOHOL
GHOST	BROKEN	WIND
TONGUE	HELP	LIBRARY
RUNNING	HIDING PLACE	LOST
BULLY	CHORES	BITE
STAIRWAY	MICHAEL	HER MOM

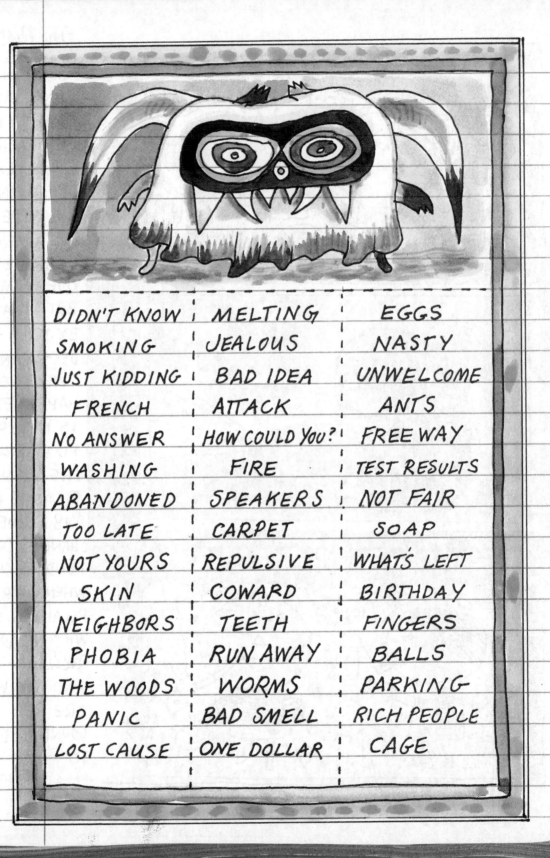

DIDN'T KNOW	MELTING	EGGS
SMOKING	JEALOUS	NASTY
JUST KIDDING	BAD IDEA	UNWELCOME
FRENCH	ATTACK	ANTS
NO ANSWER	HOW COULD YOU?	FREE WAY
WASHING	FIRE	TEST RESULTS
ABANDONED	SPEAKERS	NOT FAIR
TOO LATE	CARPET	SOAP
NOT YOURS	REPULSIVE	WHAT'S LEFT
SKIN	COWARD	BIRTHDAY
NEIGHBORS	TEETH	FINGERS
PHOBIA	RUN AWAY	BALLS
THE WOODS	WORMS	PARKING
PANIC	BAD SMELL	RICH PEOPLE
LOST CAUSE	ONE DOLLAR	CAGE

ABANDONED STUDENT DRAWING COPIED BY LYNDA BARRY 2016

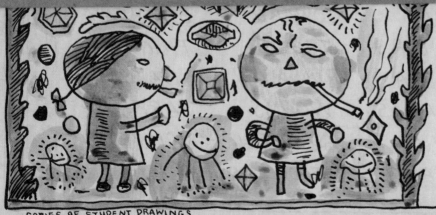

COPIES OF STUDENT DRAWINGS

The Past is in constant motion SOME SAY A MEMORY CHANGES EACH TIME WE REMEMBER IT – GIVING THE IMPRESSION THAT A MEMORY DEGRADES OVER TIME – BUT WHAT EXACTLY IS DEGRADING? "WHAT REALLY HAPPENED" IS NEVER A FIXED STATE. THE SIGNIFICANCE OF ANY ELEMENT CHANGES DEPENDING ON WHEN WE'RE RECALLING IT, WHY WE ARE RECALLING IT, AND WHO WE ARE RECOUNTING IT TO. The past is in constant motion.

BOTH autobiographical and fictional stories rely on the REMEMBERING OF CERTAIN elements as they come to you. DRAWING a place, a scene, or a character LETS INFORMATION arrive WITHOUT WORDS. One of my students HAD 3 MINUTES TO DRAW THIS character. ← all SHE HAD to GO ON WERE the words at the TOP OF THE INDEX CARD. When I look at it, I SEE ALL THE REMEMBERING THERE

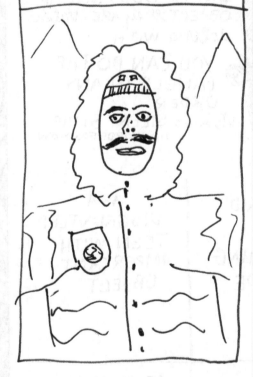

ANTARCTIC RESEARCHER

The Character is FICTIONAL but MADE REAL BY REMEMBERING. Drawing is so much more THAN GOOD OR BAD. IT IS A language FROM another part of you.

DRAWING A LIFE

MATERIALS: *index-card* CHARACTER FROM our *Drawing Jam* EXERCISE 8.5"X11" *paper* FOLDED *into* 6 FRAMES, UNIBALL PEN, TIMER.

① DRAW LINES ALONG THE FOLDS TO MAKE QUICK FRAMES

SPEND 4 MINUTES DRAWING EACH FRAME, *include* THE *Character's* ENTIRE BODY *and* AN OBJECT *they* ARE *inter-acting* WITH.

YOU CAN DO THE PANELS IN ANY ORDER.

This is a SILENT STRIP. NO WORDS FOR NOW.

Draw them AS A BABY BEING FASCINATED BY SOMETHING	AS A KID DOING SOMETHING OUTSIDE	AS A DISGRUNTLED TEEN WITH IMPORTANT OBJECT
AS A YOUNG ADULT *engaged* IN SOMETHING *Difficult*	*in* MIDDLE AGE *at Work*	AT OWN FUNERAL, BODY VISIBLE, AT LEAST TWO MOURNERS

NOW SPEND 4 MINUTES WRITING *the* OBITUARY

ABOUT *30 minutes*

Somehow, the act of drawing a character at 6 different points in life gives us a story about them we can PUT INTO WORDS - because now WE 'KNOW' THINGS ABOUT THEM.

It is FICTION but we aren't making it up.

ABANDONED STUDENT DRAWING·

This exercise will work with any character, like the person on the right in the drawing above. In 30 minutes I can know his story well enough to tell it to you: The story of remembering someone that was just ink on paper.

WHERE IS YOUR MEMORY?

- ☐ HERE?
- ☐ THERE?
- ☐ EVERYWHERE?

Floods, tides, AND typhoons

REMEMEMBER

No passenger was known to flee -
That lodged a night in memory -
That wily-subterranean Inn
Contrives that none go out again -

POEM 1406 EMILY DICKIN-SON

When a memory comes back to us, where is it coming from?

Can you go to a memory or must it come to you?

STORIES

THAT LEND THEM-SELVES TO COMICS CAN BE FOUND IN A CERTAIN KIND OF REMEMBERING I SOMETIMES CALL AN IMAGE. IT'S A SORT OF LIVING SNAPSHOT, THE KIND OF MEMORY YOU CAN TURN AROUND IN. IT NEEDS VERY LITTLE SET UP OR EXPLA-NATION. IF YOU CAN 'SEE' IT IN YOUR MIND'S EYE WITH YOUR WHOLE BODY THERE WILL BE A HINT OF A STORY THAT BIDS YOU TO FOLLOW.

THIS KIND OF STORY MOVES NOT FROM FACT TO FACT BUT FROM IMAGE TO IMAGE. IT CAN JUMP TIME. THE SAME WALK CAN CONTAIN IMAGES FROM NIGHT OR DAY, CAN SWITCH SEASON, CAN MOVE FORWARD AND BACKWARD BY YEARS. THERE IS A MAILBOX NEAR MY CHILDHOOD HOME I'VE WALKED PAST AT AGE 15, AGE 10, AGE 6, AGE 29, AND GHOSTS OF FEELING ABIDE ALONG THAT ENTIRE STREET.

THE WALK

MATERIALS
UNIBALL
COMPBOOK
TIMER

This exercise BEGINS WITH A three MINUTE memory jam. DRAW A BIG 'X' ON a COMPBOOK PAGE. THINK OF REPEATED walks YOU'VE taken IN YOUR LIFE, ONES you took OVER AND OVER. BEGIN in CHILD-HOOD AND MOVE THROUGH time. IT'S OK IF the WALK IS BORING. Think OF ONES SO FAMILIAR you DON'T have TO THINK ABOUT DIREC-TION OR GETTING LOST

FROM HOME TO JR. HIGH

DAG'S TO G'MA'S

PARKING GARAGE TO CLASSROOM

HOME TO KARENS

UNCLE GEORGES, TO FREDS GROCERY

MY APT TO EL STATION

MY DORM TO THE LIBRARY

EL STATION TO MY SHRINKS OFFICE

AROUND THE GROVE

KEY SHOP TO THE PARK

MY APT TO WRIGLEYFIELD

CHOOSE A WALK

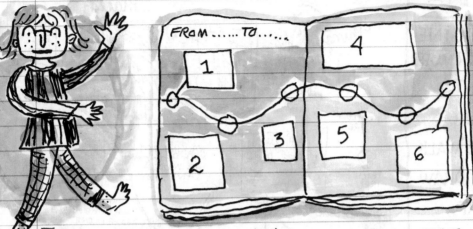

DRAW A 'STRING' ACROSS A DOUBLE PAGE SPREAD IN YOUR COMP BOOK WITH SIX "BEADS" ON IT. DRAW SIX FRAMES.

THE FIRST BEAD IS the starting POINT. DRAW your-self in THAT PLACE IN PANEL 1. Include your ENTIRE BODY AND THE setting. THIS IS A QUICK 2-3 minute DRAWING. WHEN YOU FINISH, draw a line CONNECTING THE drawing to the BEAD.

Do the same THING FOR THE last BEAD AND PANEL six. LABEL THE FIRST and 6TH BEAD WITH where THIS WALK begins AND where you will BE when it ENDS. TITLE the PAGE: FROM (PLACE) to (DESTINATION)

157

MAKE IT A MAP

IMAGINE FOUR MORE POINTS ALONG THIS WALK AND DRAW WHAT MIGHT BE THERE *in the remaining frames.* THINK OF WHAT YOU'D SEE AT THAT POINT IN YOUR WALK.

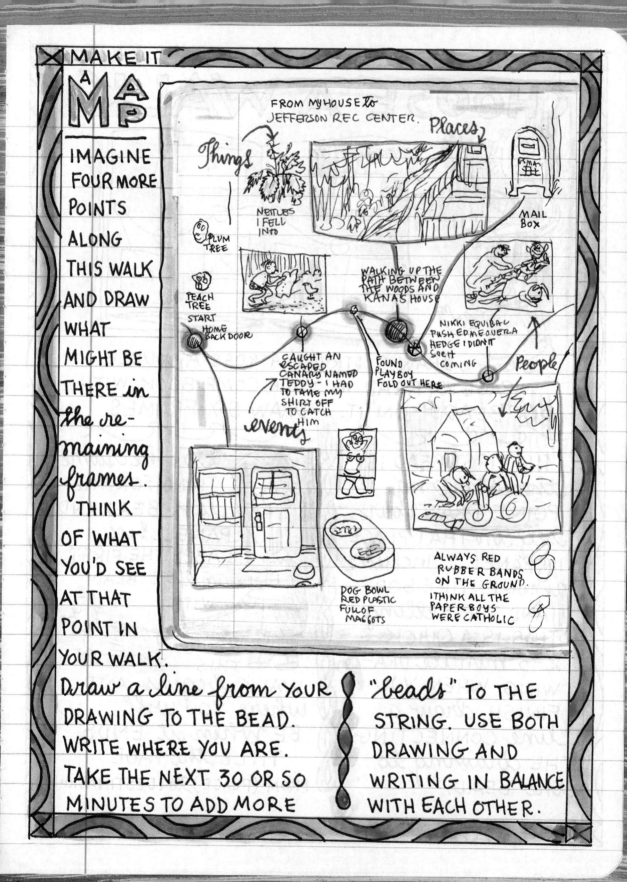

FROM MY HOUSE to JEFFERSON REC CENTER. Places

Things

NETTLES I FELL INTO

PLUM TREE

PEACH TREE

START HOME BACK DOOR

MAIL BOX

WALKING UP THE PATH BETWEEN THE WOODS AND KANA'S HOUSE

NIKKI EQUIBAL PUSHED ME OVER A HEDGE I DIDN'T SEE IT COMING

People

CAUGHT AN ESCAPED CANARY NAMED TEDDY—I HAD TO TAKE MY SHIRT OFF TO CATCH HIM

FOUND PLAYBOY FOLDOUT HERE

events

DOG BOWL RED PLASTIC FULL OF MAGGOTS

ALWAYS RED RUBBER BANDS ON THE GROUND.

I THINK ALL THE PAPER BOYS WERE CATHOLIC

Draw a line from YOUR DRAWING TO THE BEAD. WRITE WHERE YOU ARE. TAKE THE NEXT 30 OR SO MINUTES TO ADD MORE *"beads"* TO THE STRING. USE BOTH DRAWING AND WRITING IN BALANCE WITH EACH OTHER.

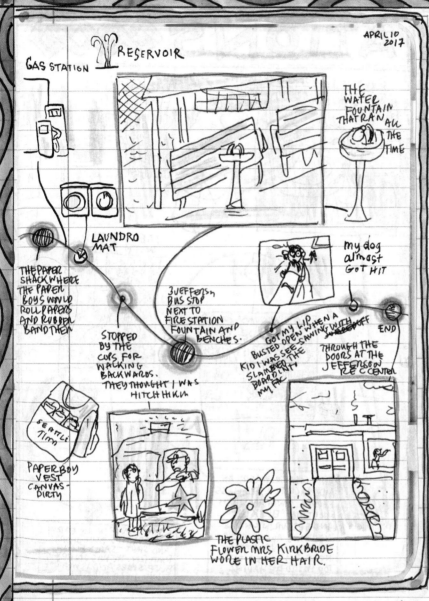

GAS STATION

RESERVOIR

APRIL 10 2017

THE WATER FOUNTAIN THAT RAN ALL THE TIME

LAUNDRO MAT

THE PAPER SHACK WHERE THE PAPER BOYS WOULD ROLL PAPERS AND RUBBER BAND THEM

STOPPED BY THE COPS FOR WALKING BACKWARDS. THEY THOUGHT I WAS HITCH HIKIN

3 JEFFERSN BUS STOP NEXT TO FIRE STATION FOUNTAIN AND BENCHES.

my dog almost GOT HIT

GOT MY LIP BUSTED OPEN WHEN A KID I WAS SEE SAWING WITH JUMPED OFF SLAMMED THE BOARD INTO MY FACE

THROUGH THE DOORS AT THE JEFFERSON ICE C CENTER

END

SEATTLE Timm

PAPERBOY VEST CANVAS- DIRTY

THE PLASTIC FLOWER MRS KIRKBRIDE WORE IN HER HAIR.

EACH BEAD IS A POSSIBLE SETTING FOR AN OCCURANCE, ANOTHER MEMORY IN THE SAME SPOT, OR SEVERAL OF THEM OVER A SPAN OF TIME. A PLACE WHERE YOU 'RUN INTO YOURSELF' AT DIFFERENT AGES ON THAT SAME WALK.

A COMIC STRIP CAN BE FOUND AT EACH OF THESE BEADS. YOU CAN USE FICTIONAL CHARACTERS IN THIS VERY REAL SETTING, YOU CAN FICTIONALIZE SOMETHING THAT HAPPENED TO YOU OR TELL IT LIKE IT WAS. FORMAT: 2 8.5"×11" PAGES - 4 PANELS PER PAGE.

VARIATIONS ◇◇◇◇

WHY NOT TRY

- A WALK YOU TOOK RECENTLY
 — OR —
- YOU TAKING THE WALK SEVEN YEARS FROM NOW
 — OR —
- A CHARACTER YOU MAKE UP TAKES THE WALK
 — OR —
- A MINOR CHARACTER IN ONE OF YOUR STORIES TAKES THE WALK

and

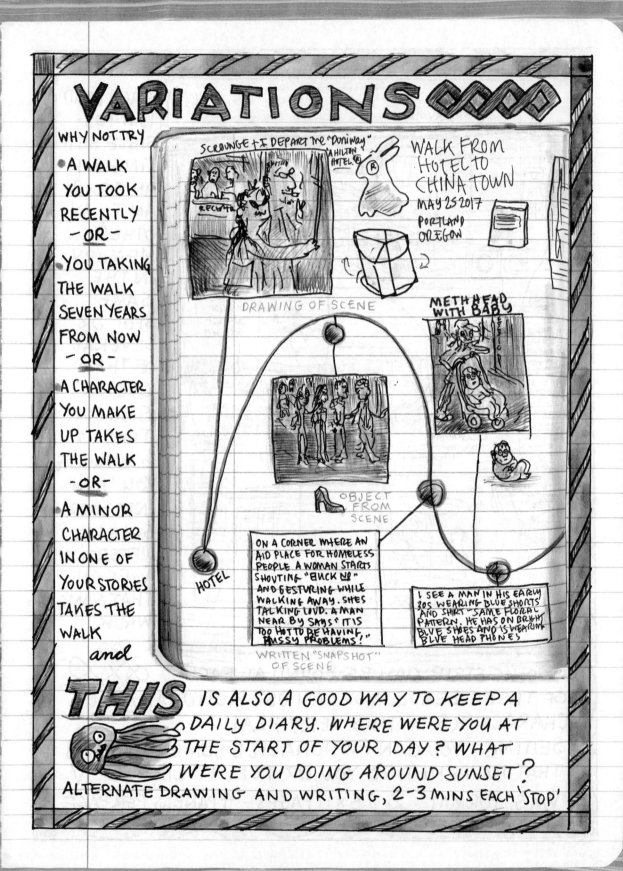

SCROUNGE + I DEPART THE "DONIWAY" A HILTON HOTEL ®

WALK FROM HOTEL TO CHINATOWN MAY 25 2017 PORTLAND OREGON

DRAWING OF SCENE

METH HEAD WITH BABY

OBJECT FROM SCENE

HOTEL

ON A CORNER WHERE AN AID PLACE FOR HOMELESS PEOPLE A WOMAN STARTS SHOUTING "FUCK N°" AND GESTURING WHILE WALKING AWAY. SHES TALKING LOUD. A MAN NEAR BY SAYS " IT IS TOO HOT TO BE HAVING PUSSY PROBLEMS!"

I SEE A MAN IN HIS EARLY 30S WEARING BLUE SHORTS AND SHIRT — SAME FLORAL PATTERN. HE HAS ON BRIGHT BLUE SHOES AND IS WEARING BLUE HEAD PHONES

WRITTEN "SNAPSHOT" OF SCENE

THIS IS ALSO A GOOD WAY TO KEEP A DAILY DIARY. WHERE WERE YOU AT THE START OF YOUR DAY? WHAT WERE YOU DOING AROUND SUNSET? ALTERNATE DRAWING AND WRITING, 2-3 MINS EACH 'STOP'

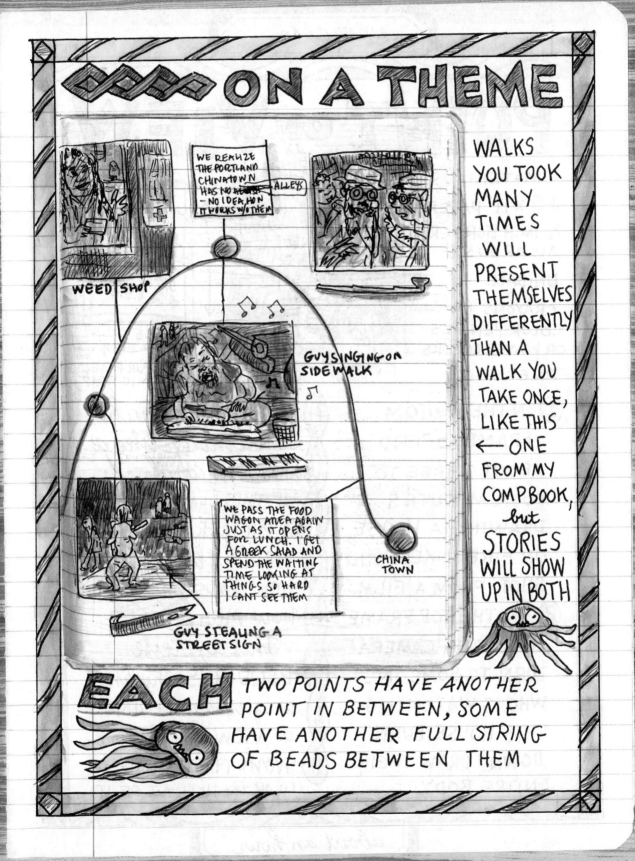

ON A THEME

WEED SHOP

WE REALIZE THE PORTLAND CHINATOWN HAS NO ~~ABOUT~~ — NO IDEA HOW IT WORKS W/ THEM — ALLEYS

GUY SINGING ON SIDE WALK

WE PASS THE FOOD WAGON AT LEA AGAIN JUST AS IT OPENS FOR LUNCH. I GET A GREEK SALAD AND SPEND THE WAITING TIME LOOKING AT THINGS SO HARD I CANT SEE THEM

CHINA TOWN

GUY STEALING A STREET SIGN

WALKS YOU TOOK MANY TIMES WILL PRESENT THEMSELVES DIFFERENTLY THAN A WALK YOU TAKE ONCE, LIKE THIS ← ONE FROM MY COMP BOOK, *but* STORIES WILL SHOW UP IN BOTH

EACH TWO POINTS HAVE ANOTHER POINT IN BETWEEN, SOME HAVE ANOTHER FULL STRING OF BEADS BETWEEN THEM

POINT OF VIEW

MATERIALS

8.5" X 11" PAPER
½ INCH BORDER
ALL AROUND

UNIBALL

CRAYONS OR
COLOR PENCILS
OR WATERCOLORS

TIMER

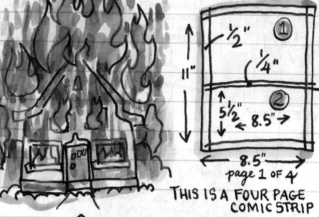

11"

① ½"

¼"

② 5½" ← 8.5" →

← 8.5" →
page 1 of 4

THIS IS A FOUR PAGE
COMIC STRIP

① IN THE BOTTOM FRAME, SPEND ABOUT THREE TO FOUR MINUTES DRAWING A HOUSE ON FIRE - LIKE A 'STILL SHOT' FROM A FILM.

② IN THE TOP FRAME HAVE THE 'CAMERA' TURN TO SOMEONE WHO IS WATCHING THIS HOUSE BURN DOWN - DRAW THEIR ENTIRE BODY.

every drawing has something like a camera angle --- IF THIS DRAWING WERE A PHOTOGRAPH, *where* WOULD *the* CAMERA *be?* HOW *close would it be?* HOW HIGH *or* LOW? *This exercise* REQUIRES *shifting angles and* POINT OF VIEW. *Do the line* WORK FIRST *Then* COLOR *the* HELL *out* OF IT

about an hour

③ THERE IS SOME ONE IN THE HOUSE WHO DOESN'T REALIZE IT'S ON FIRE. THE "CAMERA" IS HIGH - NEAR THE TOP CORNER OF THE ROOM. DRAW WHAT THEY ARE DOING, INCLUDE THEIR WHOLE BODY, FACE AND HANDS. 4 MINUTES

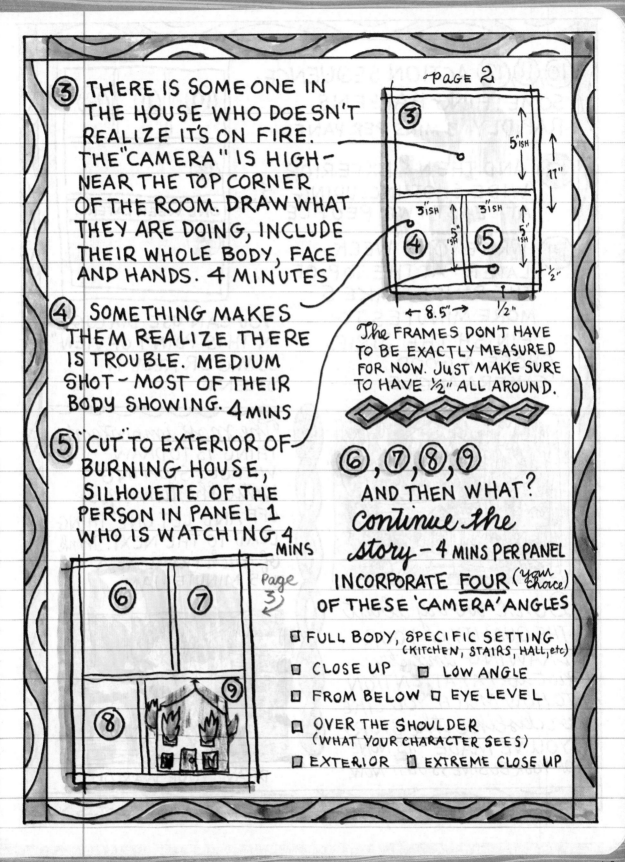

page 2

③

④ ⑤

5"ISH

11"

3"ISH 3"ISH

5"ISH 5"ISH

½"

← 8.5" → ½"

④ SOMETHING MAKES THEM REALIZE THERE IS TROUBLE. MEDIUM SHOT - MOST OF THEIR BODY SHOWING. 4 MINS

⑤ "CUT" TO EXTERIOR OF BURNING HOUSE, SILHOUETTE OF THE PERSON IN PANEL 1 WHO IS WATCHING 4 MINS

THE FRAMES DON'T HAVE TO BE EXACTLY MEASURED FOR NOW. JUST MAKE SURE TO HAVE ½" ALL AROUND.

⑥, ⑦, ⑧, ⑨ AND THEN WHAT? continue the story - 4 MINS PER PANEL INCORPORATE FOUR (Your Choice) OF THESE 'CAMERA' ANGLES

☑ FULL BODY, SPECIFIC SETTING (KITCHEN, STAIRS, HALL, etc)
☐ CLOSE UP ☐ LOW ANGLE
☐ FROM BELOW ☐ EYE LEVEL
☐ OVER THE SHOULDER (WHAT YOUR CHARACTER SEES)
☑ EXTERIOR ☑ EXTREME CLOSE UP

Page 3

⑥ ⑦

⑧ ⑨

(10), (11), (12) ACTION SEQUENCE: SOMETHING HAPPENS RAPIDLY 3 MINS PER PANEL

(13) AND THEN? EXTERIOR WIDE SHOT INCLUDING AT LEAST TWO PEOPLE 4 MINS

(14) WRITE "ONE WEEK LATER" AT THE TOP OF THE PANEL. TAKE 5 MORE MINUTES TO FINISH THE STRIP. CHOSE A GOOD 'CAMERA ANGLE

YOU CAN USE DIALOG IN THIS "POINT OF VIEW" COMIC OR KEEP IT SILENT

The most important THING IS TO DRAW WITHOUT STOPPING *until the timer goes* OFF AND LET ONE THING LEAD TO THE NEXT. *Think of each* FRAME AS A 3-5 MINUTE JAM.

Don't worry about THE QUALITY OF YOUR DRAWING *and try not to* PAY ATTENTION TO HOW MUCH YOU LIKE *or dislike the* STORY YOU'VE MADE – IT'S NONE OF YOUR BUSINESS JUST NOW.

DRAW YOUR WAY OUT

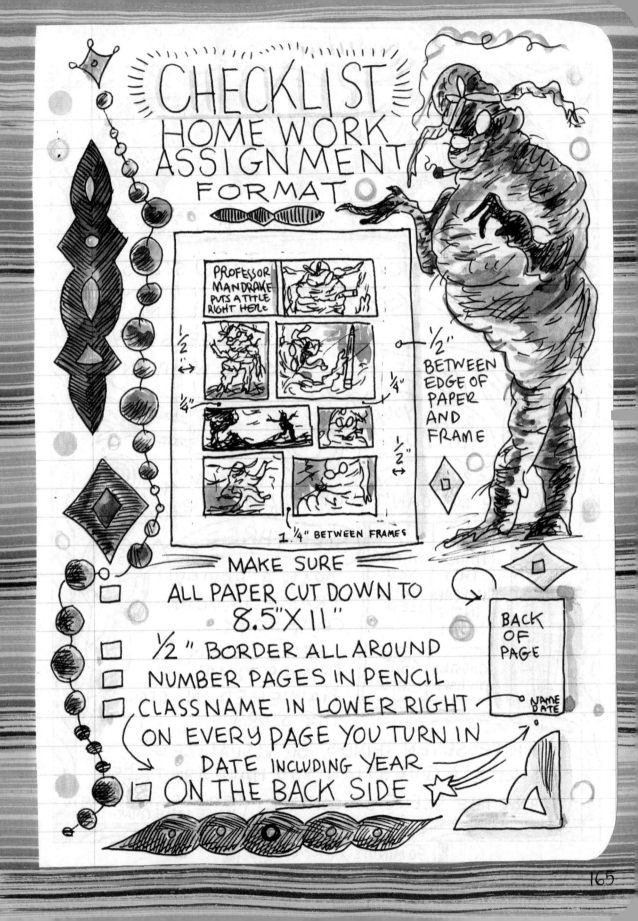

CHECKLIST
HOME WORK
ASSIGNMENT
FORMAT

PROFESSOR MANDRAKE PUTS A TITLE RIGHT HERE

½"

¼"

¼"

½"

½" BETWEEN EDGE OF PAPER AND FRAME

¼" BETWEEN FRAMES

MAKE SURE

☐ ALL PAPER CUT DOWN TO 8.5"X 11"

☐ ½" BORDER ALL AROUND

☐ NUMBER PAGES IN PENCIL

☐ CLASS NAME IN LOWER RIGHT ON EVERY PAGE YOU TURN IN

DATE including YEAR

☐ ON THE BACK SIDE

BACK OF PAGE

NAME DATE

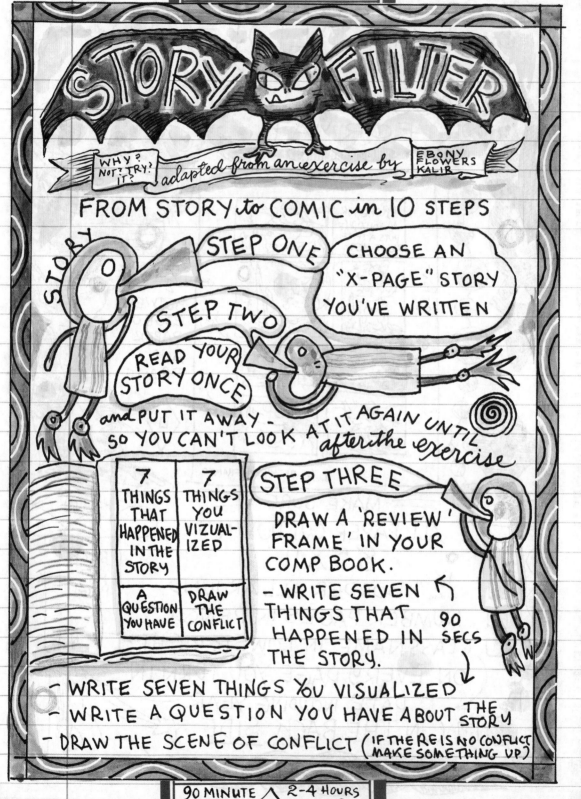

STORY FILTER

WHY? NOT? TRY? IT? — adapted from an exercise by EBONY FLOWERS KALIR

FROM STORY to COMIC in 10 STEPS

STORY

STEP ONE — CHOOSE AN "X-PAGE" STORY YOU'VE WRITTEN

STEP TWO — READ YOUR STORY ONCE and PUT IT AWAY — SO YOU CAN'T LOOK AT IT AGAIN UNTIL after the exercise

7 THINGS THAT HAPPENED IN THE STORY	7 THINGS YOU VIZUALIZED
A QUESTION YOU HAVE	DRAW THE CONFLICT

STEP THREE

DRAW A 'REVIEW FRAME' IN YOUR COMP BOOK.

- WRITE SEVEN THINGS THAT HAPPENED IN THE STORY.

90 SECS

- WRITE SEVEN THINGS YOU VISUALIZED
- WRITE A QUESTION YOU HAVE ABOUT THE STORY
- DRAW THE SCENE OF CONFLICT (IF THERE IS NO CONFLICT MAKE SOMETHING UP)

90 MINUTE exercise ◇ 2-4 HOURS HOMEWORK

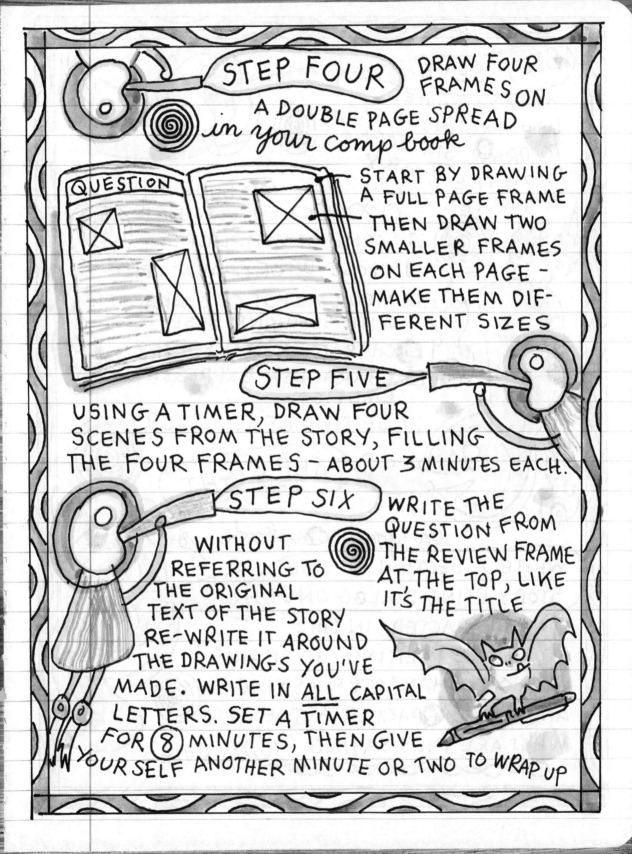

STEP FOUR — DRAW FOUR FRAMES ON A DOUBLE PAGE SPREAD *in your comp book*

QUESTION

START BY DRAWING A FULL PAGE FRAME THEN DRAW TWO SMALLER FRAMES ON EACH PAGE — MAKE THEM DIFFERENT SIZES

STEP FIVE

USING A TIMER, DRAW FOUR SCENES FROM THE STORY, FILLING THE FOUR FRAMES — ABOUT 3 MINUTES EACH.

STEP SIX

WITHOUT REFERRING TO THE ORIGINAL TEXT OF THE STORY RE-WRITE IT AROUND THE DRAWINGS YOU'VE MADE. WRITE IN ALL CAPITAL LETTERS. SET A TIMER FOR (8) MINUTES, THEN GIVE YOURSELF ANOTHER MINUTE OR TWO TO WRAP UP

WRITE THE QUESTION FROM THE REVIEW FRAME AT THE TOP, LIKE IT'S THE TITLE

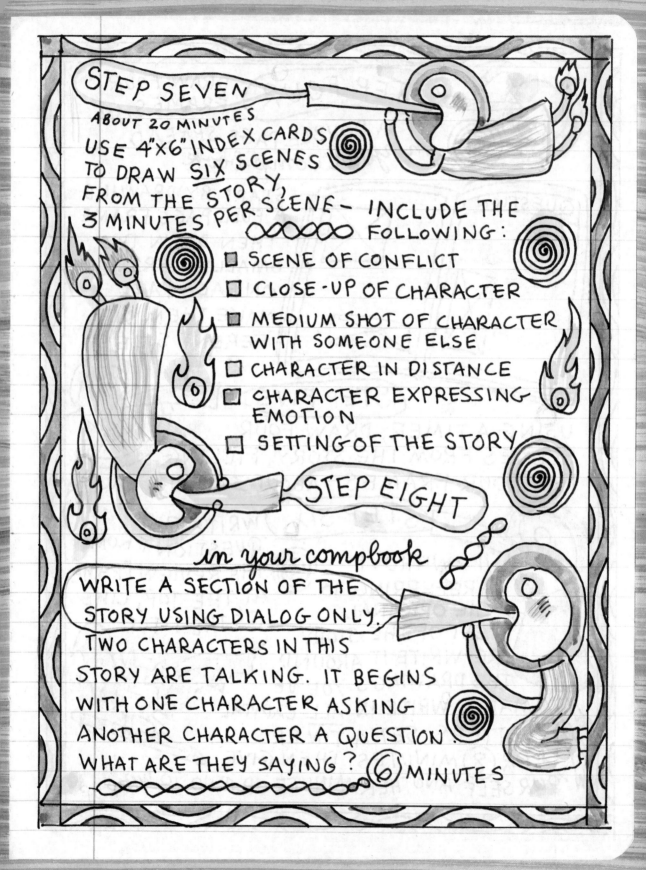

STEP SEVEN

ABOUT 20 MINUTES

USE 4"×6" INDEX CARDS TO DRAW SIX SCENES FROM THE STORY, 3 MINUTES PER SCENE — INCLUDE THE FOLLOWING:

- ☐ SCENE OF CONFLICT
- ☐ CLOSE-UP OF CHARACTER
- ☐ MEDIUM SHOT OF CHARACTER WITH SOMEONE ELSE
- ☐ CHARACTER IN DISTANCE
- ☐ CHARACTER EXPRESSING EMOTION
- ☐ SETTING OF THE STORY

STEP EIGHT

in your compbook

WRITE A SECTION OF THE STORY USING DIALOG ONLY. TWO CHARACTERS IN THIS STORY ARE TALKING. IT BEGINS WITH ONE CHARACTER ASKING ANOTHER CHARACTER A QUESTION. WHAT ARE THEY SAYING? ⑥ MINUTES

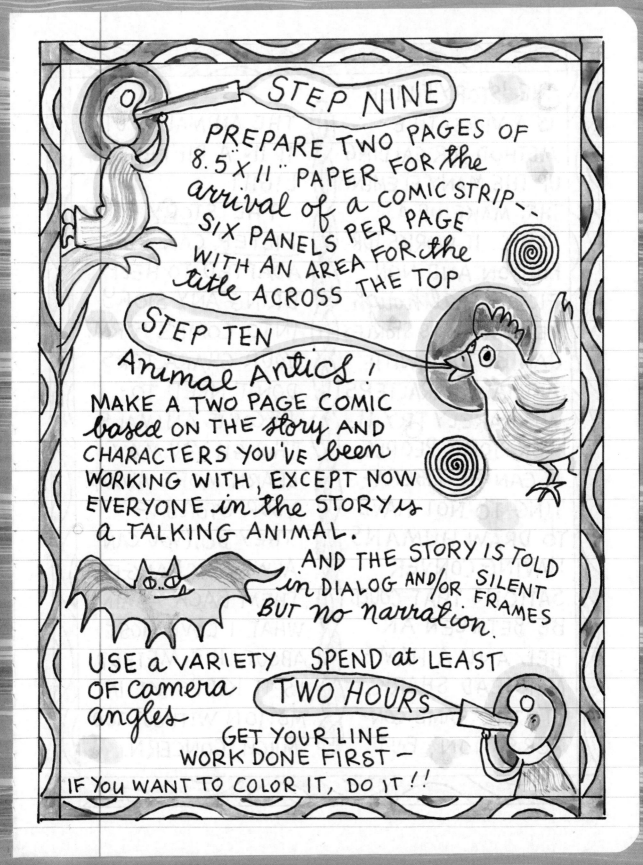

STEP NINE

PREPARE TWO PAGES OF 8.5 × 11" PAPER FOR the arrival of a COMIC STRIP-- SIX PANELS PER PAGE WITH AN AREA FOR the title ACROSS THE TOP

STEP TEN

Animal Antics!

MAKE A TWO PAGE COMIC based ON THE story AND CHARACTERS YOU'VE been WORKING WITH, EXCEPT NOW EVERYONE in the STORY is a TALKING ANIMAL.

AND THE STORY IS TOLD in DIALOG AND/OR SILENT FRAMES BUT no narration.

USE a VARIETY OF camera angles

SPEND at LEAST TWO HOURS

GET YOUR LINE WORK DONE FIRST —

IF YOU WANT TO COLOR IT, DO IT!!

169

THE 'STORY FILTER' IS A VERSATILE METHOD FOR CALLING UP THE MANY ELEMENTS THAT MAKE UP A COMIC. IT WORKS FOR FICTION AND NON-FICTION. *although* VERY SERIOUS STORIES CAN BE TOLD WITH ANIMAL CHARACTERS WE RARELY TRY IT. FOR SOME PEOPLE IT CAN BE LIBERATING TO NOT HAVE TO DRAW HUMANS HAVING CONVERSATIONS THAT COULD BE BETWEEN AN EEL AND A HAMMERHEAD SHARK. IT'S THE SAME CONVERSATION, BUT THE ANIMALS PUT IT IN A DIFFERENT LIGHT.

THE <u>STORY FILTER</u> CAN BE ADAPTED TO HELP BRING ANY STORY INTO COMICS FORM. YOUR CHARACTERS DON'T NEED TO BECOME ANIMALS, THOUGH YOU MAY LEARN MORE ABOUT YOUR STORY IF THEY DO. (YOU CAN ALWAYS CHANGE THEM BACK AGAIN.) WHAT I LOVE MOST ABOUT THIS METHOD IS IT KEEPS ME IN MOTION WITHOUT TOO MUCH CONCERN.

INTERVIEW COMIC

One of the best ways of really understanding this way of working is to teach it to someone else. This *assignment* asks you to teach two of the things we do in class: the Ivan Brunetti style of drawing and the "X" page story method. *you will need* to draw with and interview three people. One of the interviews will be used to make a comic strip.

PART ONE

You will need index cards, pens, compbooks. *a timer,* (you can use music). Plan on about an hour *for* each interview.

Start by showing Brunetti's way of drawing — big head smaller body shape, noodle arms. As you demonstrate turn the drawing into a self portrait. Give it your hair and clothes and glasses.

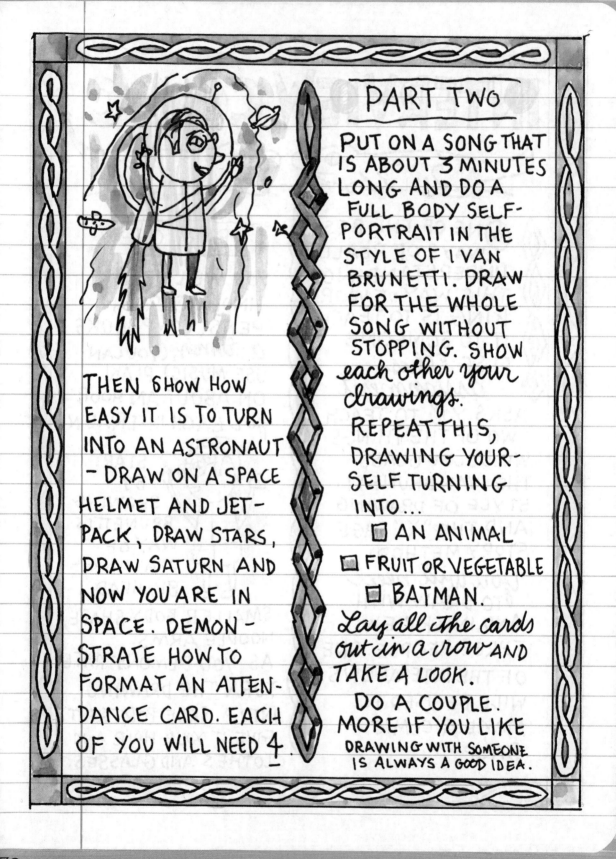

PART TWO

PUT ON A SONG THAT IS ABOUT 3 MINUTES LONG AND DO A FULL BODY SELF-PORTRAIT IN THE STYLE OF IVAN BRUNETTI. DRAW FOR THE WHOLE SONG WITHOUT STOPPING. SHOW *each other your drawings.* REPEAT THIS, DRAWING YOURSELF TURNING INTO...

☐ AN ANIMAL

☐ FRUIT OR VEGETABLE

☐ BATMAN.

Lay all the cards out in a row AND TAKE A LOOK.

DO A COUPLE MORE IF YOU LIKE DRAWING WITH SOMEONE IS ALWAYS A GOOD IDEA.

THEN SHOW HOW EASY IT IS TO TURN INTO AN ASTRONAUT — DRAW ON A SPACE HELMET AND JET-PACK, DRAW STARS, DRAW SATURN AND NOW YOU ARE IN SPACE. DEMONSTRATE HOW TO FORMAT AN ATTENDANCE CARD. EACH OF YOU WILL NEED 4.

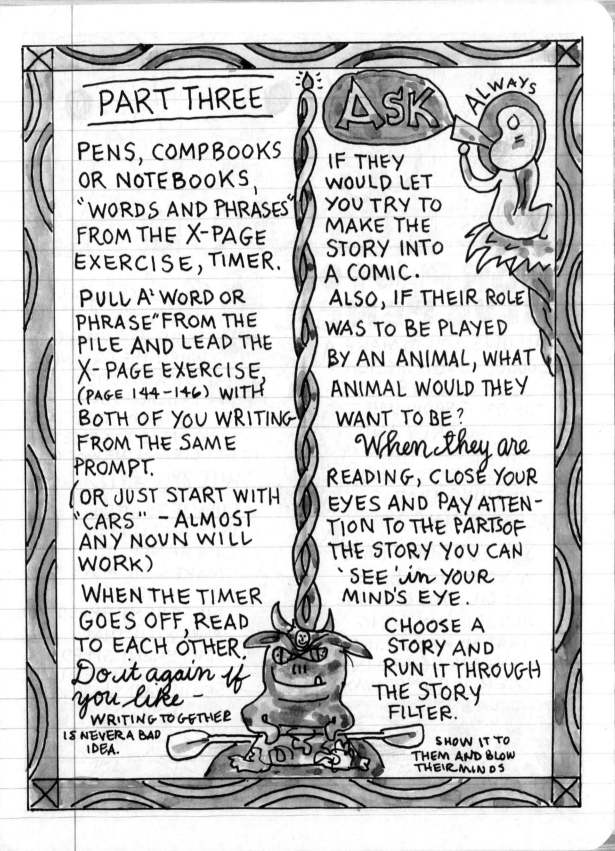

PART THREE

PENS, COMPBOOKS OR NOTEBOOKS, "WORDS AND PHRASES" FROM THE X-PAGE EXERCISE, TIMER.

PULL A "WORD OR PHRASE" FROM THE PILE AND LEAD THE X-PAGE EXERCISE, (PAGE 144-146) WITH BOTH OF YOU WRITING FROM THE SAME PROMPT.

(OR JUST START WITH "CARS" — ALMOST ANY NOUN WILL WORK)

WHEN THE TIMER GOES OFF, READ TO EACH OTHER. *Do it again if you like —* WRITING TOGETHER IS NEVER A BAD IDEA.

ASK ALWAYS

IF THEY WOULD LET YOU TRY TO MAKE THE STORY INTO A COMIC.

ALSO, IF THEIR ROLE WAS TO BE PLAYED BY AN ANIMAL, WHAT ANIMAL WOULD THEY WANT TO BE?

When they are READING, CLOSE YOUR EYES AND PAY ATTENTION TO THE PARTS OF THE STORY YOU CAN `SEE` *in* YOUR MIND'S EYE.

CHOOSE A STORY AND RUN IT THROUGH THE STORY FILTER.

SHOW IT TO THEM AND BLOW THEIR MINDS

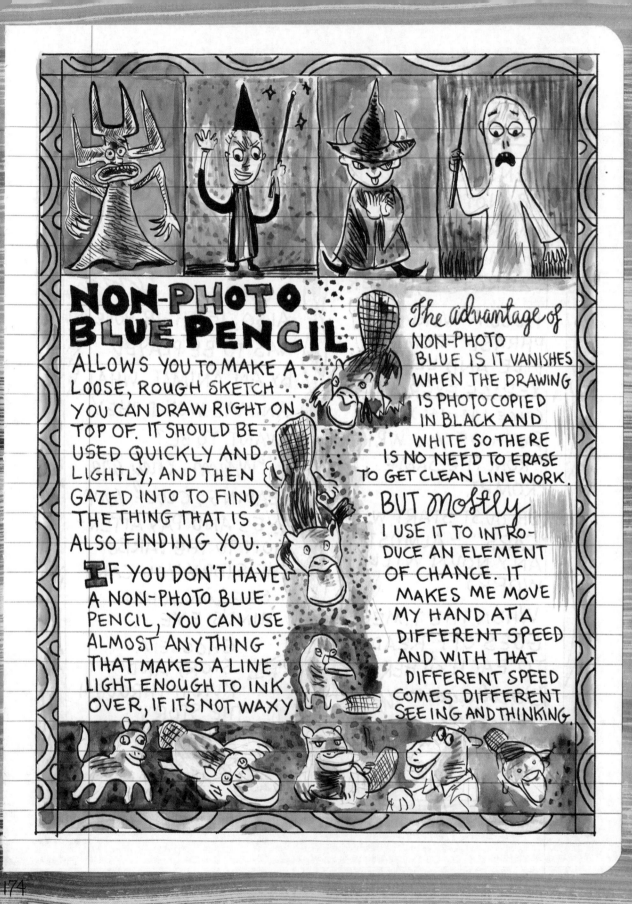

NON-PHOTO BLUE PENCIL

ALLOWS YOU TO MAKE A LOOSE, ROUGH SKETCH YOU CAN DRAW RIGHT ON TOP OF. IT SHOULD BE USED QUICKLY AND LIGHTLY, AND THEN GAZED INTO TO FIND THE THING THAT IS ALSO FINDING YOU.

IF YOU DON'T HAVE A NON-PHOTO BLUE PENCIL, YOU CAN USE ALMOST ANYTHING THAT MAKES A LINE LIGHT ENOUGH TO INK OVER, IF IT'S NOT WAXY.

The advantage of NON-PHOTO BLUE IS IT VANISHES WHEN THE DRAWING IS PHOTOCOPIED IN BLACK AND WHITE SO THERE IS NO NEED TO ERASE TO GET CLEAN LINE WORK.

BUT mostly I USE IT TO INTRO-DUCE AN ELEMENT OF CHANCE. IT MAKES ME MOVE MY HAND AT A DIFFERENT SPEED AND WITH THAT DIFFERENT SPEED COMES DIFFERENT SEEING AND THINKING.

DRAWING BOSS

ROUND ROBIN

materials

8.5" X 11" PAPER DIVIDED INTO 16 PANELS

NON-PHOTO BLUE PENCIL

UNIBALL PEN

FOLD YOUR PAPER

1. INTO 16 FRAMES AND DRAW THEM IN WITH UNIBALL

2. EACH PERSON TAKES A TURN "BOSSING" THE CLASS INTO DRAWING SOME-THING THEY CHOOSE. ALL DRAWINGS ARE DONE IN ONE MINUTE USING A STAEDTLER NON-PHOTO BLUE PENCIL* PASS PAGE AFTER EACH DRAWING.

HOMEWORK

YOU WILL INK THIS ENTIRE PAGE, DOING YOUR BEST TO FOLLOW THE NON-PHOTO BLUE PENCIL LINES MADE BY SOMEONE ELSE'S HAND.

although MANY PEOPLE MADE THE DRAWINGS YOU'LL BE INKING, IT WILL BE YOUR LINE, -- THE LINE OF THE INKER, -- THAT WILL GIVE IT A SURPRISING UNITY. EMBELLISH AND ADD SOLID BLACK.

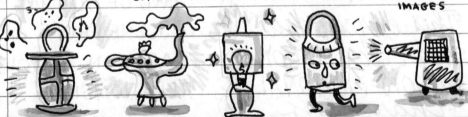

COPIES OF STUDENT DRAWING BOSS 'MAGIC LANTERN' IMAGES

* NOT EASY TO FIND BUT OTHER BRANDS ARE TOO WAXY TO DRAW OVER. WORTH ORDERING!

about an hour

CHARACTER 'ZINE

adapted from an exercise by DAN CHAON

This is a longer SUSTAINED EXER-CISE that IS BEST DONE IN ONE SITTING.

you will need YOUR COMPBOOK, a PEN, TIMER, and 4 SHEETS OF 8.5"X 11" PAPER FOLDED in HALF to make an 8-page BOOKLET

FOLD
5.5"
8.5"

This exercise will work for FICTIONAL or NON-FICTIONAL characters

take 90 SECONDS

① Start by MAKING A LIST OF PEOPLE YOU KNEW WHEN YOU Were YOUNGER

② Choose one — MAYBE SOMEONE YOU HAVEN'T THOUGHT OF in A WHILE OR SEEN LATELY

③ PICTURE the two OF YOU in a SCENE FROM EARLY ON in YOUR RELATIONSHIP

about 2 hours

Draw an X ACROSS A PAGE IN YOUR COMPBOOK and WRITE the answers TO THE 'X' PAGE (P.145) Questions ANYWHERE on the page

④ Draw A FRAME that takes UP ABOUT HALF OF the FRONT OF YOUR 'ZINE AND WRITE

CHAPTER 1
SALLY AND I ARE IN MITCHELLS GARAGE. ITS SUMMER, MIDDLE OF THE DAY AND ITS 90C IN THE SHADOW. THE SMELL IS OIL AND WOOD AND SUN

"CHAPTER ONE" BENEATH IT. Spend 4 minutes WRITING UP THIS SCENE. YOU CAN CONTINUE ON THE BACK SIDE OF THE PAGE BUT NO FURTHER. Begin with your character's name TELL US WHERE YOU ARE. make your story fit the space

⑤ DRAW the TWO OF YOU together in THIS SCENE. MAKE SURE TO include WHOLE BODIES AND indication OF SETTING 4 MINUTES

⑥ Draw ANOTHER PICTURE FRAME beneath it WRITE...

CHAPTER 2

WE WILL REPEAT THIS FORMAT FOR ALL 8 CHAPTERS Beginning each chapter on the right hand page, WRITING ON THE FRONT and BACK of the page.

ALTHOUGH YOU MAY be WRITING ABOUT A REAL PERSON, THIS *exercise requires* YOU TO MAKE UP SOME PARTS *that* YOU MAY *not* KNOW, *So let* THAT HAPPEN. *Keep* YOUR PEN IN *Motion*

◆ Chapter 2 ◆

WRITE A BRIEF STORY ABOUT SOME THING THAT HAPPENED TO YOUR CHARACTER *When they were* LITTLE –3 *minutes*
– *then* –

DRAW *a scene* FROM THE STORY – 4 MINUTES

INCLUDING WHOLE *bodies* AND SETTING *Will* GIVE YOU *more* INFORMATION ABOUT YOUR *story.*

◆ Chapter 3 ◆

DRAW AN OBJECT *you* ASSOCIATE WITH THIS PERSON – 3 *minutes*

WRITE ABOUT IT – 3 *minutes*

◆ Chapter 4 ◆

WRITE SOME DIALOG – SOMETHING SOME ONE SAID ABOUT THIS PERSON *to* YOU OR TO SOME ONE *else.* 3 *minutes*

DRAW *your character* EATING THEIR TYPICAL LUNCH. *make* SURE WE CAN TELL *where they are* AND *what is around them*

◆ Chapter 5 ◆

DRAW a scene WITH YOUR CHARACTER DOING SOMETHING ALONE that GIVES US SOME IDEA OF THEIR DISPOSITION toward THE WORLD
— 3 minutes

BEGIN with your character's NAME and WRITE up this scene. WHAT'S GOING ON? 3-MINS

◆ Chapter 6 ◆

WRITE A scene THAT TAKES PLACE in PRESENT DAY WHERE YOU ENCOUNTER SOMETHING THAT BRINGS this

character to mind. YOU CAN BEGIN WITH SOMETHING like "I THOUGHT OF (name) YESTERDAY WHEN
— 3 minutes
Draw the scene
— 3 MINUTES

◆ Chapter 7 ◆

WRITE A SHORT SCENE in WHICH YOU IMAGINE them ON A TRIP SOMEWHERE. AT SOME POINT IN the STORY they SAY SOMETHING.
— 3 minutes
Draw A SCENE FROM the TRIP. ◆ what are they WEARING? WHAT ARE they DOING? 3 mins WHAT WILL they SAY?

Chapter 8

WRITE a SHORT scene that IS SORT OF A SNAP-SHOT OF one OF the LAST TIMES YOU SAW EACH OTHER. INCLUDE the SETTING. 4 MINS

Draw it 4 MINS

Cover and Back cover →

DRAW A BIG FRAME. The title of your 'ZINE IS the NAME OF YOUR CHARACTER. Draw a full-body PICTURE OF YOUR CHARACTER AND LETTER the TITLE — 5 minutes

by Lynda Barry 2019

on the "BACK COVER" draw a LITTLE SOME-THING RELATED to the STORY

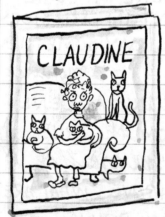

CLAUDINE

FOLD ANOTHER SHEET in HALF

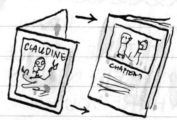

CLAUDINE

CHAPTER 1

SLIP the COVER on AND Dig it!

VARIATION

YOU CAN REPEAT THIS *exercise* WITH A FICTIONAL *character*.

OR DRAW TWO *characters* FROM THE CHARACTER JAM AND HAVE ONE DO THE *exercise* ABOUT THE OTHER.

in the end you'll have a first draft of a new story

2ND DRAFT
in the Making Comics class

I ASK STUDENTS to RE-DRAW AND RE-WRITE THEIR 'ZINES ON BETTER PAPER - 8.5"×11"

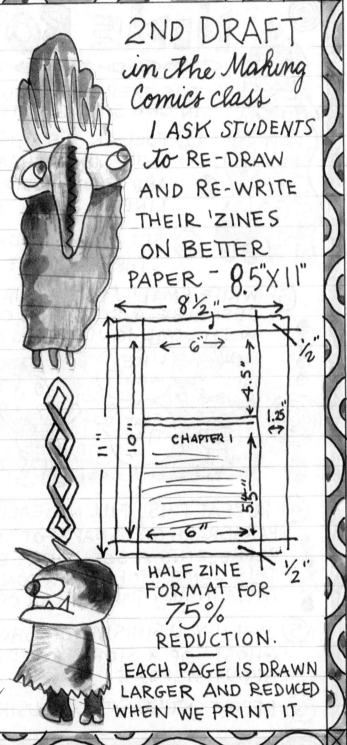

← 8½" →

← 6" →

½"

4.5"

1.25"

11"

10"

CHAPTER 1

5.5"

← 6" →

½"

HALF ZINE FORMAT FOR **75%** REDUCTION.

EACH PAGE IS DRAWN LARGER AND REDUCED WHEN WE PRINT IT

NINE BOXES

THIS EXERCISE SHOULD BE DONE IN ONE SITTING WITH NO BREAKS

PAPER
PEN
TIMER
GO!

① FOLD AN 8.5" X 11" PAGE INTO NINE CHAMBERS AND DRAW THE DIVIDING LINES

② SET A TIMER FOR THREE MINUTES

③ WRITE SMALL! IN THE FIRST BOX DESCRIBE A SITUATION OR SCENE WITH SOME KIND OF TROUBLE GOING ON

LIKE WHAT?

FLAT TIRE

OR... STABBED IN THE NECK, ENVY, PYROMANIA, FLEAS, COWARDICE, BEING BIT ON THE ASS BY STRANGE DOG, ETC.

④ REPEAT THIS, FILLING EACH BOX WITH A PARAGRAPH OR "SNAPSHOT" IMAGE WHICH REPRESENTS A SCENE OR SECTION FROM THIS SAME STORY. YOU DON'T HAVE TO DO THEM IN ANY PARTICULAR ORDER.

⑤ WHEN YOU FINISH, YOU SHOULD HAVE THE "GHOST" OF A STORY YOU DIDN'T KNOW ABOUT BEFORE.

⑥ REPEAT ENTIRE EXERCISE USING ONLY DRAWINGS.

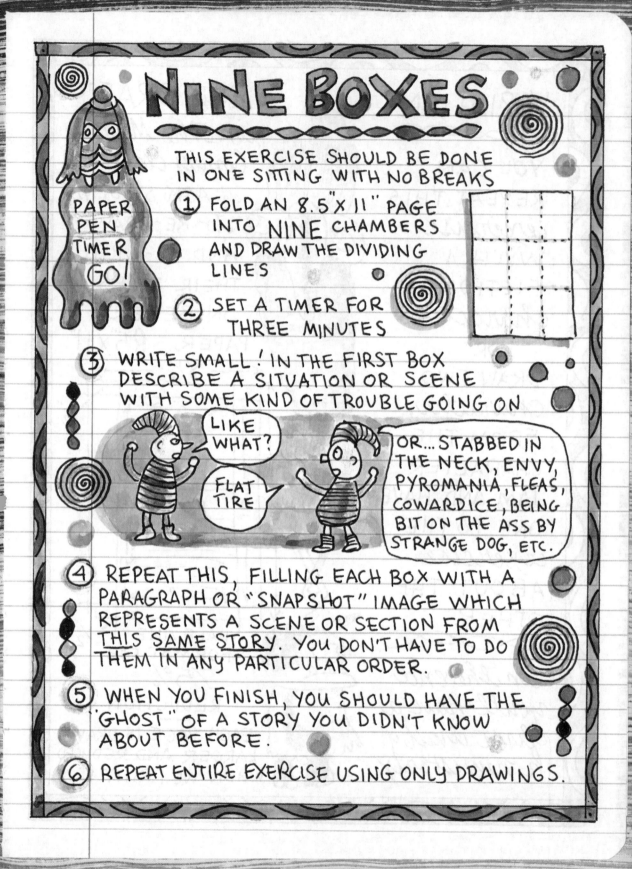

VARIATIONS

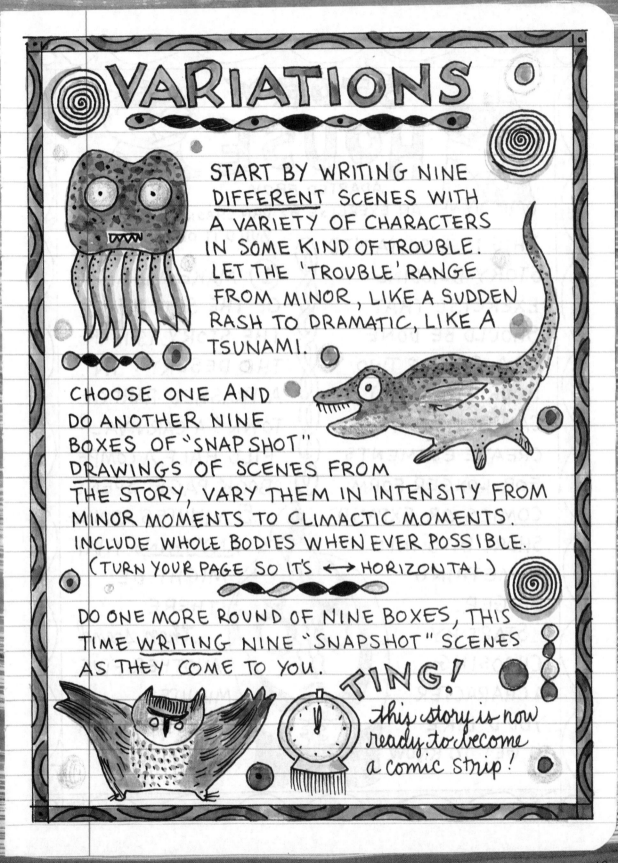

START BY WRITING NINE DIFFERENT SCENES WITH A VARIETY OF CHARACTERS IN SOME KIND OF TROUBLE. LET THE 'TROUBLE' RANGE FROM MINOR, LIKE A SUDDEN RASH TO DRAMATIC, LIKE A TSUNAMI.

CHOOSE ONE AND DO ANOTHER NINE BOXES OF "SNAPSHOT" DRAWINGS OF SCENES FROM THE STORY, VARY THEM IN INTENSITY FROM MINOR MOMENTS TO CLIMACTIC MOMENTS. INCLUDE WHOLE BODIES WHENEVER POSSIBLE. (TURN YOUR PAGE SO IT'S ⟷ HORIZONTAL)

DO ONE MORE ROUND OF NINE BOXES, THIS TIME WRITING NINE "SNAPSHOT" SCENES AS THEY COME TO YOU.

TING!

this story is now ready to become a comic strip!

STORY HOUSE

ADAPTED FROM AN EXERCISE BY DAN CHAON

THIS IS A SUSTAINED STORY-BUILDING EXERCISE THAT SHOULD BE DONE IN A SINGLE TWO HOUR SITTING. IT CAN BE USED TO CREATE ELEMENTS FOR LONGER FORM COMICS OR EXPAND SHORT BITS INTO SOMETHING BIGGER.

START BY CHOOSING A CHARACTER YOU'D LIKE TO GET TO KNOW.

BUILD IT ONE SCENE AT A TIME!

① MAKE A DRAWING OF THE SETTING OF THE STORY. IS IT IN THE DESERT? IN A TRASHED PART OF TOWN? A CARNIVAL? FILL HALF A COMP-BOOK PAGE. SPEND 5 MINUTES ADDING ANYTHING THAT MIGHT BE THERE.

then spend ANOTHER FIVE MINUTES WRITING ABOUT THIS PLACE.

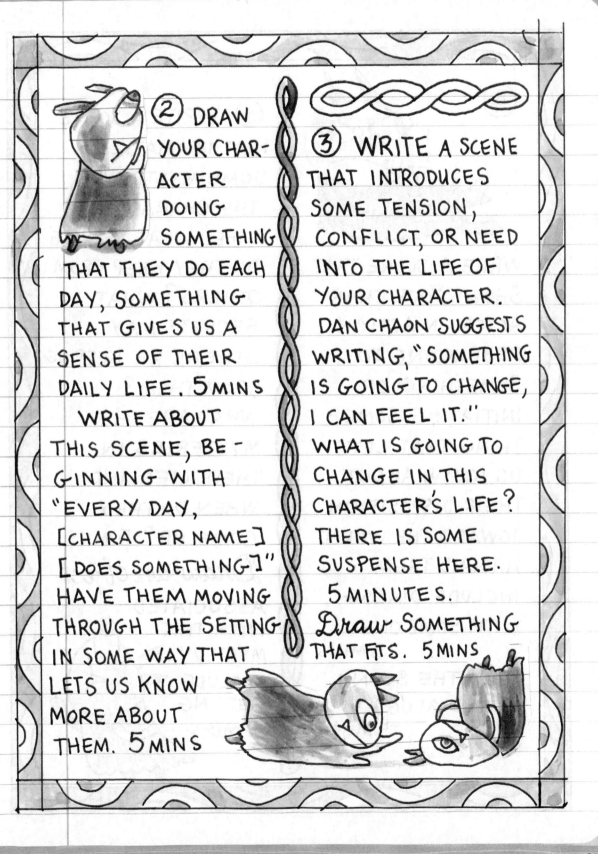

② DRAW YOUR CHARACTER DOING SOMETHING THAT THEY DO EACH DAY, SOMETHING THAT GIVES US A SENSE OF THEIR DAILY LIFE. 5 MINS

WRITE ABOUT THIS SCENE, BEGINNING WITH "EVERY DAY, [CHARACTER NAME] [DOES SOMETHING]" HAVE THEM MOVING THROUGH THE SETTING IN SOME WAY THAT LETS US KNOW MORE ABOUT THEM. 5 MINS

③ WRITE A SCENE THAT INTRODUCES SOME TENSION, CONFLICT, OR NEED INTO THE LIFE OF YOUR CHARACTER. DAN CHAON SUGGESTS WRITING, "SOMETHING IS GOING TO CHANGE, I CAN FEEL IT." WHAT IS GOING TO CHANGE IN THIS CHARACTER'S LIFE? THERE IS SOME SUSPENSE HERE. 5 MINUTES.

Draw SOMETHING THAT FITS. 5 MINS

④

WRITE A SCENE THAT
SHOWS YOUR CHAR-
ACTER IN ACTION
RESPONDING TO
SOMETHING OR
INITIATING SOME-
THING THAT LETS
US KNOW ABOUT
THEIR DISPOSITION
TOWARD THE WORLD
AROUND THEM.
INCLUDE DIALOG
WITH SOMEONE
 5 MINS
DRAW THE SCENE
WITH DIALOG
 5 MINS

⑤ WRITE A SCENE
THAT DRAMATIZES
SOME MYSTERY IN
THE CHARACTER'S
LIFE. WHAT SECRETS
DO THEY KEEP FROM
OTHERS? WHAT
SECRETS MAY
OTHERS BE KEEPING
FROM THEM?
WHAT ARE THE
MYSTERIES IN
THEIR LIFE AND
WHEN DO THEY
COME UP? 5 MINS.
Draw an object
ASSOCIATED
WITH THIS
MYSTERY.
INCLUDE
SETTING.
5 mins

⑥ WRITE A SCENE
WHICH SHOWS
THE CHARACTER
ENGAGED IN SOME
SIGNIFICANT
ACTION THAT
SURPRISES THEM
OR SEEMS OUT
OF CHARACTER:
SOMETHING
THAT MAKES
THEM THINK
"I CAN'T
BELIEVE
I JUST DID
THAT"
5 MINS

DRAW *this*
SCENE.
5 MINS

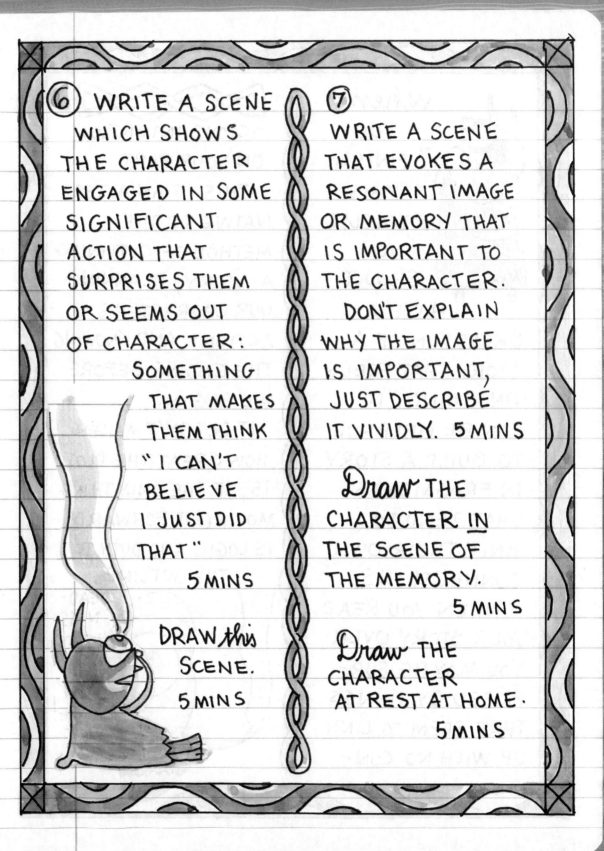

⑦ WRITE A SCENE
THAT EVOKES A
RESONANT IMAGE
OR MEMORY THAT
IS IMPORTANT TO
THE CHARACTER.
DON'T EXPLAIN
WHY THE IMAGE
IS IMPORTANT,
JUST DESCRIBE
IT VIVIDLY. 5 MINS

Draw THE
CHARACTER _IN_
THE SCENE OF
THE MEMORY.
5 MINS

Draw THE
CHARACTER
AT REST AT HOME.
5 MINS

When you FINISH THIS *exercise* you SHOULD HAVE A SKELETON OF A STORY THAT FEELS ON-GOING. IT CAN BE HELPFUL TO BUILD A STORY IN FRAGMENTS THAT TEND TO KNIT THEIR OWN CONNECTIONS.

WHEN YOU READ YOUR STORY OVER YOU MAY BE SUR-PRISED BY THINGS THAT SEEM TO LINK UP WITH NO CON-SCIOUS INTENTION ON YOUR PART.

THIS IS AN ALTER-NATIVE TO THE METHOD OF OUTLINING A STORY, PLANNING OUR CHARACTERS ACTIONS, AND KNOWING THE ENDING BEFORE WE BEGIN.

IT DOESN'T MATTER HOW GREAT THE PLOT IS, IF THE ONLY THING MOVING IT FORWARD IS LOGIC AND DUTY TO THE OUTLINE, DEAD-NESS SETS IN. STAY ALIVE!

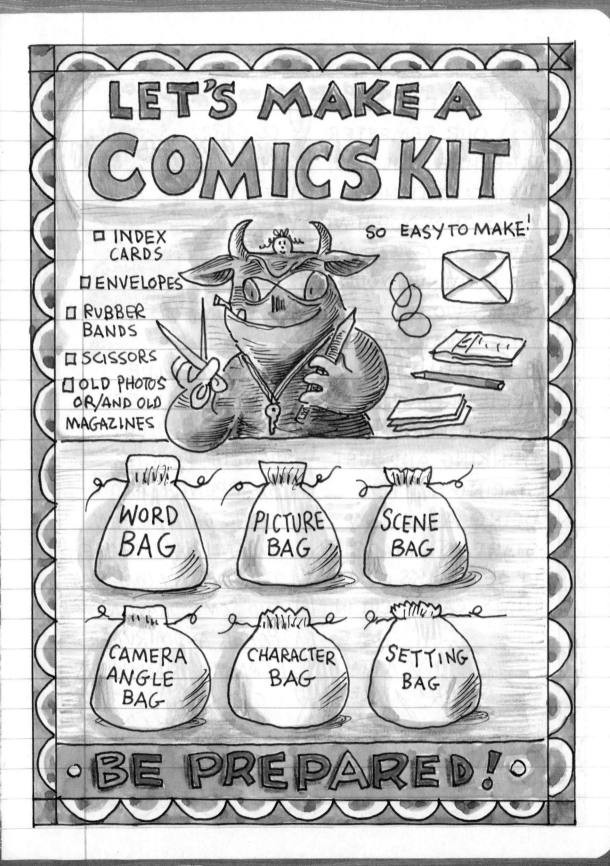

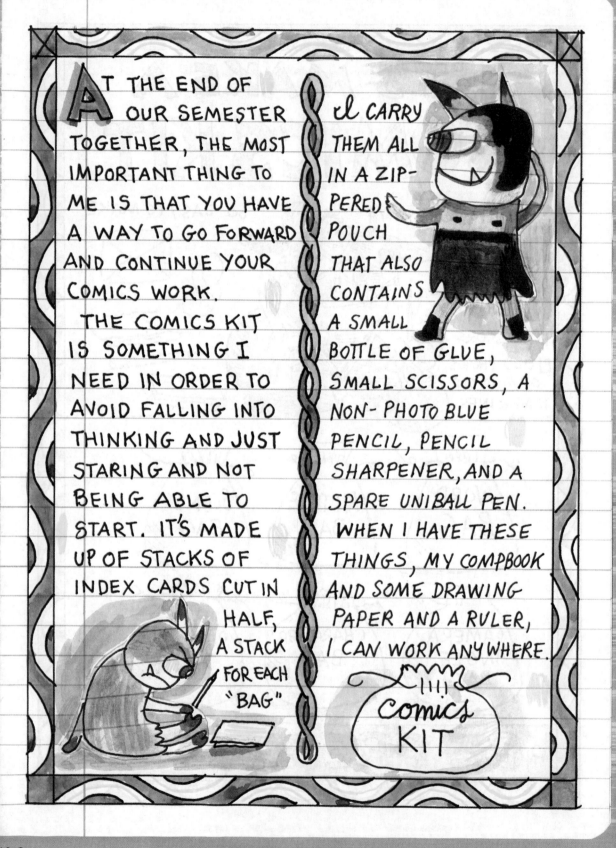

AT THE END OF OUR SEMESTER TOGETHER, THE MOST IMPORTANT THING TO ME IS THAT YOU HAVE A WAY TO GO FORWARD AND CONTINUE YOUR COMICS WORK.

THE COMICS KIT IS SOMETHING I NEED IN ORDER TO AVOID FALLING INTO THINKING AND JUST STARING AND NOT BEING ABLE TO START. IT'S MADE UP OF STACKS OF INDEX CARDS CUT IN HALF, A STACK FOR EACH "BAG"

I CARRY THEM ALL IN A ZIP-PERED POUCH THAT ALSO CONTAINS A SMALL BOTTLE OF GLUE, SMALL SCISSORS, A NON-PHOTO BLUE PENCIL, PENCIL SHARPENER, AND A SPARE UNIBALL PEN. WHEN I HAVE THESE THINGS, MY COMPBOOK AND SOME DRAWING PAPER AND A RULER, I CAN WORK ANYWHERE.

Comics KIT

WORD BAG

A SET OF CARDS WITH NOUNS WRITTEN ON THEM. USE FOR AUTOBIO- GRAPHICAL X-PAGE STORIES OR FICTION, COMBINE WITH PICTURES OR CHARACTERS TO START UP A STORY.

I DON'T USE A BAG - MINE ARE A STACK OF CARDS WITH A RUBBER BAND AROUND IT. I'M ALWAYS ADDING TO IT. I HAVE SEVERAL OF THEM.

PICTURE BAG

I USE FOUND PHOTOS AND IMAGES FROM OLD NATIONAL GEOGRAPHICS. THEY ARE USED FOR X-PAGE STORIES AND COMBINED WITH WORDS, PHRASES, AND CHARACTERS.

I LIKE ANSWERING THE X-PAGE QUES- TIONS WHEN LOOKING AT A PHOTOGRAPH. WHERE IS THE LIGHT COMING FROM? WHAT'S GOING ON? WHAT ARE SOME OF THE SOUNDS IN THIS IMAGE?

SCENE BAG

THIS IS A COLLEC-
TION OF STORY
POINTS BASED ON
AN EXERCISE BY
DAN CHAON. EACH
CARD IS AN ELEMENT
OF A STORY AND I
SOMETIMES PLAY
IT LIKE A GAME.
I START WITH A
CHARACTER, A
SETTING, AND A SIT-
UATION AND THEN
I PULL A SCENE BAG
CARD AND GIVE MY-
SELF 3-4 MINUTES
TO MAKE AN IMAGE,
ALTER-
NATING
BETWEEN
WRITING
AND
DRAWING
THE IMAGE
THAT COMES
TO ME.
This non-linear
WAY OF MAKING A
STORY ALWAYS SUR-
PRISES ME, AND
BEING SURPRISED
WHILE YOU ARE
WORKING IS EVERY-
THING. YOU CAN MAKE
UP YOUR OWN ELE-
MENTS OR COPY THE
ONES ON THE NEXT
PAGE.

CHARACTER GOING ABOUT A MUNDANE BUT NECESSARY TASK	THE CLIMACTIC SCENE OF THE STORY
SCENE THAT SHOWS THE SETTING OF THE STORY	SCENE AFTER THE CLIMAX – DIRECTLY AFTER OR A FEW DAYS LATER
SCENE DIRECTLY BEFORE THE CLIMAX	SCENE BEFORE CLIMAX SHOWING CHARACTER HOPING FOR SOMETHING OR DREADING SOMETHING
ALONE, AT NIGHT, WAITING FOR SOMETHING	AN EVENT THAT LEADS TO THE CLIMAX
A MEMORY THAT COMES TO THE CHARACTER DURING THE CLIMAX	SCENE FROM YOUR CHARACTER'S PAST
SCENE WHERE YOUR CHARACTER EXPERIENCES TENSION OR CONFLICT	DAY TO DAY LIFE
ONE WEEK AFTER	INTRUSION OF EXTERNAL EVENT
SCENE THAT LEADS TOWARD THE CLIMAX	CHARACTER IN DIALOG WITH SOMEONE

ANGLE BAG

I LIKE TO WATCH *movies* AND WATCH FOR ANGLES I CAN USE *in* COMICS. HERE ARE A FEW...

AERIAL SHOT	FULL BODY IN SPECIFIC SETTING	"SECURITY CAMERA" ANGLE
OVER THE SHOULDER VIEW OF WHAT THE CHARACTER SEES	MEDIUM SHOT, LOW ANGLE	WIDE SHOT INCLUDES SETTING
CLOSE-UP, PERSON	ESTABLISHING SHOT	WEATHER SHOT
TWO FULL BODIES	FROM ABOVE, MEDIUM SHOT	CLOSE-UP OBJECT
LONG SHOT	PEOPLE IN THE DISTANCE	SILHOUETTE
MEDIUM SHOT, EYE LEVEL	CUT AWAY (A SHOT OF SOMETHING OTHER THAN THE SUBJECT)	SETTING

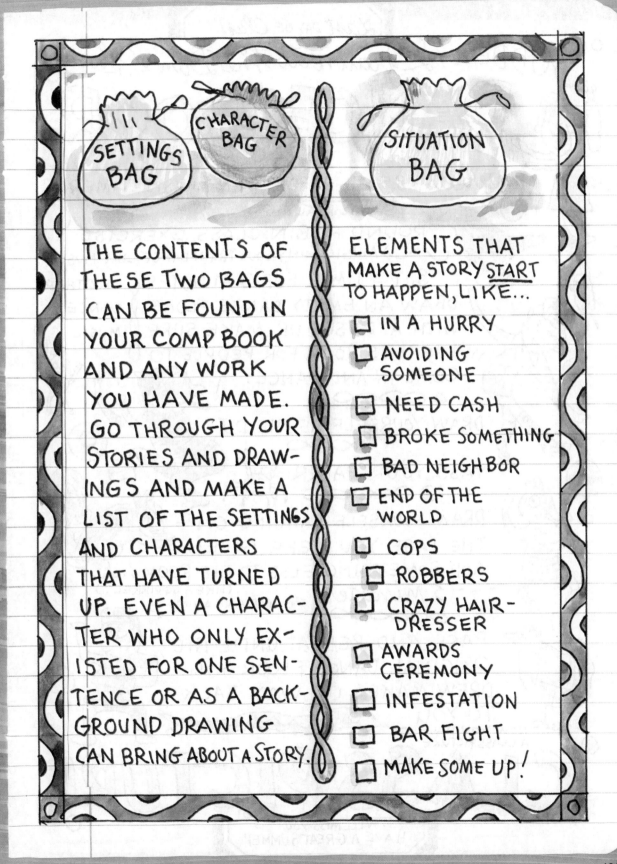

SETTINGS BAG

CHARACTER BAG

SITUATION BAG

THE CONTENTS OF THESE TWO BAGS CAN BE FOUND IN YOUR COMP BOOK AND ANY WORK YOU HAVE MADE. GO THROUGH YOUR STORIES AND DRAWINGS AND MAKE A LIST OF THE SETTINGS AND CHARACTERS THAT HAVE TURNED UP. EVEN A CHARACTER WHO ONLY EXISTED FOR ONE SENTENCE OR AS A BACKGROUND DRAWING CAN BRING ABOUT A STORY.

ELEMENTS THAT MAKE A STORY START TO HAPPEN, LIKE...

☐ IN A HURRY
☐ AVOIDING SOMEONE
☐ NEED CASH
☐ BROKE SOMETHING
☐ BAD NEIGHBOR
☐ END OF THE WORLD
☐ COPS
☐ ROBBERS
☐ CRAZY HAIR-DRESSER
☐ AWARDS CEREMONY
☐ INFESTATION
☐ BAR FIGHT
☐ MAKE SOME UP!

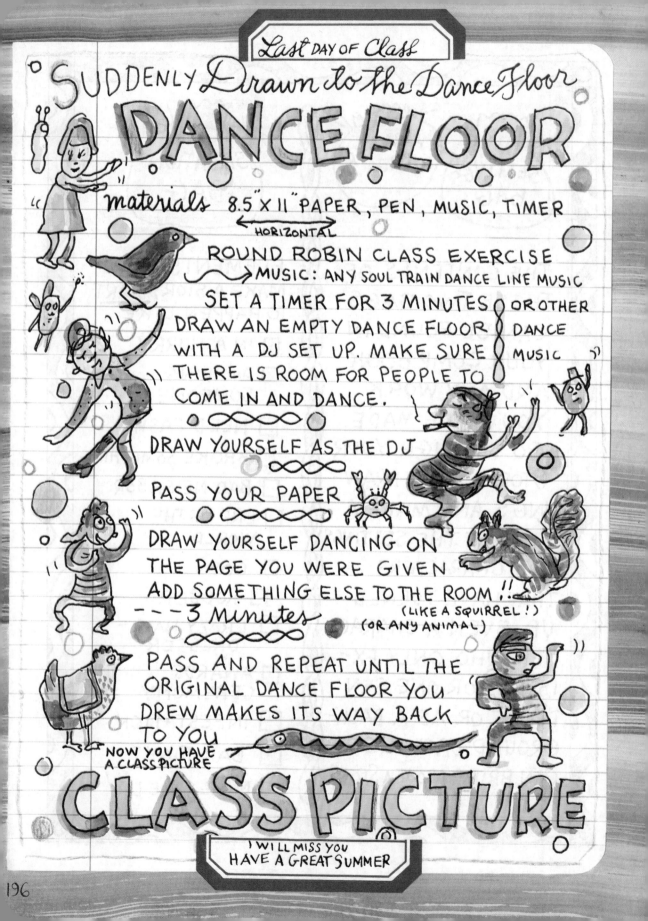

SUDDENLY Drawn to the Dance Floor

DANCE FLOOR

materials 8.5" X 11" PAPER, PEN, MUSIC, TIMER

HORIZONTAL

ROUND ROBIN CLASS EXERCISE

MUSIC: ANY SOUL TRAIN DANCE LINE MUSIC

SET A TIMER FOR 3 MINUTES OR OTHER

DRAW AN EMPTY DANCE FLOOR DANCE

WITH A DJ SET UP. MAKE SURE MUSIC

THERE IS ROOM FOR PEOPLE TO

COME IN AND DANCE.

DRAW YOURSELF AS THE DJ

PASS YOUR PAPER

DRAW YOURSELF DANCING ON
THE PAGE YOU WERE GIVEN
ADD SOMETHING ELSE TO THE ROOM !!
---- 3 Minutes

(LIKE A SQUIRREL !)
(OR ANY ANIMAL)

PASS AND REPEAT UNTIL THE
ORIGINAL DANCE FLOOR YOU
DREW MAKES ITS WAY BACK
TO YOU

NOW YOU HAVE
A CLASS PICTURE

CLASS PICTURE

I WILL MISS YOU
HAVE A GREAT SUMMER

(illegible signature)
4/21/16

I BELIEVE ANY-
ONE CAN MAKE
COMICS. THE
MOST LIVELY
WORK COMES
FROM PEOPLE
WHO GAVE UP ON
DRAWING A LONG
TIME AGO, AND
I'VE BEEN SO
HAPPY TO WIT-
NESS THE JOY
AND SURPRISE
COMICS BRING
TO LIFE. Every-
thing GOOD in
MY LIFE CAME
because I
DREW A PICTURE.
I HOPE YOU
WILL DRAW A
PICTURE SOON.
I WILL ALWAYS
WANT TO SEE IT. XOX LB♥

Thank you to the person
at NASA who did this portrait
OF ME. THANK YOU TO EBONY
FLOWERS KALIR, KC COUNCILOR,
JASON KARTEZ, LIZ KOZIK,
JOSH MCMAHON, TOM TAAGEN,
TEACHERS KRISTIN and
VANESSA AT EAGLE'S WING
4K, the STAFF AND FACULTY
OF UW-MADISON ART DEPT.
Liz Darhansof, STEVEN
BARCLAY and Co., Susan GRODE
SCROUNGE ROCHELEAU, KELLY
HOGAN, Background BEAR,
The United States Artists grant
GIVERS. MARILYN + SALLY.

Thank-you to my Students AT UW-MADISON 2012-2019

AFKA 'L' • AKIRA • ALTAIR IBN-LA'AHAD • Ambrose • AMETHYST • American Street Kid • AMYGDALA • ARABELLA • ARABELLA • Arya Stark • Ashmedai • Auntie Whispers • ∞ • AVATAR ROKU • BB Bernadette • BABY Pork chip • BAUBO • Beatrix Kiddo • BELLATRIX LESTRANGE • BEN BAG BAG • Bender • BEZDOMNY • Big Boss ✦ • BIG CHUNGUS • BJORK • Bluto • BOOTSY • Bozho • BRAINSTEM • Bulma • BUNNY • CALCIFER • Cactus • CAPTAIN ACTION 🎲🎲 • Captain Haddock ; Captain Underpants • CARMEN SANDIEGO ; Cassandra ; CERE-bellum ; CEREBRAL CORTEX ; Charlie BUCKETS ; Chase Carver ; CHEF BOY-ardee ; CLUMSY KID • Coleslaw • ✦ • CORN • Companion Cube • COUNT - Chocula • CORPUS CALLOSUM • CHARLIE HEBDO • Chewbacca • DADDY • Radish • Danger MOUSE • Daria • DICK GRAYSON • Director Flossie • Dorothy DARLYING • DR. BRONNER • DR. Dolomite • Dr. GIRLFRIEND • DR. HIBBLETON • DR. Jones • Dumbo • Drifter • DROGO? • Eeyore • Eliza THORNBERRY • Ellie • EMPERATOR Furiosa • EVE(NINGS) • Fat Louie • FAY ATOMZ • Falada • FEATHERS McGraw • FELICITY Merriman • FENRIR • Fermina DAZA, FINN • Fox • Free WILLY • Freida Cashflow • FRITH • FRONTAL lobe • GARLIC Jr. • G.K. George Washington • GINGER • GLOWING CLOUD • GODZilla • ARTEMIS • CLAUDIA GONSON • mark TRAIL • JEFF Cold BEER • GRACE HOPPER

Goodfella • GORILLA Grodd • GORT • Gravelord NITO • GRACE Hopper • GRAY • Green Puppy • GRUNDY • Haiku • HAL 9000 • Hallelujah JONES • Hamlet • HARPER ROW • Harry BLACKSTONE Dresden COPPEFIELD • Hello - KITTY • Herman • HERMIONE - Granger • HIPPO • Hippocampus • HOMOEROTIC SUBTEXT IN SPACE • Honeybee • HOOPS • Huck Finn • HUNCA MUNCA • Hydra • HYPATIA • Hypothalamus • INSPECTOR GADGET • Dolomite • Invader - Skoodge • ISTANBUL • Jane • JEAN VALJEAN • Jester • JOHN Adams • Judee • JUGEMU JUGEMU • JUJU • Kal El • Kale • Kali Ku-GELMAN • Kawaille • KIWI JEAN Killian • KING DINGALING • Kitty FOREMAN • Knuckles HEMINGWAY • 'L' • LMNOP • Lady Amalthea • Lapis Jazuli • LAVENDER LIZARD • LESLIE Knope • Levi • Linus • LIT-TLE FOOT • Little My • LITTLE Nemo • LIRAEL • Live Harm-LESS REPTILES • LOIS LANE • Lola • Lolly • LORE • Loretta LINDEN • LORD Zuko • LUCY LOU • Luna Love GOOD • Lutra Lutra • LYMBIC SYSTEM • MACKEREL Sky • Mae Boroski • MAE WEST • MAFALDA • Mako Malachy • Man Mazik

Marceline • MARLA SINGER • MARTHA Stewart • Mary Poppins • Maya THE BEE • MC. GRITZ • MEELO • Megan • Mick Mickie • MIGHTY MANFRED • MIGHTY Mouse • Mindless Philosopher • MOLLY McDONALD MONKEY KING • Mordechai • Mother Courage • MR. BUMPY MR. MADILLA • Mr November Nala, NEKO, Ambrose; NIKKI MINAJ • Nogi • NORA Ephron • NOSTALGIA • Nott the BRAVE • #5 • Obelix • Octopus Carwash • OLD SKULL • OPTIMUS PRIME • Orange MAR-MALADE • Otis Redding • OWLA • Party Peanut • PECO • Pen-Guino; PERCY • Pegasus PIXIU • Pictor • PIGPEN Pigwidgeon • Pippi LONG-STOCKING • Pons • POPUKO • Prefrontal Cortex • Princess BUBBLEGUM • PRINCESS LEIA Princess Lolly • Princess PEACH • Quail Man • Rajah • RATTLESNAKE Master RASPBERRY Beret; RAVEN • Redemption • REGINA PHALANGE REGULAR SIZED RUDY • Rick • Robin Hood • ROSE QUARTZ • ROSIE the RIVETER • Santa Claus • Scott Pilgrim • SCOUT • SELCO • SELKIE • shark bait • Sherlock Holmes • SIMON SNOW • SISTER - All the CARDS in the DECK FOR Writing the UNTHINKABLE

mary IGNATIUS S.C. • Sitri • SKEETER • Smaug • SMILEY Bone • SNAKE EYES • SNOOPY • SnapCrackle Pop • Spethjasu • SPINAL CORD • SPINELLI • Spooks • SPOT • Squid • SQUILLIAM Fancison SQUIRRELHEAD • Storm • Stichy • STEVANNI • STEVIE Beach • Stella Luna • Starfire • STOIBINATOR • SuperOne FOODS • Supreme Overlord • SWEET J P • TACO JOHN • Temporal Lobe • Terra • THALAMUS WONG • THE BUFFALO • The Girl • The Princess Anastasia • THE SHMOO • THE SPIRIT • Tim ? • Tizita • Tigger • TURTLE DAVIS • TOES • Tonks • TOOTHLESS • TRACE Lactose • TWI-light SPARKLE • 2 BISCUITS • uncle Bill • UNG • Usagi • VANTH • Veggie • Venus Flytrap • Vicki MINAU • Venus • SPACE Dandy • ViQueen OF Madness • Waldo • Wilder • Woodstock • WRIGLEY • WYOMING • Young, Gifted and Black YOGI BEAR • ZEF • Zenyatta Zola, Zorba, Zusha If your name isn't here It's in my heart. ♡
Love, Lynda B

Watercolor post card FROM Danny Ceballos SPRING 2019

For Dan C. ♥
and Ivan B. ♥

drawnandquarterly.com
978-177046-369-1
FIRST edition OCT. 2019
PRINTED in MALAYSIA
10 9 8 7 6 5 4 3 2 1

♡ Peggy Burns ♡
PUBLISHER
Drawn & Quarterly
6750 AVENUE
DE L'ESPLANADE
Montreal, CANADA
QCH2V4M1

GRATITUDE to KATHY ♥
♥ CHAZEN
and the CHAZEN
FAMILY whose
GENEROSITY AND
SUPPORT TRANSFORMED the COMICS ROOM
at the University of WISCONSIN-madison
AND the LIVES OF MY students. YOU MADE
ALL THE DIFFERENCE for ME AS A TEACHER.
We had everything we needed! LOVE TO YOU!